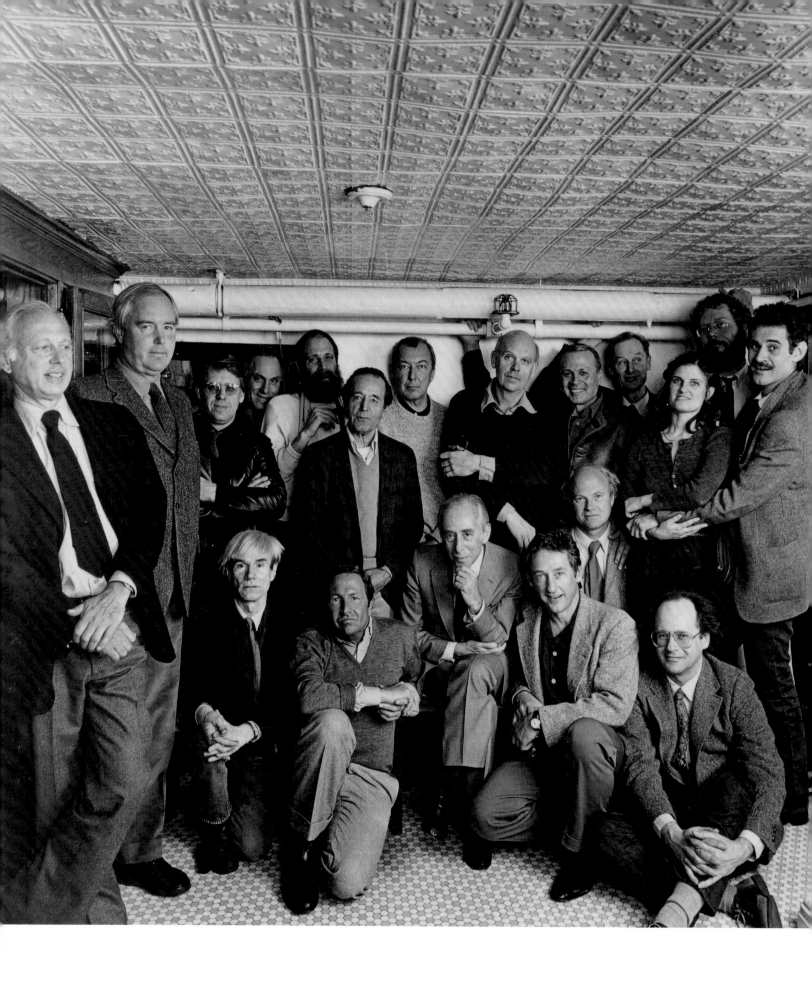

HANS NAMUTH
PORTRAITS

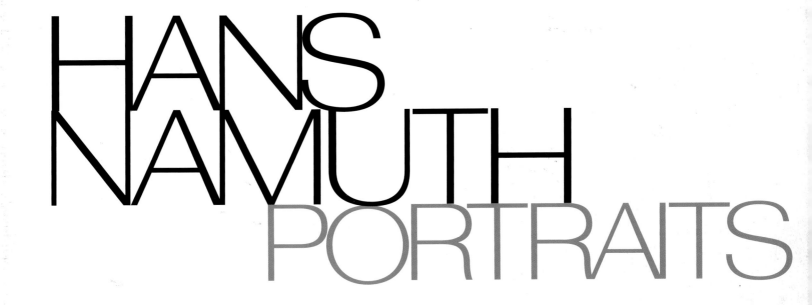

CAROLYN KINDER CARR

PUBLISHED FOR THE NATIONAL PORTRAIT GALLERY
BY THE SMITHSONIAN INSTITUTION PRESS

WASHINGTON • LONDON

An exhibition at the National Portrait Gallery,

Smithsonian Institution, Washington, D.C., April 30–September 6, 1999

Edited by: Frances K. Stevenson and Dru Dowdy

Designed by: Linda McKnight

Library of Congress Cataloging-in-Publication Data

Carr, Carolyn Kinder.

Hans Namuth : portraits / Carolyn Kinder Carr.

 p. cm.

Exhibition held at the National Portrait Gallery, April 30–September 6, 1999, and others.

Includes bibliographical references and index.

ISBN 1-56098-809-6 (alk. paper)

1. Namuth, Hans—Exhibitions. 2. Portrait photography—Exhibitions. I. Namuth, Hans.

II. National Portrait Gallery (Smithsonian Institution). III. Title.

TR680.C365 1999

779′.2′092—dc21 98-50685

British Library Cataloguing-in-Publication Data available

Printed in Singapore, not at government expense

06 05 04 03 02 01 00 99 5 4 3 2 1

♾ The paper used in this publication meets the minimum requirements of the American
National Standard for Information Sciences—Permanence of Paper for Printed Library
Materials ANSI Z39.48-1984.

Frontispiece: *Leo Castelli and His Artists.* Gelatin silver print, 1982. National Portrait
Gallery, Smithsonian Institution, gift of the estate of Hans Namuth.

Photography credits: Marianne Gurley: page 43
Rolland White: page 28

CONTENTS

FOREWORD

From the moment of the establishment of the Department of Photography in the National Portrait Gallery, the specialists in the Gallery have been exploring the many ways in which they could place before the American public the contribution made to portraiture by photographers. The public today is constantly exposed to photography, and this familiarity has perhaps led many to overlook the striking individuality of the work of different photographers. For that reason, a series of one-person exhibitions commenced some years ago, each accompanied by a substantial publication. Among the photographers covered have been Robert Cornelius, Mathew Brady, Arnold Newman, Irving Penn, Richard Avedon, Annie Leibovitz, and Philippe Halsman. It is the intent of this series of explorations into the work of the accomplished photographic portraitists of the nineteenth and twentieth centuries to discern the qualities of each artist, to suggest something of the development of his or her work, and to explore the relationship of the photographer with his subjects.

In this, the latest in our monographic studies of portrait photographers, Carolyn Carr has chosen the late Hans Namuth as her subject. Namuth came to the Gallery's attention when an exhibition of artists and writers of the 1950s was being planned a few years ago, and we were anxious to show compelling photographs of the so-called Abstract Expressionists who had enlivened the New York art scene forty years ago. In the visual arts, when many of us think of Jackson Pollock, we immediately call to mind the image of the painter in his working clothes, leaning over his canvas on the floor and hurling paint from above to create the swirling gestures unique to his works. Hans Namuth was the photographer responsible for the best-known of these pictures, and for photographs of many of the other artists, architects, and writers who came to prominence in the 1950s and 1960s. Namuth was one of the chroniclers of the newly vibrant American art scene, and he developed such close relationships with many of its personalities that he became a participant as well as a recorder.

We contacted Namuth's family, and they not only made available

the photographs used in the exhibition but also enabled the National Portrait Gallery to acquire a representative selection of Namuth's best work for its collections. We are grateful for their cooperation in both projects, and are very pleased to have been able to add these impressive portraits of artists at work to our holdings for the benefit of future generations.

This volume is also the first extended account of Namuth's life to be published. Curiously, he was never as well known as either the artists he photographed or the other accomplished photographers of his time. Informed members of the public probably would recognize the names of Alfred Stieglitz, Edward Steichen, Irving Penn, or Richard Avedon, but few know Hans Namuth by name, although they have seen his photographs reproduced in countless publications. Of the American photographers who so far have been the subject of monographic treatment at the National Portrait Gallery, only Namuth and Halsman were not born in this country. Both left Europe as it became clear that the Second World War was inevitable, and that people of the wrong politics or the wrong race were in grave danger. Namuth joined a legion of other immigrants to America in the late 1930s, many of whom profoundly enriched the cultural life and academic life of this country. Other photographers included Josef Breitenbach, André Kertész, Robert Capa, and dozens more. An entire generation of art historians were educated by Irwin Panofsky, H. W. Janson, Rudolph Wittkower, and their colleagues. Stanley William Hayter transplanted his *Atélier 17* to New York from Paris, and attracted artists as diverse as Max Ernst and André Racz to the studio. Among the former European artists that Namuth photographed were Willem de Kooning, Josef and Anni Albers, Constantino Nivola, and Saul Steinberg, as well as dealers like Leo Castelli.

Namuth's first photographs were taken in Europe, and I suppose that his personal style was informed by his foreign origins. Certainly, as a newcomer to the United States, he was sensitive to phenomena that were almost invisible to most Americans. In Europe, as Carolyn Carr

tells us, he was associated early in his life with writers and intellectuals. He went to Spain during the Civil War there, and photographed what he saw. When he came to America, he found that he was little attracted to ordinary life in the Midwest. New York was more to his taste, where he could find people and activity more to his liking, and where he felt the presence of intellectual and creative forces that energized his own work.

Some photographers, like Mathew Brady, kept a distance from their subjects. Brady's political sympathies appeared to be with the Northern side in the Civil War, yet he photographed General Lee with considerable sympathy; though he was well known for his images of Lincoln, he also photographed a number of other politicians who were unsympathetic to Lincoln's positions. In contrast, many of Namuth's photographs emerged from personal contact, including artists, dealers, critics, architects, and others active in the New York art world after the Second World War. As Namuth completed his initial photographs of Jackson Pollock in the summer of 1950, he began to formulate the vision that would shape the remainder of his photographic career. To underscore the symbiotic relationship between the artist and his work, he went into the studios and workrooms of his subjects. His friendships with the painters provided him with contacts that led to others in the arts, and over the next four decades Namuth assembled a portfolio recording one of the great cultural periods in America.

We must all be grateful to Deputy Director Carolyn Carr and Ann Shumard, assistant curator in the Gallery's Department of Photography, for bringing this collection together and interpreting it for the rest of us. Dr. Carr has written a fascinating account of Namuth's life and work. I join her in expressing gratitude to the many colleagues at the Gallery and at the Smithsonian Institution Press who have given form to this book and to the exhibition that accompanies it. But without the support of Hans Namuth's children, Peter and Tessa, none of this could have come about, and the Gallery is deeply appreciative of their cooperation.

Alan Fern
Director
National Portrait Gallery

ACKNOWLEDGMENTS

Alan Fern, director of the National Portrait Gallery, and I have always shared an interest in photography, and our perceptions regarding quality and significance are similar. So it was not difficult to persuade him that Hans Namuth's contribution to the history of twentieth-century portraiture should be represented in the museum's collection by a major body of work, just as the Gallery has paid homage to the achievements of Irving Penn and Arnold Newman by acquiring a selection of their master images. With his blessing, I approached Peter Namuth and Tessa Namuth Papademetriou, who responded to my enthusiasm for their father's work with a gift to the Gallery of fifty-two portraits. And it is through their continued support that this book and the accompanying exhibition have come to fruition. They have shared with me unpublished letters, written when Namuth was a young man still living in Europe and first finding his way to America, showed me family photographs, and provided answers to endless questions about their father, whom I had never met.

Ann Shumard, assistant curator of photographs, joined with me in the selection of photographs from the Namuth estate. I still remember the excitement she and I felt as we were given access to the images in Namuth's studio and the freedom to choose those we thought appropriate for the collection. It was a heady experience opening box after box of portraits and finding telling representations of many of America's foremost leaders in the arts. It was a surprise for us to discover—as I think it will be for the readers of this book—the range of individuals that Namuth photographed. For while Namuth is best known for his portraits of artists, he also made stunning portraits of architects, writers, and musicians, and even that master of culinary creativity, Julia Child.

In late September 1997, I visited Water Mill. It was an idyllic weekend, with the Long Island landscape bathed in the golden light of early fall. As I explored the area, kept my appointment at the Pollock-Krasner house, saw the Green River Cemetery where so many artists and writers of the 1950s were buried, and stopped at local farm stands, I could sense Namuth's excitement as he traversed the small country roads in

search of a friend and an opportunity to photograph. I saw where Namuth lived, and Tessa and her husband Peter introduced me to such close family friends as Barbara Hale, Ruth Nivola, and David Porter, the latter who told me not only about Hans and Carmen's glorious parties, but about his days in Washington during the 1940s, when he and Caresse Crosby ran the G Place Gallery and showed new, young, then-unknown talent such as Jackson Pollock. Their anecdotes, as well as those in telephone interviews with Jeffery Potter and Peter Blake, provided me with a sense of the lively scene in the East Hampton area in the 1950s, when the region was shaped by the lives of fishermen and farmers, rather than movie stars and Wall Street wealth. An additional treat completing this halcyon weekend was the canoe outing my hostess Sue Halpern, a friend from college, and I undertook on Georgica Pond, so I could see, as the morning fog lifted, a wonderful water view of the former estate of Alfonso Ossorio, a friend to both Pollock and Namuth.

My view of Namuth was shaped by many: Konrad Reisner, Alice Stern and her daughter Gabriella (whom I located through Lucien Kapp), and Florence Reiff remembered Namuth from his first years in America; William Gladstone talked to me about Namuth's career in World War II; Philip Herrera, Carmen's nephew, vividly remembered Namuth in the years after the war, as did Charles Byron. Lillian Bassman, as well as Richard Avedon, provided me with information about photography classes taught under the aegis of Alexey Brodovitch. Frank Zachary told me more about his experiences with *Portfolio,* which was the first magazine to publish Namuth's photographs of Jackson Pollock, and his days selecting his portraits for *Holiday;* Gil Wintering told me how *Early American Tools* came into being; and Mrs. Paul Falkenberg reconstructed what she knew of her husband's early years and his later relationship with Namuth.

To gain some understanding of Namuth's working method, I interviewed numerous individuals who had sat for the photographer. As Namuth was an individual who considered rapport with the subject crucial to a successful photograph, most of these individuals were his friends as well. Regrettably, many fascinating details, consequential and otherwise, that I learned about Namuth could not be incorporated into this short biography with its emphasis on his career as a photographer. (How, for instance, could I use the fact that Namuth's favorite drink was a negroni, which emerged from my long and lovely conversation with Helen Frankenthaler, to elucidate the nature of Namuth's portraiture?) But through her generosity, and that of Leo Castelli, Arnold and Milly Glimcher, Ellsworth Kelly, the late Roy Lichtenstein, James Rosenquist, Lucas Samaras, Julian Schnabel, George Segal, with whom I spoke; and Jasper Johns, Jerome Robbins, and Stephen Sondheim, who corresponded with me, I have a fuller understanding of the man and his

art. Jackson Benson, Arlene Bujese, Milton Esterow, Abe Franjdlich, Judith Goldman, Philip Jodidio, Brian O'Doherty, John Russell, Meryle Secrest, and Judith Wechsler, all of whom knew either Namuth or a subject he photographed, likewise provided me with invaluable insights about Namuth and his career as a photographer.

The great treasure trove of unpublished material on Namuth is in the Namuth collection at the Center for Creative Photography in Tucson, Arizona. It was an enormous pleasure not only to work at the Center, but to work with Amy Rule, head of the Archives and Study Center. Her patience, as I requested box after box of letters, looked at files of photographs, and left long lists for photocopying, was unflagging. And the assistance that both she and Leslie Calmes, assistant archivist at the Center, have given me after I left is also greatly appreciated. Other archivists have responded with equal enthusiasm: Virginia Dodier, Department of Photography at the Museum of Modern Art, provided me with information on the Varian Fry notebook; William Sloan and Charles Silver facilitated my viewing of Namuth's films at MoMA's Film Study Center; Margaret Sherry, Princeton University Library, Manuscripts and Special Collections, sent me material on Allen Tate; Joanna Stasuk of the Leo Castelli Gallery verified facts about Namuth's exhibitions at the gallery; Robert Parks, Franklin D. Roosevelt Library and Museum, confirmed my hunch that the Sumner Welles Papers would contain Barlow's correspondence on Namuth's behalf; Lisa Daum, Bibliothèque Historique de la Ville de Paris, searched the records of the library for signed Namuth photographs. I owe may thanks, too, to Judith Throm, chief of reference services at the Archives of American Art, also a major repository of unpublished materials on Namuth and the artists he photographed, as well as to Mrs. John Clemans, who today still presides over the studio of Hans Namuth and responds to all who call for assistance. The staff of the National Portrait Gallery/National Museum of American Art library, Cecilia Chin, Pat Lynagh, Katrina Brown, Kim Clark, and Stephanie Moye, have my thanks as well for their prompt responses to my various requests.

Many colleagues have answered my queries: Michael Auping shared his interview with Namuth; Judith Zilczer, her knowledge of Willem de Kooning and Richard Lindner; Pepe Karmel provided me with the press release describing Namuth's 1967 presentation at the Museum of Modern Art, as well as his article on Namuth; Ellen Landau recalled her gracious host and the pleasant evening she had when, as a young scholar, Lee Krasner took her to a party at the Namuths'. Diethart Kerbs and Sigrid Schneider told me about their interviews with Namuth; George Dwight, the attorney for the family in about 1985, about Namuth's search for the backdrop used in the Warhol photograph; Fred Baldwin, who attended the 1988 tribute to Namuth in Arles,

France, confirmed Namuth's pleasure regarding this honor. By coincidence, Tom Dennenberg overheard my conversation about Namuth's friend Hans Sahl and was able to steer me to Kenneth Keskinen, who supplied me with the correspondence between Sahl and Lotte Goslar. He also introduced me to Stephanie Taylor, who was at the Smithsonian working on a project related to Joseph Cornell. Laura Katzman led me to Shahn scholar Howard Greenfeld; Stuart Alexander answered my queries regarding any possible affiliation Namuth might have had with Magnum; Peter C. Jones, who worked with both Namuth's and Joseph Breitenbach's estates, gave me wide-ranging information about both photographers; and Sue Davis gave me an off-hours tour of the Varian Fry exhibition at the Jewish Museum. Tara L. Tappert, Cecilia Beaux scholar, led me to my friend Marion Scattergood Ballard, whose mother-in-law, Ernesta Drinker Ballard, put me in touch with Audrey Barlow Orndorff, daughter of Samuel L. M. Barlow. Mary Panzer, curator of photographs at the National Portrait Gallery, who was working on a Philippe Halsman exhibition as I was preparing for the Namuth exhibition, directed me to *Infinity,* the magazine for the Society of Magazine Publishers.

I could not have undertaken the project without Gudrun von Schoenebeck, who, assisted on occasion by Patricia Salim and Doris Rauch, translated Namuth's correspondence and diaries, all of which were in German. Her forays to the Library of Congress for copies of Namuth's published work in *Harper's* and *Holiday* were not only a labor of love but an instant education in American culture of the 1960s for this recent (and temporary) expatriate. Christopher Saks's knowledge of the National Archives led him to obtain for me Namuth's military records. Interns Dorothy Moss, as an assistant on an earlier project, assembled the published information on Jackson Pollock, Barnett Newman, Mark Rothko, and Willem de Kooning as it related to Namuth's photographs; Fred Ulrich assembled the information on the architects and writers that Namuth published; and Suzanne Kathleen Karr, immersing herself in the history of the arts in post–World War II America, fact checked innumerable citations. In addition, my staff assistant Jeanette Stimpfel Wingert coordinated myriad details related to interviews and permissions.

This book owes much to Frances Stevenson and Dru Dowdy, editors for the National Portrait Gallery, whose watchful eyes have been most welcome. I also appreciate the support of the staff of the Smithsonian Institution Press, in particular Kate Gibbs and director Peter Cannell, both of whom instantly recognized the power of Namuth's photographs. I have benefited, too, from NPG staff members Beverly Cox, Claire Kelly, Liza Karvellas, Nello Marconi, Al Elkins, and Leslie London, all of whom have contributed to the successful presentation of the Namuth exhibition that accompanies the publication of this book.

Private funds enhance both collections and scholarship at the Smithsonian, and I am most grateful for the assistance of the James Smithson Society, which made possible the purchase of twenty-three color prints by Namuth, and the Research Opportunities Fund, which underwrote the trip I made to Water Mill and my two trips to Tucson and the Center for Creative Photography.

And finally, my thanks to my husband Norman, son Christopher, and daughter Courtney, who not only cheerfully read early drafts of my manuscript, but also have long tolerated my obsession for extended projects.

Carolyn Kinder Carr
Deputy Director
National Portrait Gallery

CHRONOLOGY

1915	Born in Essen, Germany, March 17
1925	Begins classes at the Humboldt Oberrealschule, Essen, Germany (graduated 1931)
1927	Joins German Youth Movement
1930-1931	Takes classes at the Museum Folkwang and Folkwang School, Essen
1931-1933	Works at Severin, a large bookstore in Essen
1933	Arrested for leftist sympathies by the Nazis in July
	September 20: Leaves Essen for Paris
1934	Works on a Quaker farm in the Pyrenees from May to August. Begins journey to Palestine to see Marianne Stark, traveling through Marseilles in September and Florence and Rome in October
1935	January–midsummer: Continues journey to Palestine; in Athens
	Mid-August: Joins Georg Reisner in Puerto da Pollensa, Majorca
	September–November: Runs photography studio with Reisner in Majorca
	Late November: Returns with Reisner to Paris; lives at 56, rue Peronnet, Neuilly-sur-Seine
1936	Sells work to various photography agencies
	June: Returns to Majorca with Reisner to set up a photography studio. Receives assignment from *Vu* to photograph the Workers' Olympiad
	July 18: Arrives in Barcelona just as Spanish Civil War begins; covers war with Reisner for *Vu* and other magazines
1937-1938	March: Returns to Paris with Reisner; continues to photograph
1939	September–December: Interned with other Germans, first at the Parisian sports arena, and finally at Blois-en-Vienne (Loire-et-Cher), *Camps des Étrangers,* Group 28
	December 6: Joins French foreign legion

1940	October 28: Demobilized from French foreign legion. Flees to Marseilles in early November
	Late December: Georg Reisner commits suicide
1941	February 18: Leaves Marseilles; arrives in Martinique in early March and from there travels to St. Thomas and Puerto Rico
	April 10: Arrives in New York City; stays with Samuel L. M. Barlow
	Mid-July: Leaves New York for Albion, Michigan; works as an assistant to a professor at Albion College
	September: Returns to New York; works as a technician, first for Stone-Wright, then for Jerry Plucer
	December: Begins working in Hal Reiff's studio
1943	January 6: Begins military service in the United States Army; sent to Camp Croft, South Carolina
	April: Sent to Camp Ritchie, Maryland, for military intelligence training
	May 22: Becomes a United States citizen
	July 17: Marries Carmen Herrera
	December: Sent to Europe
1944	Works with military intelligence in France, Germany, and Czechoslovakia
1945	Stationed in Freising with the Judge Advocate's Office of the Third Army
	October 28: Discharged from the United States Army
1946	Works for Tesumat, Inc. Birth of daughter Tessa. Travels to Guatemala and photographs the Indians of Todos Santos for anthropologist Maud Oakes. May have begun photography classes with Josef Breitenbach
1947	Son Peter is born
1948	Exhibition "Guatemala: The Land, the People," Museum of Natural History, New York (travels to Pan-American Union, Washington, D.C.)

1949	Takes photography classes with Alexey Brodovitch at New School for Social Research. Advertising photographs published in *Harper's Bazaar*
1950	July 1: Meets Jackson Pollock and takes photographs of him throughout the summer and early fall. Makes two short films of Pollock painting, one with the assistance of Paul Falkenberg
1951	Pollock photographs published in *Portfolio* and *Art News*
1952	Pollock photographs exhibited in March in conjunction with a Pollock exhibition in Paris at the Studio Paul Facchetti
1955	Exhibition "Guatemala: The Land, the People," circulated by American Federation of Arts, New York
1958	Photographs of seventeen American painters shown at the American Pavilion at the World's Fair, Brussels
1959	Exhibition "17 American Painters," Stable Gallery, New York
1963	Begins photographing for Brian O'Doherty's book *American Masters*
1964	Films *Willem de Kooning: The Painter* with Falkenberg
1967	Thirty-foot mural with Pollock photograph shown at the Museum of Modern Art, New York
1969	Films *Josef Albers: Homage to the Square* and *De Kooning at the Modern* (released 1971) with Falkenberg
1970	Films *The Brancusi Retrospective at the Guggenheim Museum* with Falkenberg
1971	*Art News* commissions first Namuth cover portrait; films *The Matisse Centennial at the Grand Palais* with Falkenberg
1973	*American Masters* published; exhibition "American Artists," Castelli Gallery, New York
1974	Exhibition "American Artists," Corcoran Gallery, Washington, D.C.; films *Louis I. Kahn: Architect* with Falkenberg
1975	Exhibition "Early American Tools," Castelli Gallery, New York (travels to the Washington Gallery of Photography, Washington, D.C.; Water Mill Museum, New York; Guild Hall, East Hampton, New York; and to the Broxton Gallery, Los Angeles, in 1976). Group exhibition "The Photographer and the Artist," Sidney Janis Gallery
1977	Exhibition "The Spanish Civil War," Castelli Graphics, New York; exhibition "Living Together," Benson Gallery, Bridgehampton, New York; films *Alexander Calder: Calder's Universe* with Falkenberg

	Exhibition with Aaron Siskind, "Hommage à Pollock et à Kline," Galerie Zabriskie, Paris
1978	Makes new photographs of the Guatemalan Indians of Todos Santos; exhibition "Small Retrospective," Himmelfarb Gallery, Water Mill, New York
1979	Exhibition "Todos Santos," Castelli Graphics, New York (travels to the Parrish Art Museum, Southampton, New York); exhibition "Jackson Pollock," Museum of Modern Art, Oxford; Musée d'Art Moderne de la Ville, Paris (travels to the Stedelijk Museum and Galerie Fiolet, Amsterdam, 1980). Group exhibition "Self-Portraits," Center for Creative Photography, University of Arizona, Tucson
1980	Exhibition "Pictures from the War in Spain, 1936–1937," Galerie Fiolet, Amsterdam
1981	Exhibition "Artists 1950–81: A Personal View," Pace Gallery, New York
	December: Publishes article on photographer Albert Renger-Patzsch for *Art News*
1982	Solo exhibitions at the Leo Castelli Gallery, New York; Catskill Center for Photography, Woodstock, New York; Mercer County Community College, Trenton, New Jersey; Carl Solway Gallery, Cincinnati, Ohio; Hunter College, New York; Phoenix II Gallery, Washington, D.C. Group exhibition "Counterparts: Form and Emotion in Photographs," Metropolitan Museum of Art, New York; films *Alfred Stieglitz: Photographer* with Falkenberg
1983	Publishes seven portraits in *Connaissance des Arts*. Magazine commissions and publishes numerous portraits by Namuth throughout the 1980s. Publishes last cover for *Art News* in March. *Architectural Digest* initiates portrait commissions. Group exhibition "Die fotografische Sammlung," Museum Folkwang, Essen, West Germany
1984	Films *Balthus at the Pompidou* with Falkenberg. Group exhibition "Portraits of Artists," San Francisco Museum of Modern Art
	November 30: Carmen Namuth dies
1986	Group exhibition at Städtische Galerie, Munich
1988	Receives special recognition at Rencontres Internationales de la Photographie d'Arles; shows seventy prints
1990	Films *Take an Object: A Portrait, 1972–1990,* with Judith Wechsler. Exhibits portraits of artists at Parrish Art Museum Summer Gala, Southampton, New York
	October 13: Dies in automobile accident in East Hampton, New York

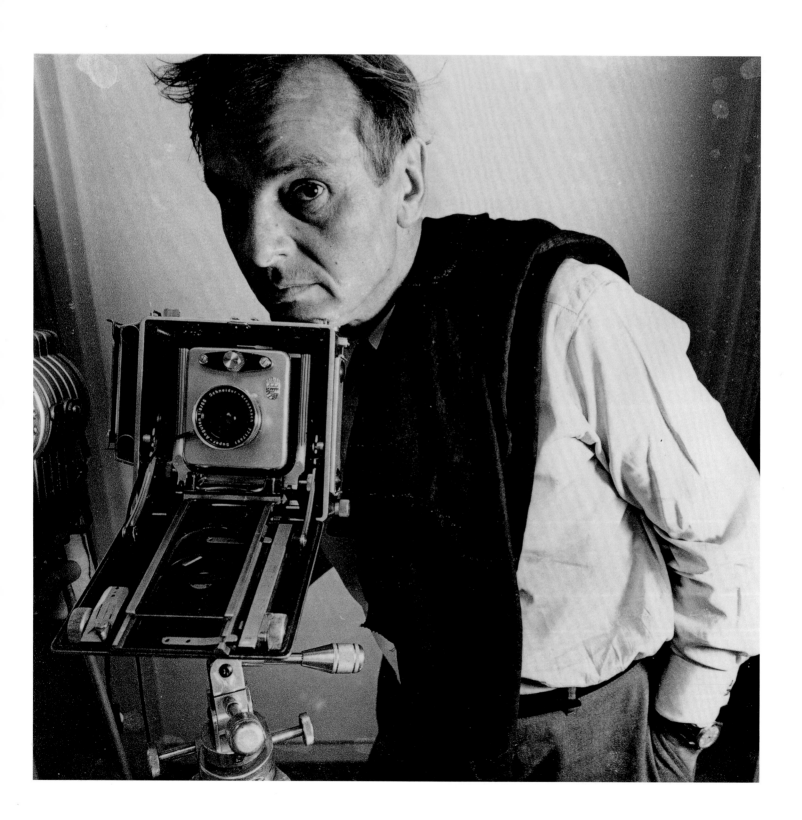

PHOTOGRAPHING THE ARTS IN AMERICA • THE PORTRAITS OF HANS NAMUTH, 1950–1990

In the summer of 1950, Hans Namuth and his wife Carmen rented a house in Water Mill, Long Island, a small farming community midway between Southampton and East Hampton. On July 1, Namuth attended an opening in East Hampton at Guild Hall. Jackson Pollock was among those featured in the group show devoted to the work of artists living in the region, and he was present. Namuth had seen Pollock's work at the Betty Parsons Gallery in New York City the previous November. He did not particularly care for Pollock's painting, but Alexey Brodovitch, his teacher at the Design Laboratory at the New School for Social Research and art director of *Harper's Bazaar,* had persuaded him that Pollock was an important artist. That hot afternoon Namuth introduced himself to Pollock and asked if he could come to his studio in the nearby town of Springs and photograph him. Pollock's wife, painter Lee Krasner, aware of the importance of media attention, encouraged Pollock to work with Namuth. From July through early October 1950, Namuth took more than five hundred photographs of the artist. As Pollock danced about his huge canvases and articulated their surfaces with dripped and thrown paint, Namuth captured the kinesthetic essence of the artist's work.

These seminal photographs forever changed the way the public viewed Pollock's paintings; they also forever changed Namuth's life. While Namuth earned his living with a variety of photographic assignments both before and after he took his landmark Pollock portraits, his avocation—no, his passion—became photographing creative personalities. His oeuvre—at least the part of it that was most important to him—is a forty-year chronicle, mainly of artists, but also of architects, writers, and musicians, who have made significant contributions to recent American cultural history.

Since the invention of photography in 1839, all photographers, but particularly those who have made portraits, have basked to some extent in the reflected glory of their prominent subjects; they have shared the limelight with those in the limelight. But for Namuth, the passion for portraiture was often as much about friendship as fame. Many of those

Plate 1.

Hans Namuth, 1966

he photographed were young and just beginning their careers when he extended to them the hand of the camera. He gravitated to Jim Dine and Julian Schnabel, as he had done with Pollock and de Kooning, at the beginning of their ascent to national prominence. While Namuth was fully cognizant of the ramifications for his own reputation of the actual or potential celebrity status of many whom he photographed, his best work emerges from his interaction with those whose ideas and abilities he admired. His portraits serve as eloquent witness to the fact that their creativity was a wellspring for his own.

Namuth was able to convey the essence of a wide range of talented individuals, but he was drawn to artists in particular because he identified with their goals and aspirations. "An artist it seems to me, is more accessible, easier to come to terms with. *We* [italics added] are related, and therefore on common ground. . . . There is a mutuality of outlook, and a respect for the other person's vision."[1]

For Namuth, rapport with a subject was the key ingredient in successful portraiture. As he reflected, at age sixty-five, on his thirty-year career and discussed the anxieties that often accompanied him as he began a portrait session, he observed that a photographer, compared to a painter, was often handicapped by the short time that he had to establish a personal connection.

> A portrait painter, unless he works from snapshots, usually needs a number of sittings with his subject, and in those hours together, can forge a relationship. But a photographer has only limited time to do a portrait; all too often, the subject is someone he has never met, of whom he knows little; he may have seen his or her work, not liking it perhaps. None of this is supposed to matter; the photographer is expected to come back with a telling insight on film. When he fails to do this it is probably due to lack of rapport.[2]

Namuth was fortunate. He possessed an innate ability to reach out to people, to charm them, and to have them meet his needs. These talents—fundamental to rapport—along with obsessive determination, served him well as a young man in making his way in politically turbulent Europe before World War II, and they served him equally well in America after the war as he began to mature and focus on his goal of recording "the great contemporary masters at work."[3]

Namuth may have arrived in America homeless and stateless, but in the half-century that he lived in this country, he forged relationships that enabled him not only to make telling portraits but to create for himself a community of lively and interesting friends and acquaintances. The seventy-five photographs that form the Namuth collection at the National Portrait Gallery are only a sample of those that he created in the four decades from 1950 to 1990, spanning the time from his first photographs of Jackson Pollock to his untimely death. They neverthe-

less serve to demonstrate, for this individual who sought to integrate his personal and professional lives, the photographic issues and ideas that were important to him and his career.

•

Hans Heinz Oskar Adolf Rudolf Namuth, the oldest of two siblings, was born on March 17, 1915, in Essen, Germany, to Adolf Friedrich Heinrich August and Anna Weisskirch Namuth.[4] His otherwise uneventful early life was shaped by his interest in political ideas and the arts. The German Youth Movement, which he joined when he was twelve, initiated his involvement in politics, while his lifelong concern for art, music, and literature—fostered by his mother—was inspired by the classes he took as a teenager at the Folkwang School and the Museum Folkwang.[5]

When Namuth left the Humboldt Oberrealschule, which he attended from 1925 to 1931, his goal was to become a theater director. When no jobs in this arena came his way, he began working for Severin, a large Essen bookstore. Surrounded by the best in contemporary and historic literature, Namuth began the process of self-education that would last a lifetime.[6] For him, the bookstore, where he worked from 1931 to 1933, was a place from which he felt that "all vibrations, cultural, political, and human started . . . and centered." It also served as a catalyst for his own writings, which he contributed to various poetry and literary journals.[7]

In July 1933 Namuth, who had joined a leftist organization in 1932, was arrested for distributing anti-Hitler leaflets and sent to the Gestapo prison in the nearby town of Recklingshausen.[8] Despite their frequent disputes and intense political differences, his father, a shopkeeper and former liberal who had joined the Nazi Party in 1929 after suffering severe economic losses, put on his storm trooper uniform, went to the prison, and demanded his son's release. Concerned that his son's political viewpoint would subject him to further trouble, Namuth's father provided him with a fourteen-day exit visa. On September 20, 1933, Namuth left his home at 309 Kruppstrasse for Paris.[9]

Namuth's life in Paris was marked by bouts of loneliness and confusion—he frequently dreamed that he was back in Germany, unable to escape because he lacked proper papers—but his considerable personal and entrepreneurial skills enabled him to survive.[10] Namuth found various committees that provided him with advice, restaurant coupons, and, eventually, papers that enabled him to register as a refugee. To pay the rent on a room he shared with a German acquaintance at 6, rue Royer-Collard in the Fifth Arrondissement, Namuth sold *Paris Soir* on the streets. Ultimately, he worked his way up the economic ladder, moving from newspaper boy to dishwasher, researcher, and a stint as a secretary for a women's magazine.[11] Gregarious and charming, Namuth made numerous friends, among them the noted German writer

Rudolf Leonhard.[12] Early on, he also befriended Hungarian photographer André Friedmann, later known as Robert Capa.[13] His friendship with filmmaker Paul Falkenberg, with whom he would later make several important documentaries, in all likelihood dates from his first year in Paris.[14]

Ill health forced Namuth to leave Paris, and from May to August 1934, he worked on a Quaker farm in the Pyrenees. The sociable nineteen-year-old found the local inhabitants interesting and welcoming, and he often played cards with them on Saturday evenings.[15] But Namuth's obsession with seeing Marianne Stark—whom he had met in Paris and with whom he had had an intense four-month relationship before she moved to Tel Aviv in February—shaped his summer. In late August, he began a yearlong odyssey to join her, which ended in Athens the following summer when he learned that she was married.[16] Although disappointed that his goal of reuniting with her was no longer feasible, Namuth quickly revised his plans. In August 1935 he joined Georg Reisner [Figure 1], a fellow German who had established a portrait photography studio catering to wealthy islanders in Puerto de Pollensa, Majorca. Namuth had met Reisner in the spring of 1934, three days before leaving Paris for the Pyrenees.[17]

Of all of Namuth's youthful friends, Reisner—who introduced him to photography—had the greatest impact on his life. Three years older than Namuth, Reisner was born in Breslau on December 9, 1911. A 1930 graduate of the Johannes-Gymnasium, he first studied medicine in Freiburg, and later law in Breslau. His interest in music complemented Namuth's interest in the theater and literature. His music criticism for the Breslau journal, the *Socialist Worker's Party,* together with his political persuasions, precipitated his May 1933 departure from Germany. He immigrated with his mother to Paris, where she had relatives. Shortly after his arrival, he took photography classes in order to earn a living.[18] When Namuth first met him, he had a job with the Associated Press, presumably as a photographer. Reisner, according to Namuth, was intelligent and well read, with a pleasant and sophisticated personality. Hundreds of long letters from Reisner to Namuth, written during Namuth's stay at the Quaker farm in the summer of 1934, had formed the basis of their relationship.[19]

Namuth liked life in Majorca, although he missed a steady supply of books and news of the latest political developments. Typically, he made friends with various German intellectuals.[20] In November, when the season in Majorca was over, he and Reisner returned to Paris. Namuth, still a German citizen, reentered France with a trumped-up press pass and a letter from Reisner to the necessary authorities stating that he had photographic jobs waiting for him.[21] In Paris, the two minimized their expenses by living with Georg's mother, who ran a "pension à famille" at 58, rue Perronet, Neuilly-sur-Seine. They supported them-

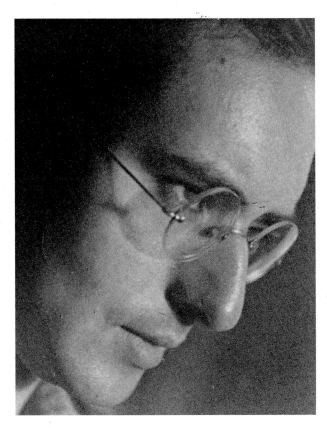

Figure 1.

Georg Reisner by an unidentified photographer, possibly Hans Namuth. Gelatin silver print, 1939. Estate of Hans Namuth, courtesy Center for Creative Photography, the University of Arizona, Tucson.

selves by selling their work to various photography agencies, among them Alliance Photo and Three Lions, and those run by Henri and Leon Daniel, who in turn placed their work in newspapers such as *Paris Match.*[22]

Although young and inexperienced, Reisner and Namuth were able to earn a living as photojournalists because magazines and newspapers were hungry for images. They were but two of hundreds of content suppliers to these mass-audience periodicals. When Henry Luce established *Life* in November 1936, he may have been the first in America to promote a magazine with a picture-filled format, but he was merely emulating a European tradition that began in the late teens, grew exponentially in the 1920s, and was at its peak in the prewar years. Paris had *Vu,* Berlin had *Berliner Illustrirte Zeitung,* and Münich had *Münchner Illustrierte Presse.* The great photojournalists Erich Solomon, Felix H. Man, Wolfgang Weber, and Tim Gidal developed their expertise and far-reaching reputations working for these widely distributed journals.[23]

Picture magazines and newspapers served not only as outlets for Namuth and Reisner's work, but also as sources for information about photography. Given their literary and visual bent, the two undoubtedly knew the work of the major photojournalists, most of whom were only a decade or two older than they. Namuth's intuitive understanding of the elements of a storytelling picture was initiated, in all likelihood, with his early studies at the Folkwang School and honed during his year at the Essen bookstore where, as a seventeen-year-old, he could have pored through the magazines that featured the major photographers of the day. As witnesses to history, Namuth and Reisner possessed keen eyes and an intuitive sense of an event's significance. They also possessed the political sympathies that appealed to the urban audience that sustained these current-events tabloids.

Namuth and Reisner returned to Majorca in the summer of 1936 to reestablish their portrait studio. They had not been on the island long when they received an assignment from *Vu* to photograph the Workers' Olympiad in Barcelona, which had been organized to protest the official games in Berlin. The two left Majorca on July 18 and arrived in Barcelona one day before the outbreak of the Spanish Civil War. "I remember I woke up in the pension where we were staying to sounds of what I thought were fire works," Namuth later recalled. "I thought the festive event had started. Instead it was machine gun fire."[24]

The war catalyzed Namuth's and Reisner's photographic careers as well as their political persuasions. Their sympathies were clearly with the Spanish workers, who were fighting against a Fascist alliance

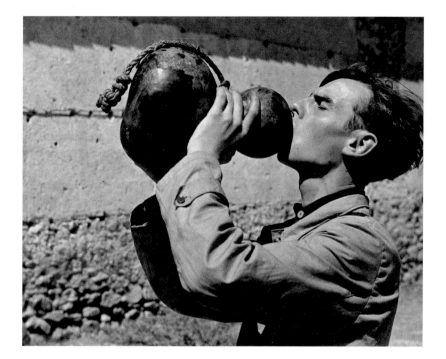

Figure 2.

Hans Namuth by Georg Reisner. Gelatin silver print, circa 1936. Estate of Hans Namuth, courtesy Center for Creative Photography, the University of Arizona, Tucson.

of right-wing, upper-class landowners, moneyed bourgeoisie, entrenched military, and the clerical establishment. The Republican army, aware of the propaganda potential of understanding and supportive journalists, provided them with uniforms—minus the cap and insignia—and frequently escorted them throughout the battle lines, sometimes alone, sometimes with other foreign correspondents. Wit and luck enabled these two German nationals to get their French press credentials extended and to travel for the next eight months throughout Spain to photograph the conflict in Valencia, Madrid, Guadalajara, Toledo, Mérida, Ciudad Real, Jaén, Alméria, and the Estremadura front. While Namuth was at times filled with disgust, at times with enthusiasm by what he saw, he was always, as he wrote in the one letter he saved from 1936, "in mortal fear" [Figure 2].[25]

Namuth and Reisner sent their Spanish Civil War photographs first to *Vu* and then, after the magazine was sold in late September, to other picture agencies with whom they had previously done business.[26] They, in turn, placed these photographs in magazines such as the *Berliner Illustrirte Zeitung* and the *Münchner Illustrierte Presse.*[27] On August 19, 1936, in the first issue of *Die Volks-Illustrierte* (the renamed *Arbeiter-Illustrierte-Zeitung*), a collage by the noted graphic designer John Heartfield—incorporating a photograph by Namuth and Reisner and a photograph of the painting *Liberty Leading the People* by Eugène Delacroix—appeared in a special section supporting the Popular Front [Figures 3 and 4].[28]

Namuth and Reisner's work was part of a long, well-established tradition of war photography, which began with daguerreotypes taken

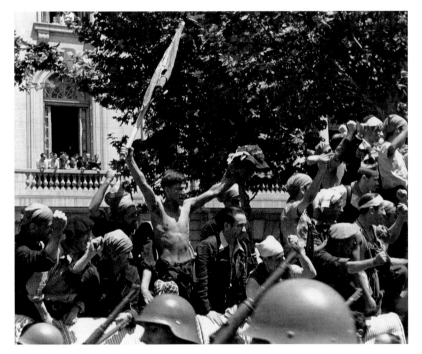

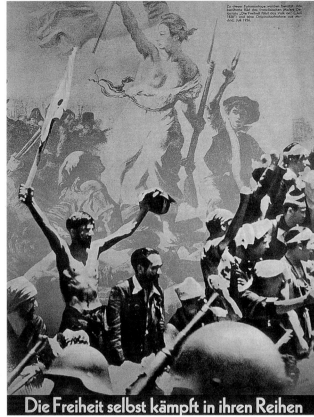

Die Freiheit selbst kämpft in ihren Reihen

Figure 3.

Departure of the Republican Troops to the Front, Barcelona by Hans Namuth/Georg Reisner. Gelatin silver print, July 1936. Estate of Hans Namuth, courtesy Center for Creative Photography, the University of Arizona, Tucson.

Figure 4.

Freedom Itself Is Fighting in Their Ranks, photomontage in *Die Volks-Illustrierte* by John Heartfield, August 19, 1936. Private collection, courtesy Kent Gallery, New York City.

of Mexican-American War officers and continues to the present day. Throughout the succeeding decades—but particularly in the 1930s, with the introduction of the small Leica camera—new equipment and materials altered the finished image of battlefield photography from the still-life arrangements characteristic of the nineteenth century to the dramatic, action-packed reportage of the modern era.[29] Namuth and Reisner, who used both a Rolleiflex and a Leica for their Spanish Civil War pictures, were on the forefront of this stylistic and technological change.[30]

Namuth and Reisner's war photographs are about the validity and virtue of the rebel cause. "We did not stay in Spain because we were press photographers," Namuth later wrote. "We stayed because Franco was the enemy, and because it was also our war."[31] Dramatic and compelling, these photographs resonate with the aura of the age as they document the resistance and its tragedies and triumphs, although not its actual battles.[32] But whether Namuth and Reisner were photographing a parade of anarchists in Barcelona, a recently deceased soldier, a church burning in Madrid, dead horses in Ávila, a barricade in Toledo, refugees fleeing from Cerro Muriano (a town just north of Córdoba), or a classical-style sculpture among a forest of furniture outside a recently abandoned castle, these images are distinguished by their compositional clarity and their focus on telling and evocative details [Figures 5, 6, 7, and 8].

When Namuth first exhibited the Spanish Civil War images in 1977, and when he published them in 1986 in *Spanisches Tagebuch: 1936,* he was unwilling to claim exclusive authorship. According to him, he

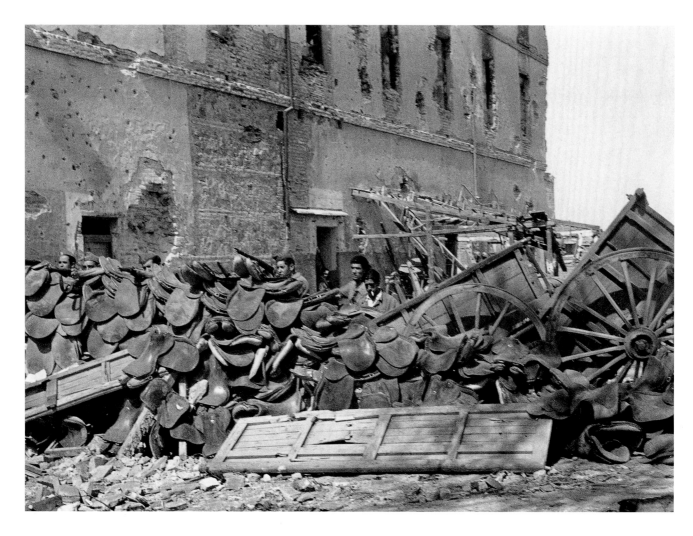

and Reisner were constantly exchanging cameras and it was impossi-
ble to tell who took which image.[33] It is likely, however, that Namuth
took the elegant and haunting portraits that appeared in the exhibition
and permeate this book. The careworn faces of the peasants pictured
suggest that they were selected by an eye that had some art-historical
training and was familiar with the ancestors of these men and women
who had served as models for seventeenth-century realist painters,
such as Diego Velázquez. Moreover, a fascination with character as
revealed in the face of an individual was the *leitmotif* shaping Namuth's
career in America [Figure 9].

While in Spain, Namuth and Reisner crossed paths with an eclec-
tic mix of writers and photographers, among them the Russian-born
journalist Ilya Ehrenburg, the Swiss-born Franz Borkenau, the Hungar-
ian Arthur Koestler, the American Louis Fischer, and the Polish-born
photographer David Seymour (Chim). In Valencia, French author André
Malraux offered Namuth his hotel room because he had another place
to stay. Later they realized that both they and their Parisian acquain-
tance Robert Capa were in this small village of Cerro Muriano on Sep-
tember 5 photographing refugees fleeing an air attack [Figure 10].[34]

Figure 5.

Barricade in Toledo by Hans Namuth/
Georg Reisner. Gelatin silver print, 1936.
Estate of Hans Namuth, courtesy Center
for Creative Photography, the University of
Arizona, Tucson.

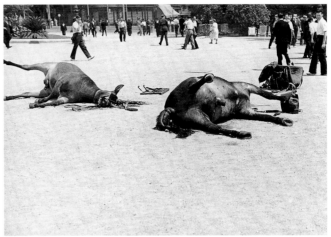

Figure 6.

Propaganda by Hans Namuth/Georg Reisner. Gelatin silver print, 1936. Estate of Hans Namuth, courtesy Center for Creative Photography, the University of Arizona, Tucson.

Figure 7.

Ávila by Hans Namuth/Georg Reisner. Gelatin silver print, 1936. Estate of Hans Namuth, courtesy Center for Creative Photography, the University of Arizona, Tucson.

Figure 8.

In the Park in front of the Palace of the Duke of Alba by Hans Namuth/Georg Reisner. Gelatin silver print, 1936. Estate of Hans Namuth, courtesy Center for Creative Photography, the University of Arizona, Tucson.

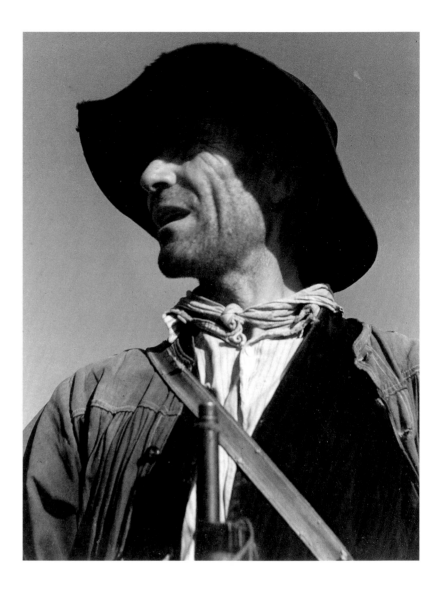

Figure 9.

Armed peasant by Hans Namuth/Georg Reisner. Gelatin silver print, 1936. Estate of Hans Namuth, courtesy Center for Creative Photography, the University of Arizona, Tucson.

In December 1936, while Namuth was in Paris for the Christmas holidays, Reisner was arrested. Subsequently, Namuth was also arrested, but Louis Fischer managed to obtain his release. Although Namuth and Reisner were sympathetic to leftist causes, they had no interest in giving active support to any of the various Communist factions, and in March 1937 the two returned to Paris.[35] Later, Namuth reflected that, despite their political commitment, "in retrospect, we probably stayed too long. We finally left, disillusioned and unable to bear the political tension."[36]

On their return from Spain, the two again lived and worked at 56, rue Perronet and sold their images to various picture agencies.[37] Namuth, as before, found life in Paris both enticing and cruel.[38] He loved the street where "after a thunderstorm . . . the chestnut alley in front of our house smells of young wine, of young girls, and other improper things."[39] He loved the city's cultural attractions and he looked forward to again seeing the *Green Table,* the *ballet macabre* by Essen native Kurt Jooss.[40] He read voraciously, and he kept a list of what he had

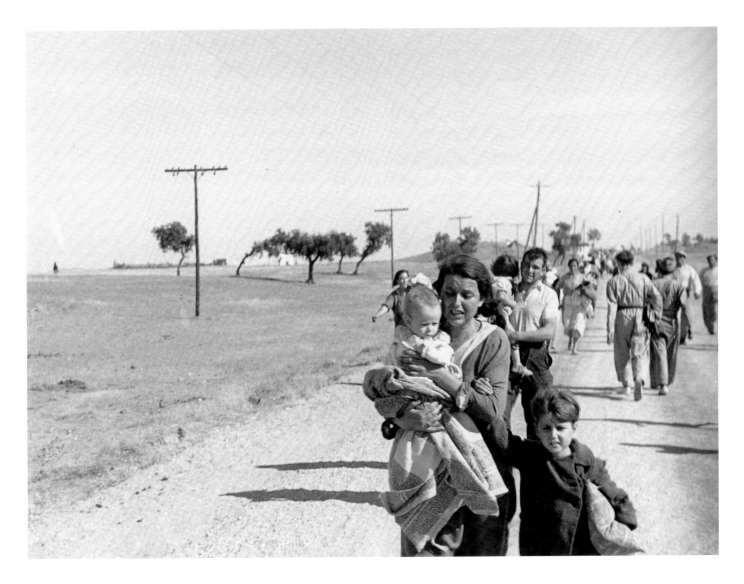

Figure 10.

Refugees from the town of Cerro Muriano (near Córdoba), near the Front by Hans Namuth/Georg Reisner. Gelatin silver print, 1936. Estate of Hans Namuth, courtesy Center for Creative Photography, the University of Arizona, Tucson.

read and what he wished to read.[41] But the need to report monthly to the local prefecture to receive a blue stamp signifying his refugee status, and accounts of former friends who had been arrested or who had died, reminded him constantly of the growing political instability enveloping Europe.[42]

Namuth's letters during this period are peppered with the names of young women to whom he was or had been attached. These romances and the intense feelings they inspired were an integral part of his youthful psyche. In the late 1980s he recommended to artist Helen Frankenthaler Milan Kundera's *The Unbearable Lightness of Being,* a story set in Czechoslovakia in the 1960s about a young doctor who has a way with women and an aversion to the dominant political party. Clearly Namuth identified with the physician, whose life, like young Namuth's, was shaped by his country's political turmoil and crises with the women in his life.[43]

Namuth often worked fifteen or sixteen hours a day taking pictures and developing them. He felt unduly overburdened when Reisner

was not in Paris, as in the spring of 1937, when he spent several weeks on the Riviera.[44] It was Reisner's thought that the two of them might set up a studio there as they had done in Majorca. Namuth found working in the summer particularly unbearable, and he lamented his financial situation. Having money would have enabled him to have a more leisurely and pleasurable lifestyle.

> Summer is when everything sticks to one's body, when one stands for six hours in the darkroom, cursing: the Parisian heat kills, and if one had money, one would be sitting at a sidewalk café in a serious conversation with friends in the evening, yellow wine sparkling, and the stars blinking in a funny way.[45]

Namuth's oeuvre in Paris encompassed both portraiture and photojournalism. The May opening of the 1937 Paris International Exposition d'Arts et Métiers Modernes provided him and Reisner with a variety of commissions and opportunities. Important visitors to Paris, such as Nicolas Titulescu, the Romanian statesman, and Luis Companys, the first president of Catalonia, who was later executed by Franco, were captured by their lenses.[46] Namuth also took numerous portraits of friends, among them that of American Allen Porter [Figure 11].[47] Another was of author Joseph Roth, a distinguished member of the German expatriate community, whom Namuth probably met at the home of yet another expatriate, photographer Gisele Freund.[48]

As many of Namuth's photographs for magazines were printed without a credit line, and few originals from this period exist, it is difficult to provide a full assessment of his work as a photojournalist in the late 1930s. But images in a pictorial essay for *Vulu* suggest Namuth's sense of ironic humor. *Le Buffet Escamoté* ("The Filched Buffet"), taken at the International Exposition during the opening of the Romanian Pavilion, shows the well-fed attendees devouring the hors-d'oeuvres at the reception as if they were starving refugees, leaving the formerly laden table a gastronomic wasteland [Figure 12].[49]

Namuth's busy but otherwise orderly existence came to an abrupt halt in September 1939, when France, along with Great Britain, declared war against Germany after the invasion of Poland and the signing of the nonaggression pact between Germany and the Soviet Union. All German males between the ages of seventeen and sixty-five who were living in France were subject to internment. For Namuth, who was more than willing to serve France in the fight against Hitler, this was a particularly humiliating experience. He was first sent to Le Stade Colombe, the Parisian sports arena, and then to Blois-en-Vienne (Loire-et-Cher). There, in the *Camps des Étrangers,* the approximately three hundred detainees lived in groups of thirty in primitive barns. But according to Namuth, this was one of the better concentration camps: "We were free to walk about during the day and to play chess. That is

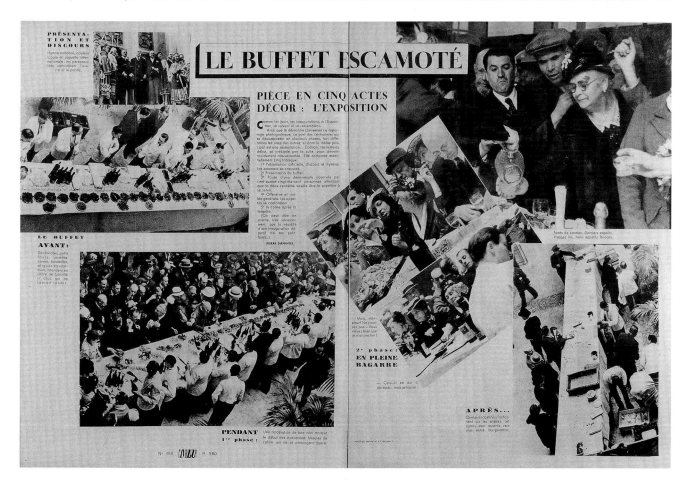

Figure 11.

Allen Porter by Hans Namuth. Gelatin silver print, 1938. Estate of Hans Namuth, courtesy Center for Creative Photography, the University of Arizona, Tucson.

Figure 12.

Layout for *Le Buffet Escamoté* (The filched buffet). Published in *Vulu,* July 21, 1937. Bibliothèque historique de la Ville de Paris.

actually all we did. Fortunately, I had a passion for playing chess. . . . It would have been easy to escape as there were few guards around. Foolishly, nobody ever thought of escaping."[50] Later that fall, the ever-fortunate Namuth left for three weeks to pick grapes in the Loire Valley with a friend and fellow German detainee, Andreas Becker. The two were permitted to assist with the harvest because traditional vineyard laborers had joined the army. Always one to make the most of any new experience, Namuth, a lifelong gourmand, enjoyed fine meals at the regional restaurants on his weekly free day.[51]

Germans were able to escape internment if they agreed to join the French foreign legion. Initially, Namuth resisted the idea. But on December 6, he became a member of this notorious mercenary group, which traditionally awarded French citizenship to its members after five years of service.[52] He received his basic training in Meknès, Morocco, with a group assigned to fight the Italians in Tunisia. But this conflict was resolved before he was sent to the front, and Namuth, who had enlisted only for the duration of the war in Tunisia, was subsequently demobilized on October 28, 1940.[53]

With his discharge from the foreign legion, Namuth became a stateless civilian, with no papers other than a French military passport. Although he was not of Jewish descent, his history of anti-Fascist activity meant that he was extremely vulnerable to the requirements of Article 19, which was tucked among the various conditions of the armistice that France had signed with Germany in June 1940 and stated that "the French Government is obliged to surrender on demand all Germans living in France named by the German government."[54]

Namuth fled to Marseilles, the chief seaport in unoccupied France, which served as the headquarters for a vast number of individuals who wanted to leave France. There he lived at the Hotel St. Louis and the Château de Pastré, in the suburb of Montredon, while he sought help from the Emergency Rescue Committee (ERC), headed by Varian Fry, a French- and German-speaking Harvard-trained classicist [Figure 13].[55]

The ERC—which was formed three days after France had signed the armistice with Germany, and headquartered in New York City— played a seminal role in bringing numerous individuals in jeopardy to America, including a variety of distinguished artists and writers who were vulnerable to German retribution.[56] So great was the demand for the services of the Centre Américain de Secours (CAS) (as the Emergency Rescue Committee was known in France), that during the first eight months of its existence, the staff of this organization interviewed fifteen thousand people, and gave financial or technical assistance to more than four thousand people who sought to come to America.[57]

A major coup occurred in February 1941, when the committee arranged passage out of France on cargo ships sailing directly from Marseilles to Martinique, with no stops in Spain. That country, while

ostensibly neutral, remained sympathetic to the German cause and often created problems for many refugees. On February 18, 1941, nine people, including Hans Namuth, left Marseilles for Martinique, via Oran and Casablanca.[58] Namuth arrived on the French island in early March and stayed in the Grand Hotel at Fort de France for between four and ten days. His next stop was St. Thomas. From there he went to San Juan, Puerto Rico, where, on April 6, he boarded the S.S. *San Jacinto.* Namuth landed in New York on April 10, 1941, carrying with him a six-month emergency visa.[59]

How Namuth managed to wangle a place on the first boat leaving Marseilles, when clearly talented individuals with far more distinguished reputations were clamoring for safe passage, is not known. The twenty-five-year-old Namuth's considerable charm, his long and credible anti-Nazi history, his ability to travel alone on a moment's notice, the arrival of his exit visa on the day of departure, money for passage, a sponsor in New York, plus good luck, must all have contributed to this fortuitous circumstance, which ended his four months of "turmoil and torment."[60] Other close friends were not as fortunate. Reisner, who escaped to Marseilles after being interned in the winter of 1939, was reinterned at Les Milles, a notorious prison camp near Aix-en-Provence. Although Namuth sold his cameras to buy Reisner's freedom, Reisner, fearful that he would not receive an American visa and terrified that he would be sent back to Germany, committed suicide in late December.[61]

Figure 13.

Varian Fry by YLLA. Gelatin silver print, 1941. Museum of Modern Art, New York City.

Andreas Becker, the friend with whom Namuth had picked grapes in the summer of 1939, was arrested in Saintes-Maries de la Mer and returned to Germany.[62]

In addition to Varian Fry, the other individual who played a seminal role in facilitating Namuth's departure from France was Samuel L. M. Barlow, a well-connected American composer, writer, and champion of liberal causes, who lived part of the year at his château at Èze, a small medieval hill town about six miles west of Nice [Figure 14].[63] Namuth had known Barlow—a descendant of the poet Joel Barlow—for several years before he came to America.[64] Most likely, he met him through Georg Reisner, possibly about May 1937, when Reisner was on the Riviera and when he and Reisner were considering setting up a studio there. When or how often Namuth traveled to the Riviera and stayed in Èze before coming to America is not clear, although on at least one occasion he took photographs in the vicinity.[65] But in September 1938, when Namuth saw the deterioration of the European political situation, he thought he knew Barlow sufficiently well to ask him to assist his immigration to America.[66] During his internment the following year, he also sought Barlow's help.[67]

Figure 14.

Sam Barlow at Èze, France, by an unidentified photographer, circa 1936. Audrey Barlow Orndorff.

Barlow's diaries for 1940–1941 reveal numerous passages that indicate his ongoing concern for Namuth's well-being and his safe passage to America.[68] More important, Barlow translated this concern into action and, beginning about November 1940, badgered his Groton and Harvard classmate, Under Secretary of State Sumner Welles, to facilitate the processing of a coveted emergency visa to America for Namuth.[69] Barlow also appears to have contributed the approximately $400 necessary for passage and support needed by every émigré before he or she could leave France. Moreover, when Namuth arrived in America, Barlow steered him to the committees that could help him find employment, and he allowed him to live in the upstairs apartment in his home at 11 Gramercy Park South from April to November 1940, except for mid-July through September, when Namuth was in Michigan.[70]

Namuth spent the first three months in America adjusting to New York City, communicating with other refugees and their friends—among them the writers Hans Sahl and Hans Siemsen, whom he had seen frequently in Marseilles—and assisting those still in Europe, such as Andreas Becker, Georg Reisner's parents, and Walter Lichtenstein, a photographer and filmmaker he had met in the foreign legion.[71] Namuth found New York exciting, but wholly unlike Paris. He was optimistic about living there, although he admitted, "One needs lots of nerve—more than I can muster—much energy, much initiative." He worried about his lack of money and the fact that he could not work as a photographer, since he had sold his cameras in Marseilles.[72] He was also concerned that he had no job, despite his excellent contacts and his intensive two-month search.

In mid-July, Namuth left New York for Albion, Michigan, where the American Committee for Christian Refugees had arranged a position for him. Initially, Namuth was enthusiastic about going to the Midwest, as he wanted to know more about the United States.[73] His job was to assist G. G. Rathje, a professor of French and German at Albion College. He was not paid, but he received room and board at the professor's home and a two-dollar weekly allowance, which he noted with characteristic irony, "I spend recklessly."[74] The summer in Albion was not a particularly satisfying experience for Namuth, but the time he spent on his extensive correspondence helped mitigate his loneliness. Namuth took advantage of the library, where he was delighted to discover the complete works of Klabund, whom he had always admired.[75] Namuth described his hosts as "upright people, very likable, except for their political views: against the war, against Roosevelt." Namuth was appalled that so many Americans were "fluctuating between political indifference and utter confusion" in regard to the situation in Europe.[76]

Namuth used his time in Albion to also take stock of himself. To Lisa Rothschild, a German-born photographer whom he may have met either in Paris or when he first arrived in New York, he wrote: "I love life

in all its expressions. Death does not terrify or frighten me in any way. I don't have a very high opinion of human kind in general [but] I love individual people and could do anything for them, I could die for them."[77] As in Paris, when he wrote as a twenty-three-year-old that he hadn't done anything yet for posterity, Namuth was concerned with his ability to make a mark: "I don't have a very high opinion of myself. I will never achieve much—in the bourgeois sense."[78] While Namuth's letter to Rothschild is marked by youthful angst and naïveté, it nevertheless addresses themes that define his personality and concerns in later life— his love of life, his love of people, and his desire for significant achievement, both professionally and financially.

A highlight of Namuth's summer was his early August visit to Dr. Erich Stern, an internist living in Decatur, Illinois, whom he had located through a newspaper advertisement.[79] Stern was a friend from Essen, with whom Namuth used to play chess and drink wine. They also shared an interest in photography. When Namuth told the doctor of his lack of a camera, Stern lent him his "fairly new Exacta—with a 2.8 Zeiss lens." Less restless than Namuth, Stern liked life in Decatur. It was not only good for his eight-year-old daughter, but it was "far more restful for our frazzled nerves than being with fellow immigrants all the time and exchange [*sic*] each other's trials and tribulations."[80]

Namuth had hitchhiked to and from Decatur, and on his return trip, by coincidence, he found himself in Decatur, Michigan, where his foreign roots made him a bit of a celebrity. "I spent the night in the home of the village barber," he wrote to Dr. Stern. "He and his entire family were beside themselves with delight to have me there. I had to admire about 100 family portraits . . . and that was quite exhausting." The next morning, the local paper wanted an interview, which he avoided by fleeing the scene.[81] While Namuth was euphoric about his trip to Illinois, in Albion he felt depressed and claustrophobic. Although his trip had helped him understand the average American, who now "no longer instills fear in me," he was despondent that Americans did not understand Europe; they were consumed by making money and working long hours and rarely read a book. "They cannot appreciate the value of the freedom they are always talking about," he lamented, "because they demand it *gratis* or at the smallest possible cost. That one must pay for it, pay a lot for it; even with one's life—the French, too, refused to realize in 1938 and 39."[82]

Namuth had consulted Dr. Stern about his health, for he was unable to explain his abnormal fatigue and weakness despite the simple life that he led. Evidently Namuth had no understanding of how depression affected one physically and how the psychic and spiritual dislocation, the loss of his friend Georg Reisner, and his fear for friends and family still in Germany had affected him. The dreams that he recorded

in his diary reflect his continuing anxieties, particularly his persistent guilt over the death of Reisner.[83] Namuth's love life was also less than satisfactory. As he confided to his diary:

> Nothing disappointed me more than the American women. In the beginning they are lovely young creatures. But they are endowed with a portion of materialism and factualness, that inhibits any love for them and from them. They remain virgins until their marriage, but love excitement. All of them, even college girls, have only one thing in mind: getting married. Once they are married, they start physical and mental changes. They become fat, satiated and less intelligent than the day they were born. And one thing is remarkable: they *all* wear glasses. They are void of any charm, without secrets. I despise them. Never will I be able to love an American woman.[84]

Namuth's last job in Albion, which he began the third week in August, was as a waiter. He worked eleven and twelve hours a day.[85] As he continued to "wait" on America, and get a closer glimpse of its citizens, Namuth became more despairing:

> There is no longer any doubt: I am not disappointed about America. I am deeply shocked. I am paralyzed like one who has expected the promised-land and found himself in the coldness of the desert. And I cannot discuss this with anybody. I must be "grateful" and fake it. Anybody who asked me (and everybody does ask) "How do you like America?" would feel personally insulted if my spontaneous reply would be anything but "Very much, very much indeed."[86]

Namuth left Albion on September 29, eager to see his many friends in New York.[87] He arrived in that fog-enshrouded city after a terrible thirty-hour trip, disappointed that his beloved city "didn't smile at me . . . didn't welcome me . . . no longer knew me."[88] Fortunately, by mid-October, when Indian summer cast its warm glow, Namuth rediscovered the poetry of New York "in the din of the El, in the Union Square orators, in the sales clerk at the ticket window of the Chinese Theater, in the sailor with his girl at 2:30 a.m. in the subway."[89]

Part of Namuth's optimism can be attributed to the fact that in late October or early November, armed with a Social Security card, he got a job as an assistant operator at Stone-Wright, a large photography studio near Union Square, for a weekly salary of $15.[90] On December 4, he took a job for $22 a week with Jerry Plucer, an artist-turned-photographer who ran a commercial studio on 480 Lexington Avenue.[91] In April, a $4-a-week increase led him to 10 West 47th Street and the studio of Hal Reiff, who had recently purchased Price Picture News.[92]

Namuth seemingly made no attempt to establish a studio (as he

and Reisner had done in Majorca), or to freelance as a photojournalist (as he and Reisner had done in Paris), or to become—as numerous other expatriate photographers did—a staff photographer for an American picture, fashion, or home-decorating magazine. This was probably less a language problem (how well Namuth spoke English at this time is not known), or an immediate need for money, than it was a symptom of Namuth's continuing depression and concomitant low self-esteem. Indeed, throughout 1942, in his correspondence and in his diaries, Namuth freely admitted that he continued to be plagued by loneliness and pervasive anxiety, feelings that he confessed he often drowned with excessive drinking.

Figure 15.

Luxembourg Gardens by Hans Namuth. Gelatin silver print, circa 1937–1938. Varian Fry Album, Photographic Archives, Museum of Modern Art, New York; gift of Annette Riley Fry.

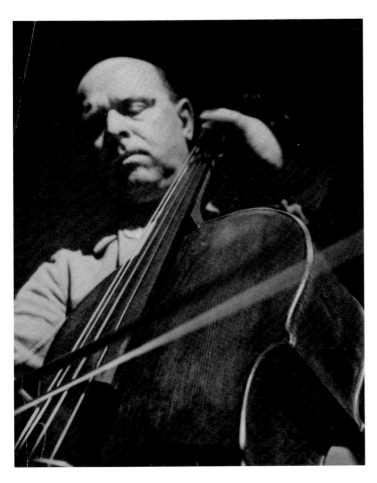

Figure 16.

Pablo Casals by Hans Namuth. Gelatin silver print, circa 1940. Varian Fry Album, Photographic Archives, Museum of Modern Art, New York; gift of Annette Riley Fry.

Namuth sought to allay this emotional turmoil with numerous romantic encounters and an otherwise busy social life.[93] In May, for instance, he went to see *A Farewell to Arms* with Varian Fry, who had returned to New York from France the previous September.[94] This was the third time that Namuth had seen the film. But his reaction was "unending tears," as it had been when he first saw the movie in Paris in 1933 with Marianne Stark, and when he saw it again in 1937 in Barcelona. Fry, who had never seen the film, "cried like a little boy."[95]

Fry, who had paved the way for Namuth's immigration to America, together with Namuth's other mentor, Sam Barlow, also launched the next dramatic change in Namuth's life. On May 18, 1942, upon the recommendation of Fry and Barlow, Namuth was considered for service by the United States Military Intelligence Agency. After two interviews in August 1942, he was accepted for service in the United States Army, although he did not become an American citizen until May 22, 1943.[96] Namuth's gratitude and his admiration for Fry's work with the Emergency Rescue Committee prompted him to make a photo notebook for Fry as a Christmas present. This small album, which included photographs of Paris, the Spanish Civil War, the Riviera, and Èze, as well as a portrait of Pablo Casals, was a mini-diary of Namuth's previous life. In all likelihood, these images represent most of what Namuth was able to salvage on his long journey to America [Figures 15 and 16].[97]

On January 6, 1943, Private Namuth began his military service. A week later he was sent to Camp Croft, near Spartanburg, South Carolina, for thirteen weeks of basic training, after which he was placed in the Military Intelligence Service and sent to Camp Ritchie, Maryland, for further training.[98] Ever the idealist, Namuth was eager to serve. As he later recollected:

> I wanted to combat the forces that had driven me out of Germany and Europe—Nazism, Hitler. I was very much of an idealist in those days. I would never have shown the same ardor if I had been sent to the Far East. That was not my war. My war was in Europe.[99]

In the months preceding his summer 1942 interviews with military intelligence, Namuth, after ending numerous relationships, had the good fortune to meet Carmen Elisa Herrera, who had recently separated from her husband. She was living with her two young sons,

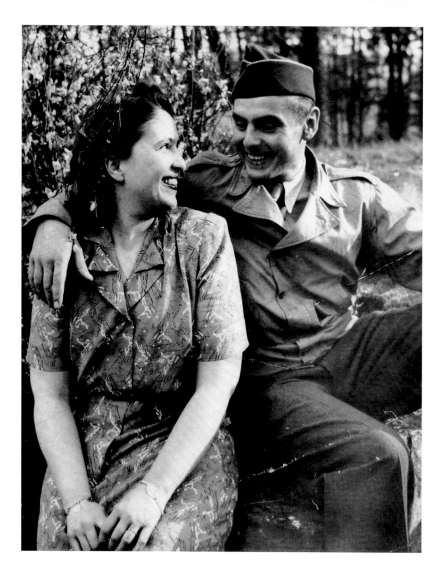

Figure 17.

Hans and Carmen Herrera Namuth, Camp Ritchie, Maryland, by an unidentified photographer, July 1943. Estate of Hans Namuth, courtesy Peter Namuth.

Figure 18.

Hans Namuth in Europe by an unidentified photographer, 1944. Estate of Hans Namuth, courtesy Peter Namuth.

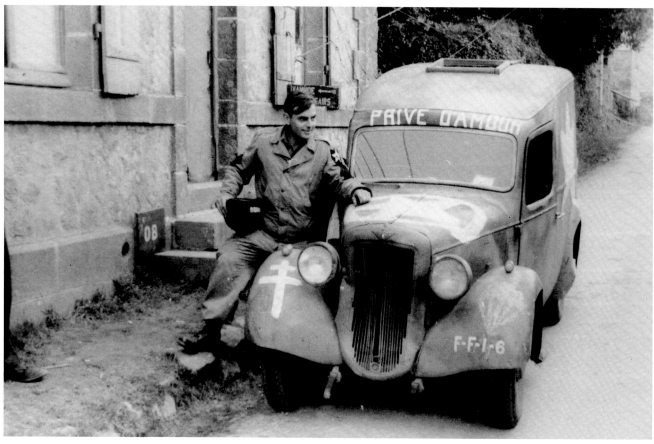

Alvaro and Raul, at her mother's house in Mill Neck, Long Island. If Namuth's family background was modest—his father ran a small neighborhood store and later a dairy—Carmen's was decidedly not. Her father was from a distinguished and wealthy Guatemalan family. He was in Paris as a member of the diplomatic corps when she was born on July 3, 1916. Although Carmen grew up in a Paris apartment on the Avenue Foch and was educated at Swiss and German boarding schools, she was, according to all who knew her, warm, charming, and down-to-earth. On July 17, 1943, the two were married in a modest ceremony at Camp Ritchie [Figure 17].[100]

In December 1943, Namuth sailed for Scotland on the *Queen Mary*. From there he was assigned to the Twenty-eighth Division in Tenby, Wales. Subsequently, he became part of the Second Infantry Division, with a rank of master sergeant in MIT 415. In 1944, a few days after D-Day, he landed on Omaha Beach in France. Subsequently, he was sent to the Elbe and then to Czechoslovakia [Figure 18].[101] When the war was over in May 1945, Namuth stayed on in Freising, Germany, with the Judge Advocate's Office of the Third Army as part of the war crimes division. His assignment was to travel throughout the American and British zones and arrest wanted Germans. Most of these were "not big shots, but 'minor bastards.'" Namuth had a difficult time internalizing the concept that not all Germans were guilty of having killed five million Jews. As he later recollected,

> I felt that every German was either de facto guilty or guilty by association. Perhaps I was unjust in that assumption that anyone who had protested could have done so or left the country. But I think to continue living in Germany and watching, or witnessing rather, what was going on made the whole German people guilty.[102]

Namuth was demobilized on October 27, 1945; he did not return to Germany until late 1970, by which time both of his parents were deceased.[103]

When Namuth returned from the war, his goals were to raise a family, to travel, and to photograph as a hobby. To support his family—which would increase with the birth of his daughter Tessa in 1946 and the birth of his son Peter in 1947—Namuth, at the suggestion of Julio Herrera, Carmen's brother and a stockbroker, took a job at Tesumat, Inc. Namuth worked at this firm, which sought to develop waterproof paper, from 1945 to 1947. But he did not find his seventy-five-dollar-a-week position as secretary of the corporation particularly satisfying, and when the company went bankrupt, Namuth used this employment hiatus to confront his unhappiness and to reassess his priorities and ambitions. Slowly, photography, which he had relegated to an avoca-tion, became his vocation.[104]

Namuth's reintroduction to photography began in 1946 with evening classes that he took "to brush up." His initial teacher was Josef Breitenbach, a German-born photographer who immigrated to America in 1941, and with whom he may have studied when he lived in Paris.[105] But the classes that most profoundly influenced his career were the ones he subsequently took with Russian expatriate Alexey Brodovitch.

Brodovitch, who had lived in Paris during the 1920s, moved to the United States in 1930 to head the design department at the Philadelphia College of Art. In 1934 he became art director of *Harper's Bazaar.* For the next twenty-four years he played a major role in shaping the look of this magazine devoted to fashion and the fashionable. In 1947 the energetic and talented Brodovitch established the Design Laboratory at the New School for Social Research. During the next four years, at various locations and with various assistants, he taught a workshop called "Art Applied to Graphic Journalism." The aim of the course, according to the *New School Bulletin,* was "to help the student to discover his individuality, crystallize his taste, and develop his feeling for the contemporary trend by stimulating his sense of invention and perfecting his technical ability."[106] The impact of Brodovitch on late-twentieth-century photography, either through these classes or as an art editor, cannot be underestimated. Richard Avedon, Irving Penn, Robert Frank, and Garry Winogrand, as well as Namuth, were among those who benefited from his guiding eye and subsequently made important contributions to the recent history of photography in America.[107]

Namuth's contact with Brodovitch began in 1949, when he bribed his way into a class Brodovitch was conducting at Avedon's studio on Madison Avenue. That night, George Hoyningen-Huene, a Russian-born portrait and fashion photographer, was speaking about his Spanish photographs. Later that evening, Brodovitch held his usual session evaluating student work. Namuth was fascinated by his tough and uncompromising critique, and excited by what he saw and heard. He enrolled in the next course, using the G.I. Bill of Rights to pay for these classes.[108] As he later wrote,

> During the following ten weeks my outlook on life changed. I worked hard for the weekly assignments, almost always ruining my family's week-end plans; I was crushed when my work went by unnoticed—elated when Brodovitch would hold it up at the class, saying in his un-funny Russian accent . . . "Quite exciting."[109]

Breitenbach, according to Namuth, taught him technique, but Brodovitch taught him to think.

> Brodovitch constantly made us think in new terms when we were approaching a problem, be it fashion photography, still life,

or portraiture or reportage. He always made us think about how to do it differently, how to find new ways of studying a man or woman's face, and how to bring out new approaches. This had nothing to do with technique. He knew nothing about technique.[110]

The roles of Georg Reisner and Alexey Brodovitch in Namuth's life have obvious parallels. Reisner introduced Namuth to photography and, as the older and more experienced of the two, provided Namuth with the opportunities that permitted him to make use of his inherent talent. Brodovitch, older, well-established professionally, and possessing a wide range of intellectual and cultural interests, likewise served as a mentor and catalyst. Under Brodovitch's inspiration, Namuth, after a hiatus of nearly ten years, returned to photography as a professional endeavor. More important, Brodovitch's ideas and enthusiasms served as the initial motivating force that enabled Namuth to seek experiences which allowed him to pursue a direction in photography that would make use of his personal and technical skills, be emotionally and intellectually satisfying, and produce a body of work that would have lasting impact.

Initially, Brodovitch was instrumental in Namuth's entry into the world of fashion and advertising photography, for from May 1949 through the early 1950s, photographs bearing Namuth's credit line appeared in *Harper's Bazaar*.[111] Although these assignments and subsequent campaigns for clients such as Ford Motor Company and Donmoor Shirts provided Namuth with a level of economic security throughout his life, and although he took pride in his layouts featuring children and his work with the industrial designer Paul Rand, advertising and fashion photographs were not his passion, nor did they fully tap his creative resources.[112]

But Brodovitch's conviction that Jackson Pollock was a significant artist was of far greater importance to Namuth's career than the door this cicerone opened to the pages of *Harper's Bazaar*. Namuth—who was an inveterate gallery visitor, even before it was useful to him professionally—had seen Pollock's paintings at the Betty Parsons Gallery during his November 1949 show. He was not particularly captivated by the work, but he trusted his mentor's judgment. Thus, when the thirty-eight-year-old Pollock appeared in East Hampton at a Guild Hall exhibition opening of Long Island artists on July 1, 1950, Namuth introduced himself to the reclusive Pollock, who stood awkwardly among the white-gloved ladies who ran the institution and otherwise populated the reception. He asked if he could come to the artist's studio on Fireplace Road, in nearby Springs, and take pictures. Although reluctant, Pollock agreed.[113]

In the initial sitting, Pollock first claimed that Namuth could not

photograph him because he had completed the painting on which he was working. But as Namuth began to photograph the studio, Pollock began to work again on the "finished" painting. Namuth photographed as long as Pollock painted, about half an hour. Namuth used a Rolleiflex and took four or five rolls of black-and-white Tri-X film. The following weekend, Namuth returned with his proof sheets, gratified that he found several images on each page that pleased him. Jackson and his wife Lee Krasner, who was also a painter, liked the work. Krasner, ever cognizant of the importance of media attention, encouraged the shy Pollock, who was loath to paint in the presence of others, to work with Namuth. From July to early October 1950, Namuth took more than five hundred photographs. As Namuth photographed Pollock moving around his huge canvases and defining their surfaces with dripped, poured, and thrown paint, he captured the intellectual and creative essence of Pollock's method of working [Plates 2, 3, 4, 5, and 6].[114] The cinematic effect of these photographs subsequently led Namuth to make a film of the artist at work.

Namuth's photographs of Pollock painting are not the first to show the artist at work. Two photographs of Pollock painting by Martha Holmes appeared in the August 1949 *Life* magazine essay on the painter.[115] In one photograph, Pollock stoops and drips paint over his canvas; in the other, he applies sand to the canvas. While both of these photographs show Pollock in the process of making a painting, neither captures the dynamism that was part of his style or the theoretical implications inherent in the energetic engagement of the artist with his paint and canvas. Conversely, Namuth's photographs have become seminal images in the history of American art because they reveal the link between the physical act of painting and its metaphysical implications. As Francis V. O'Connor has observed, "It is a tribute to the strength of Namuth's technical and visual sensibility that his images of Jackson Pollock not only record the artist at work but, in certain instances, have come to symbolize the aesthetic roots of an entire school of American painting."[116] Namuth's genius in his Pollock photographs, as well as in the best of those he made of other painters and sculptors during the next forty years of his career, was to imbue them with a sense of the inherent meaning of an artist's style.

In addition to his photographs of Pollock painting, which represented a revolutionary approach to documenting an artist in his studio, Namuth also took more traditional photographs of Pollock. "His face," Namuth later wrote, "was the reason I learned to like him sooner than I learned to appreciate his work."[117] When Namuth photographed Pollock with his new Linhof—his first large-format camera—he placed the artist beside his Model A Ford. With the latter as a metaphor for Pollock's physical and psychic state, Namuth recorded a face, careworn and lost in thought, that was a modern personification of the artistic tempera-

ment recorded centuries earlier by Albrecht Dürer in *Melencholia* [Plate 7].[118] When Namuth placed Pollock in the bright, sunlit fields outside his house, he suggested the symbolic relationship between nature and the artist. Implicit in these portraits of Pollock, as well as in those photographs of Pollock painting, was the romantic notion of the artist as an outsider and loner. The analogy between these images and those of rebel heroes portrayed in the films of the 1950s by such actors as Paul Newman, Marlon Brando, and James Dean has been observed by numerous scholars.[119]

The impetus to photograph Pollock in a more conventional manner may have been influenced to some extent by Edward Steichen, curator of photography at the Museum of Modern Art. When, in October 1950, Namuth took him his portfolio, Steichen assessed the now-famous pictures of Pollock painting and said:

> You know, Namuth, this is not the way to photograph an artist, the nature of the personality of such a complex human being is only partially revealed when you show him at work. Spend some time with the man. Take pictures of him as he wakes up in the morning, brushes his teeth, talks to his wife, eats breakfast. Follow him through the day.[120]

But the banal, narrative aspects of an artist's life did not interest Namuth. What he sought from his photographs of artists—not just those of Jackson Pollock—was that ingredient—possibly facial, possibly gestural, possibly environmental, or a combination of all three—that would reveal an artist's creative essence. Namuth wanted his photographs to reveal the unique, special nature of the artist. He was not interested in what the artist might have in common with Everyman.

Although Namuth's Pollock photographs did not capture Steichen's fancy, today they are the images by which a vast majority of those interested in the history of modern art know Pollock. But despite their current iconic status, initially these photographs only slowly penetrated the visual consciousness of the art cognoscenti. They were first published in the spring 1951 issue of *Portfolio,* a short-lived publication produced by Brodovitch and Frank Zachary, an art editor whom Namuth had met at Brodovitch's Design Lab classes [Figure 19].[121] Brodovitch, who had always exhorted his students to "show him something interesting, something different," must have seen immediately the special nature of the Pollock photographs. These images reached a wider audience, albeit still a highly specialized one, when they accompanied painter Robert Goodnough's essay "Pollock Paints a Picture," which appeared in the May 1951 issue of *Art News.*[122] Namuth's pictures of Pollock painting—as well as the short film he made of the artist in the fall of 1950—clearly influenced Harold Rosenberg, one of the foremost critics of Abstract Expressionist art, in the formulation of his

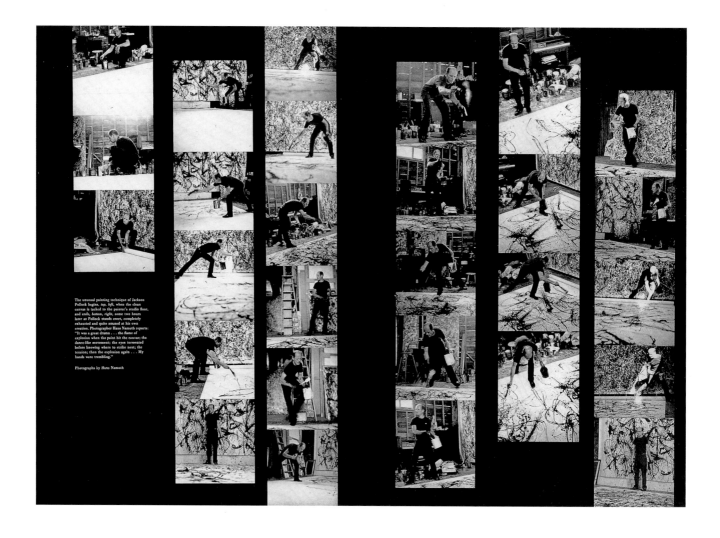

The unusual painting technique of Jackson Pollock begins, *top, left,* when the clean canvas is tacked to the painter's studio floor, and ends, *bottom, right,* some two hours later as Pollock stands erect, completely exhausted and quite amazed at his own creation. Photographer Hans Namuth reports: "It was a great drama . . . the flame of explosion when the paint hit the canvas; the dance-like movement; the eyes tormented before knowing where to strike next; the tension; then the explosion again . . . My hands were trembling."

Photographs by Hans Namuth

important essay "The American Action Painters." In this December 1952 article, Rosenberg defined the uniqueness and significance of recent abstract art by noting that the important painters of the period approached the canvas as "an arena in which to act rather than as a space in which to reproduce, redesign, analyze or express an object, actual or imagined." The act of painting was, according to him, of the same metaphysical substance as the artist's existence.[123] Rosenberg had begun to articulate his feelings about the new style of painting in a 1949 essay for the "Intrasubjectives" exhibition held at the Samuel Kootz gallery.[124] But the new clarity of thought and specific choice of words in his *Art News* essay suggest that Namuth's work gave shape and definition to his articulation of the essential nature of Action Painting. Even though Namuth's photographs were not used to illustrate his article, the parallels between Rosenberg's words and Namuth's images of Pollock painting are too great to be merely coincidental, whether their meaning and implications were assimilated consciously or unconsciously.

Namuth's seminal photographs of Pollock painting ultimately provided him with a secure place in the history of American photography, but initially they also nourished his psychic and imaginative life. They in-

Figure 19.

Portfolio Magazine with Pollock layout, 1951. Alan and Lois Fern.

augurated a process of creative reciprocity between subject and artist that was central to his best work. In them, he found a direction for his photographic career and a vehicle with which he could tap the energy he received from creative people. The force of these portraits as an engine driving his existence and leading him to create a body of work based on photographing individuals in the arts probably explains why Namuth, with the exception of a few picture essays for magazines such as *Holiday,* eschewed traditional photojournalism, despite the major role it had played in his life in the late 1930s.

In the summer of 1952, Namuth and his wife Carmen bought a house in Water Mill, Long Island, on the edge of Mecox Bay, after renting in previous summers from Everett Halsey, a local farmer. Namuth continued to photograph Pollock and his work, but with nothing like the intensity of the summer of 1950. Pollock's drinking, his growing depression, and his marital difficulties diminished the contact between the two, as well as Namuth's enthusiasm for photographing the artist. "I did not wish," he later wrote, "to show a great and tragic artist in his declining years."[125]

Nevertheless, Namuth's initial friendship with Lee and Jackson remained key to his photographic career in the early 1950s. Through them, the inherently outgoing Namuth met numerous other artists who had studios in the Bridgehampton–East Hampton area, and many of the photographs he took of artists affiliated with the New York School radiated from this friendship.[126] Artists Barnett Newman, Franz Kline, James Brooks, Tony Smith, John Little, Alfonso Ossorio, Conrad Marca-Relli, and Constantino Nivola, as well as critic Clement Greenberg, were among those Namuth met through the Pollocks and subsequently photographed [Plate 8].[127]

Newman, in turn, introduced Namuth to the reclusive Clyfford Still. Still, like Pollock and Newman, showed at the Betty Parsons Gallery, and his 1951 solo exhibition at the Gallery may have been the catalyst for Namuth's photograph of him in his studio at 48 Cooper Square. Still was "a gentleman," Namuth later recollected, but one with a need for "secrecy that was very unusual, even among artists who can tend to be secretive."[128] At their first meeting, Newman asked Still, who kept all his paintings turned to the wall, to show Namuth his work.

> In total silence Still turned the canvases around, one after the other. I was stunned by their power and their presence. One naked electric bulb shone down on an explosion of yellows, blacks, gleaming reds, stark whites, red flames. I asked him to sit in front of one of the paintings. He did, and I photographed him without uttering a word. His tormented face and the flame spring mysteriously out of a band of darkness. Again there was the shutter failure of the fatigued camera, but the picture miraculously became the richer for it [Plate 9].[129]

Newman, whom Namuth called "the brains of the operation"—referring to his role as an articulate and media-savvy spokesperson for the New York School artists—also introduced the photographer to Willem de Kooning, Robert Motherwell, and Ad Reinhardt.[130] Thus by 1952, the gregarious Namuth was clearly an established part of the Long Island and New York art scene that surrounded the Abstract Expressionists. "Namuth was always there," remarked Leo Castelli and others when queried about their initial introduction to the photographer.[131]

Newman may have introduced Namuth to Willem de Kooning at an opening—perhaps even at de Kooning's own April 1952 show at the Charles Egan Gallery—for gallery celebrations were often the venue for Namuth's initial contacts with many artists. But if he had first established the relationship with de Kooning in the city, in all likelihood Namuth cemented his connection to this important art-world figure and his wife during the summers of 1952 and 1953, when the two lived in East Hampton in the Jericho Lane house of art dealer Leo Castelli.

Namuth first photographed the de Koonings on August 23, 1953 [Plate 10].[132] This was an important year for Willem, a Dutch-born immigrant who had come to this country in 1926. Although de Kooning had participated in group exhibitions since 1942, and his first solo show in April 1948 had been greeted with a rave review by critic Clement Greenberg, his reputation was enhanced with the favorable reviews of his spring exhibition at the Sidney Janis Gallery and the Museum of Modern Art's purchase of *Woman I, 1950–51*.[133]

Namuth's photograph of the two de Koonings stands in vivid juxtaposition to those he made of Pollock, and even to those he made of Pollock and Krasner together. While de Kooning's paintings of this period were as visually and psychologically rich and intense as Pollock's, the prescient image that emerged from this sitting was not primarily about the artist or his manner of painting, but about the relationship between him and his wife. Elaine and Willem flank an unfinished painting from his *Woman* series, like donors on the wings of a medieval altarpiece. The click of Namuth's camera caught the muscular de Kooning, arms crossed, casually standing in front of his violent sea of slashing brushstrokes. Only the proximity of the artist to the work of art implies his profession and his relationship to the painting in the background. Unlike Pollock, who appeared oblivious to the photographer-voyeur as he painted, de Kooning confronts the unseen cameraman as if he were responding to a traveling salesman's unwelcome knock. Elaine de Kooning sits to the right of the painting, dour, disengaged, and distracted. Although she, like Lee Krasner, played a major role in promoting her husband's work, she was not as comfortable as Krasner in appearing before the camera in the guise of subordinate onlooker or

adoring companion, as this and other Namuth images of her and her husband amply demonstrate.[134]

According to Elaine de Kooning, she initially asked Namuth to make a photograph of her standing in front of this *Woman* painting. She wanted to "establish once and for all that I did not pose for these ferocious women." But the opposite proved true. "I was taken aback to discover in Hans's photograph that I and the painted lady seemed like one flesh, like mother and daughter."[135] Presumably, de Kooning's request to Namuth emerged from the art-world gossip that took note of the fact that the relationship between the de Koonings had begun to unravel. Indeed, by 1957 the two had separated.[136] The staying power of this photograph, which has been repeatedly reproduced, resides in part in its role as a clairvoyant document elucidating the historical reality of their troubled relationship. But just as Namuth's Pollock photographs have entered the visual canon of art history because they defined the spirit of art-making in the 1950s, this portrait of the de Koonings has also attained an extended resonance because it encapsulates the complex relationship between individuals with strong personalities as they seek to assert and define themselves.[137]

Willem de Kooning, who outlived most of those associated with Abstract Expressionism, was photographed by Namuth repeatedly over the next three decades.[138] In 1968, the year the Museum of Modern Art organized a major retrospective of the artist's work, Namuth photographed the painter in his Springs studio, which he had built in the early 1960s. In the fifteen years that had elapsed since Namuth first photographed him in the cramped space afforded by Leo Castelli's front porch, it is apparent that de Kooning has grown comfortable with the camera-laden observer and, oblivious to his presence, is preoccupied only with the demands of his work [Plate 11].

Robert Motherwell, like de Kooning, was photographed by Namuth on numerous occasions, beginning in 1953.[139] For his last commission, Namuth took the cover and story illustrations to accompany an essay in *Art News* that paid tribute to Motherwell's lifetime achievement as a "spokesman and statesman of Abstract Expressionism."[140] While Namuth's 1953 and 1982 photographs of Motherwell are separated by almost thirty years and the artist has aged substantially between the two sessions, the spirit of the photograph remains constant. What Namuth saw as he photographed this Californian, who had been educated at Stanford, Harvard, and Columbia, was the persistently thoughtful personality, the man driven to make art as stimulus for dialogue and discourse, both visual and verbal [Plates 12 and 13].[141]

Namuth's photographs of Pollock may be his best-known work dating to 1950, but they were by no means the only portraits that he had made at this early date. When he applied for a Guggenheim Foundation

award in November 1950 asking for support to film "the great contemporary masters at work," he stated that he had created a portfolio of photographs that included, in addition to Jackson Pollock and Lee Krasner, portraits of Alexander Brook, James Brooks, Lucia Christafonetti, Enrico Donati, Caroline Gordon, Balcomb Greene, Justine Fuller, Buffie Johnson, Gina Knee, Guitou Knoop, John Little, George Sakier, Saul Steinberg, Gerald Sykes, Allen Tate, and Wilfrid Zogbaum.[142] Thus, even before his Pollock photographs were published, and he had received some public feedback in terms of the significance of his work, Namuth had begun to shape and develop his personal passion of exploring the creative personality.

Throughout the 1950s as he pursued his personal quest, Namuth both rephotographed artists he knew—as with his 1952 portrait of the charmingly shy humorist Saul Steinberg [Plate 14]—and expanded his focus by making the portraits of other artists such as Theodoros Stamos, Mike Goldberg, and David Porter, who were also summer neighbors.[143] His 1953 portrait of German-born artist Richard Lindner prompted a charming birthday drawing from his fellow émigré.[144] In 1958 he took the portrait of Larry Rivers and Frank O'Hara as they were working on *Stones,* a series of twelve lithographs published by Tatyana Grosman's Universal Limited Art Editions (U.L.A.E.), and created an eloquently intimate portrait of this relationship. It reveals a side of Rivers not found in the antic pose of his 1965 portrait [Plates 15 and16].[145] By 1958, Namuth's growing reputation led to a commission to photograph seventeen artists under age forty for the United States Pavilion at the 1958 Brussels World's Fair, among them William Baziotes, Robert Motherwell, Richard Diebenkorn, Ellsworth Kelly, and Ad Reinhardt.[146]

The bond between Krasner and Namuth, forged in 1950, persisted until her death in 1984. Although Krasner was devastated by Pollock's death in 1956, his tragic automobile accident liberated her. No longer concerned with championing him, she directed her formidable energies to her own painting and its promotion. As part of her actual as well as psychic transition, Krasner moved from her tiny studio on the second floor of the Fireplace Road house to Pollock's studio, a far more commodious space. It is here that Namuth photographed her in 1962. No longer an adjunct to Pollock, as she so often appeared in Namuth's photographs of her taken while he was alive, the barefooted Krasner stands triumphantly in her domain. Her paintings line the walls of the studio as Pollock's had once done. Occupying the central space in the photograph, she confronts the observer as a secure conqueror, a metaphorical David who has vanquished an unseen Goliath. For those who know Namuth's photographs of this space when it was occupied by Pollock and his paintings, the image possesses a resonance that is eerie and unsettling [Plate 17].[147]

Not all of Namuth's portraits of the 1950s focused on artists who

were part of the Abstract Expressionist or New York School circles. In the early 1950s, architects became part of the constellation of creative talent that he captured with his camera. This body of work initially grew out of his collaboration with architect Peter Blake, a fellow German whom Namuth saw frequently at Jackson Pollock's during the summer of 1950.[148] About 1952 Blake conceived of several architectural stories for various magazines for which he wrote the text and Namuth took the pictures, usually, however, of the building rather than the designer. Blake, who was then an associate editor at *Architectural Forum,* said he began to work with Namuth because he knew a lot of photographers from his work at *Architectural Forum.* Namuth, however, was the one he knew best.[149]

When Namuth first began photographing houses in the 1950s, he professed to see this as an easier task than photographing people. "A building, an assortment of shapes, such as those in a tea service, is less troublesome than a pair of eyes looking back at you through the lens." But, as he confessed, "I changed, little by little, and photographed more people than houses."[150] Namuth's collaboration with Blake ended in the early 1970s. Ultimately, "he did not," said the architect, "love buildings as well as people."[151]

One of the earliest assignments that Namuth and Blake undertook included the portrait of Walter Gropius, the noted German architect who after 1919 headed the Bauhaus, the famous avant-garde design school. The Cambridge-based architect, who had immigrated to America in 1937, was featured in a June 1952 article for *Harper's Bazaar,* where Namuth's longtime friend Alexey Brodovitch remained as art editor. The essay noted that the seventy-year-old Gropius had recently completed the design for Harvard's new Graduate Center, received the commission to advise UNESCO on its Parisian headquarters, and just ended a retrospective exhibition in Boston. When Namuth took the photograph in March 1952, he placed Gropius before the Joan Miró mural that had been commissioned for the dining room in the Graduate Center [Plate 18].[152]

In August 1952, *Holiday* magazine—where Frank Zachary, Namuth's friend and editor of the now-defunct *Portfolio,* had recently become art editor—featured an article by Blake on houses by architects who had studied with Gropius.[153] Although no portraits were included, Namuth's photograph of Hungarian-born Marcel Breuer, an architect who studied with Gropius at the Bauhaus in Germany and later joined his Cambridge-based practice, was probably taken with this essay in mind. Namuth, who had met Breuer at Jackson Pollock's two years earlier, sought to encapsulate the spare essence of the architect's work in a simple, unassuming image that shows the architect seated, contemplating the way in which nature and natural materials interact in one of his light-infused interiors [Plate 19].[154]

Additional commissions from *Harper's Bazaar* to photograph architects led to Namuth's 1954 portrait of Eero Saarinen standing before a photo mural of his model of the Massachusetts Institute of Technology's theater, which was completed in 1955 [Plate 20].[155] The magazine returned to Namuth again in 1959 with a request to photograph Buckminster Fuller, designer of the geodesic dome. Fuller had just returned from Moscow, where his signature piece had housed the American National Exhibition in Sokolniki Park. The dramatically angled photograph was taken in August at the Metropolitan Museum of Art, where many of Fuller's works were on view before being displayed in the sculpture garden at the Museum of Modern Art [Plate 21].[156] Namuth's photograph of the iconoclastic Frank Lloyd Wright, commissioned the previous year by *Holiday,* shows the ninety-year-old architect standing next to his latest and last project, the Guggenheim Museum, unwavering and convinced that, despite the hailstorm of criticism, his building was a little temple among New York's forest of skyscrapers [Plate 22].[157]

During the 1960s, Namuth photographed for the first time architects José Louis Sert, Nathaniel Owings, Harry Weese, Louis Kahn, and Ludwig Mies van der Rohe, the latter standing beside his great monument to modernism, the Seagram Building [Plate 23]. Kahn, whom Namuth met through Peter Blake and who had been the subject of a recent film by the photographer, was the sole architect whom he photographed in the 1970s [Plate 24].[158] But this area of portrait-making enjoyed a resurgence during the 1980s, when Philip Jodidio, editor of *Connaissance des Arts,* a French publication, commissioned portraits of Michael Graves, Robert A. M. Stern, I. M. Pei, Helmut Jahn, Philip C. Johnson, and Peter Eisenman, and featured them among other notable Americans with flourishing careers in the arts [Figure 20].[159]

Namuth took two portraits for *Connaissance des Arts* of the redoubtable Johnson, the last living architect among those who came to prominence in the 1950s. For a feature on New York personalities, Namuth shows the eighty-year-old architect seated on a Knoll chair designed by Robert Venturi in his recently constructed office building on Third Avenue, a model of which is beside him. The space around Johnson explodes with dizzying energy, a fitting metaphor for the irrepressible architect who had completed eleven major commissions within the last five years [Plate 25].[160]

Although this portrait of Johnson is the more visually arresting, the July–August 1988 cover of *Connaissance des Arts,* uncharacteristically anecdotal, resonates with more telling historical references. For this assignment, Namuth photographed Johnson on the stairs of the Museum of Modern Art, standing in front of Oskar Schlemmer's 1932 painting *Bauhaus* [Plate 26]. Johnson, a trustee of the museum since 1958, had donated this work to the museum. Although the painting

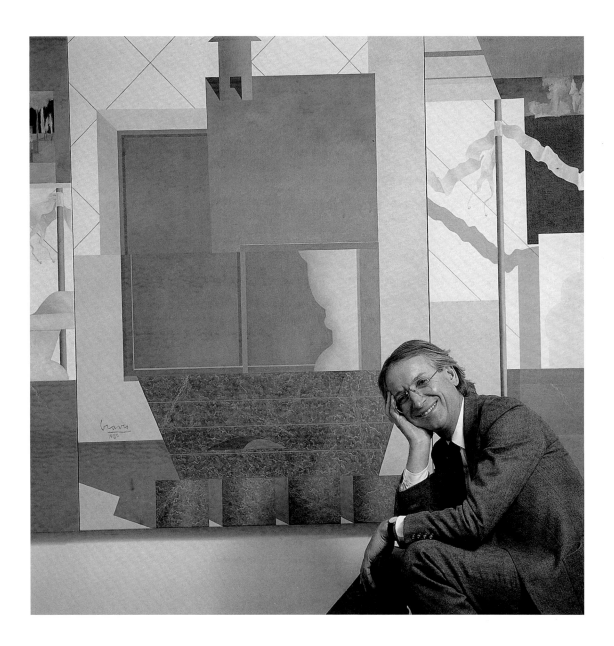

Figure 20.

Michael Graves by Hans Namuth, 1981. Estate of Hans Namuth, courtesy Center for Creative Photography, the University of Arizona, Tucson.

can allude to his role as a collector and patron, it also speaks to his involvement with the International Style architecture that emanated from this school. Johnson, who had established the museum's department of architecture in 1930 and served as its first curator, planned with architectural historian Henry Russell Hitchcock the 1932 exhibition "Modern Architecture: International Style" and coauthored *The International Style: Architecture since 1922,* the early, definitive history of this architectural movement.[161] His own architectural work—particularly his 1949 pared-down, jewel-like, see-through glass country house in New Canaan, Connecticut—also traced its roots to this school and its minimalist style. In the late 1950s, Johnson collaborated with Mies van der Rohe, one of the distinguished teachers at the Bauhaus who immigrated to Chicago in 1937, on the Seagram Building, New York City's great commercial monument to the International Style. He also used

the principles of this style in his 1964 design for the east wing of the museum, the staircase of which is shown here.

One of Johnson's great strengths as an architect was his ability to reinvent himself. While known as a champion of the International Style, during the 1970s and 1980s he used the architectural vocabulary of Postmodernism—which reintroduced historic detail on hitherto pristine and unadulterated Modernist surfaces—with equally innovative effect. As the spirited and witty creator of the Chippendale-topped AT&T building candidly remarked, "I put the nail in the coffin of Modernism." Johnson also became a fervent admirer of Deconstructivist architecture, a mode of building that, as its name suggests, challenges accepted structural and spatial notions. As this photograph was being made, the architect was busy working as a co-curator on the museum's forthcoming exhibition on Deconstructivist architecture. The painting that Johnson holds, by the Russian suprematist Kasimir Malevich, *Suprematist Composition: Airplane Flying* (1914), refers not only to Johnson's taste for abstraction in art, and reiterates his role as a collector and a patron, but also to this show. For in the exhibition catalogue accompanying "Deconstructivist Architecture," Johnson juxtaposed the tendencies of Russian Constructivist painting with those of the Deconstructivist architects. Constructivists, he posited, wanted to create revolutionary perfection in painting, while the Deconstructivists wanted anything but perfection—they wanted to create buildings that are in a sense subversive.[162]

Throughout the 1950s and early 1960s, *Harper's Bazaar* and *Holiday* remained steady clients for Namuth's portraits.[163] *Vogue, Cosmopolitan, Look,* and *Fortune* were each sporadic customers, and in the late 1950s and early 1960s *Horizon* gave Namuth several assignments.[164] Some of these assignments led Namuth to add personalities from the world of music to his repertoire. *Harper's Bazaar,* for instance, contracted with Namuth for portraits of pianist Wilhelm Backhaus, opera buff Arnold Gamson, and composer Gian Carlo Menotti.[165] Namuth's strategy for representing Menotti in 1954 was to juxtapose him with a large-scale reproduction of the music for his new opera *The Saint of Bleecker Street*—which would open the following December and garner for its author a second Pulitzer Prize—thus giving the somber-faced Menotti and his score equal billing [Plate 27].

At the end of the 1950s, *Holiday* commissioned Namuth to photograph Richard Rodgers and Oscar Hammerstein II, the duo who dominated Broadway from their first collaboration on *Oklahoma!* in 1943 until Hammerstein's death in 1960. Namuth's portrait, which accompanied a laudatory article by society writer Cleveland Amory, was published in February 1959, a month after the opening of their eighth play, *Flower Drum Song.* The inherent informality and intimacy of the image implies

the physical and psychic closeness that was intrinsic to their successful collaboration [Plate 28].[166]

Namuth must have liked the ambience of the Rodgers and Hammerstein picture, because he used a similar format for his portrait of thirty-year-old Stephen Sondheim, who had recently secured his place in the history of American musical theater as the lyricist for *West Side Story* and *Gypsy.* For this *Horizon* commission, Namuth photographed Sondheim in Manhattan in his Turtle Bay townhouse. The elaborate house, with its enormous stained-glass window, was once owned by renowned editor Maxwell Perkins. As a setting, it underscores the life of luxury that has come to the young and talented Sondheim as the result of the success of these musicals [Plate 29].[167]

In August 1963 *Harper's Bazaar* included in a composite photograph Namuth's portrait of the prolific avant-garde composer John Cage, a man who was as much an inspiration to visual artists as to musicians.[168] The previous year, Cage had gained media attention with the performance of his new composition *Music Walk with Dancer.* "Mayhem" was the *New York Times*'s succinct description of the event.[169] Namuth kept a head-only variant of the *Harper's Bazaar* photograph for his personal collection [Plate 30]. This image gives no clue as to Cage's profession, but the pose—like that of a naughty five-year-old who peeks out from behind his hand to see what mischief he has wrought—suggests the musician's awareness of the tumultuous critical debates that often surrounded his musical presentations.

For his elegant photograph of sixty-year-old Jerome Robbins, which was taken at the choreographer's Bridgehampton home in September 1978, Namuth returned to a full-length format. Robbins is barefooted, simply dressed, and seated on summer furniture. The photographer uses the contrast of black and white to provide the only drama in this highly sculptural image [Plate 31]. This portrait may have been a commission, but it is also possible that Namuth, knowing Robbins's reputation and knowing that he summered near his Water Mill home, may have instigated the encounter. This was his modus operandi on many occasions during the 1950s and, according to artists Jim Dine and Julian Schnabel, a practice he continued in later decades.[170]

Threaded throughout Namuth's portfolio during the 1950s and early 1960s are portraits of various writers.[171] Several appear to have been done for book jackets and some, because they were such informative images, subsequently became book jackets. Allen Tate's portrait, for instance, has all the hallmarks of a book jacket commission, although the circumstances surrounding the sitting are not clear.[172] In this close-up, the author is portrayed as thoughtful and contemplative. He holds a cigarette, a pervasive symbol of sophistication in portraits made during the 1940s and 1950s [Plate 32]. Nothing about the photo-

graph suggests that Namuth and Tate, the noted writer of southern-inspired fiction who had been in New York since the mid-1940s—first as an editor for Henry Holt, and then on the faculty at New York University—had come together for more than a business session, but even in the most simple of images, friendship is an ingredient. The two had known each other since at least 1948, when Namuth wrote to congratulate the author on his recent award from the American Academy of Arts and Letters, and the rapport between them clearly extended beyond a working relationship. Not only did Namuth approach Tate in 1950 for an essay in a forthcoming brochure on the woodcuts of Buffie Johnson, but when, in 1951, he submitted a photograph of himself for the new member column of *Infinity* (the in-house publication for the American Society of Magazine Photographers), he chose one taken by Tate. Namuth had also used Tate as a reference on his November 1950 Guggenheim Fellowship application.[173]

In the fall of 1959 *Horizon* commissioned Namuth to photograph writers living in the Housatonic Valley for an essay that appeared the following May.[174] Malcolm Cowley, at the time an editor at Viking Press and known, among other things, as an early promoter of writer William Faulkner and as the one who "discovered" John Cheever, was included in the group. Namuth, in keeping with the geographical tenor of the assignment, photographed the casually dressed Cowley outdoors, standing beside the fruits of his labors—not with flowers and vegetables, as is characteristic of traditional cornucopia iconography, but with the books that he has brought into the world either as editor or critic. Namuth's sun-filled photograph suggests the abundance and well-being of the life of the mind [Plate 33].

Namuth must have been pleased with the effect of Cowley's portrait, for he chose to photograph John Steinbeck on the grounds of his Sag Harbor home, rather than in his study, a more customary location for an author portrait. The charming portrait that Namuth took in April 1961 was published in the July issue of *Holiday,* where it accompanied Steinbeck's "In Quest of America," an excerpt from his forthcoming book *Travels with Charley* [Plate 34]. Charley was Steinbeck's French poodle—a genuine French poodle, the author was fond of saying, "one who responded to commands in French faster than to those in English." Charley had accompanied Steinbeck on his just-completed nine-month trip across America. He was the conversation opener. "What degree of a dog is that?" the author was asked repeatedly. Of this photograph, in which he is dressed in clothes similar to those he wore throughout the trip, the witty Steinbeck remarked that he "looked much more like Charley than Charley."[175]

Namuth's beloved Long Island landscape appears again in a 1962 photograph of authors Jean Stafford and A. J. Liebling that was taken three years after they were married and one year before Liebling died

[Plate 35].[176] Liebling, a legendary figure in American journalism who had lived in France and covered the Normandy invasion, undoubtedly amused Namuth with wonderful anecdotes from those days. The two also shared a taste for haute cuisine. Namuth was known for his sociable forays to friends with camera in hand, and the informal nature of this image suggests that, whatever its subsequent use, it initially could have been taken as a casual snapshot.[177] The relaxed intimacy of Namuth's photograph of Stafford and Liebling is a visual counterpart to author Wilfred Sheed's words. "Liebling was," he opined, "strictly a caviar man, and a funny one. And she was fine for him, with her earthy laugh, her quick-take for the bizarre, and her noble, tough countenance."[178]

In August 1963, the *Herald Tribune* commissioned Namuth to photograph novelist John O'Hara, and Namuth went to his summer home in Quogue, Long Island, to take his picture of the tall, dapper observer of society.[179] A comparison of the proof sheet with the final printed version of the O'Hara photograph illustrates Namuth's ability to intensify and enrich both the visual appeal and the meaning of a photograph. In the darkroom, Namuth eliminated extraneous architectural details so that the final print focuses on the elegant cut of O'Hara's English jacket and the wonderful, rhythmic repetition of the architectural details. The filtered light functions as a metaphor for the dreamy world of the imagination as it transforms reality [Plate 36]. Fellow writer E. B. White once described O'Hara as having a "gift for the language," and an "eye for details."[180] It could also be said that Namuth had a gift for the language of the camera and an eye for visual detail.

The O'Hara portrait makes an interesting contrast with the one of chess champion Bobby Fischer, taken in February for the May 1963 issue of *Holiday*. Namuth placed the tall, lean, immaculately groomed Fischer against a white paper background. Fischer is identified only by the chessboard before him. The minimalist sensibility is reminiscent of Irving Penn's portraits in the late 1940s, but here the lack of any specific context serves Namuth well as a visual device conveying the subject's controlled, non-revealing, hermetic personality [Plate 37].[181]

As Namuth increasingly focused on photographing painters and sculptors in the 1970s and 1980s, and as he became widely known for this work, fewer and fewer assignments outside this arena came his way. Thus, his photograph of playwright Edward Albee, taken in his New York apartment in June 1980, was among his last known portraits of a writer [Plate 38].[182] Casual and unpretentious, it focuses on the environment in which the author works, rather than the author at work. Devoid of profession-defining details, it presupposes an audience who knows Albee's achievements and wants to know about Albee, rather than about what he does to warrant the public attention of a photograph. Namuth was an admirer of Albee's plays, and six months earlier he had attended the January 31, 1980, opening night of *The Lady from*

Dubuque at the Morosco Theatre.[183] Like so many other creative personalities—particularly those whom Namuth photographed repeatedly—Albee, who had a house in Montauk, was also a summer neighbor.[184]

About 1963, Namuth began taking photographs for *American Masters: The Voice and the Myth,* a book project conceived by artist and writer Brian O'Doherty.[185] O'Doherty's intention was to examine the dialogue between the myth of the artist (the social armature that stabilizes a work of art) and the work of art (the voice of the artist), as well as the manner in which the two intersect and often reinforce each other. He sought to elucidate these concepts through the lives and work of eight twentieth-century artists. Stuart Davis and Edward Hopper represented the major figures of the first part of the century; Willem de Kooning, Jackson Pollock, and Mark Rothko sketched the main parameters of Abstract Expressionism; Robert Rauschenberg exemplified the generation of influential artists after Abstract Expressionism; while Andrew Wyeth and Joseph Cornell embodied those aspects of American art that remained outside the mainstream. Jerry Mason, O'Doherty's editor at Ridge Press, suggested Namuth as a photographer whose work could most aptly illustrate and enhance O'Doherty's thesis.[186] The irony implicit in Mason's support could not have been lost on Namuth. Mason had been the editor of the catalogue for Edward Steichen's 1955 Museum of Modern Art exhibition "The Family of Man," a show that did not include Namuth or the kind of portraiture that he considered important.

Namuth had not met Davis and Hopper before he began the book project, and while he knew Rothko—in fact it was he who introduced O'Doherty to Rothko—and Rauschenberg, he clearly used the book as an opportunity to photograph them. The book was likewise the impetus for his photographs of Cornell and Wyeth. Namuth's 1963 photograph of Hans Hofmann and his 1964 portrait of Ben Shahn were also taken at O'Doherty's behest, although neither was subsequently profiled [Plates 39 and 40]. While working on *American Masters,* Namuth took the portraits of Leonard Baskin and Josef Albers [Plates 41 and 42]. Although neither was commissioned by O'Doherty, the mood and spirit of these images have numerous parallels with the work that Namuth was doing for O'Doherty's book.

Namuth's letter to Shahn vis-à-vis his session with him underscores the photographer's commitment to the idea that a telling photograph comes from knowing the artist well. After thanking Shahn and his wife and sending them some pictures from "his overflow of snaps," he then went to the heart of his concern:

> I would so much like to come and take some more pictures—
> more *real* (since we'll have known each other better) and more
> . . . dare I say "poignant?"

What I am anxious to do cannot be done in one day—and not in two. . . . But perhaps you can help me and tell me when there may be a good occasion? This may not have to be the act of painting (although that would be very good); it could be within the community, . . . etc.

Please be patient with me a little longer! I want this to be the truest and the best record of contemporary art and artists.[187]

The image of the artist in his studio is the leitmotif that permeates *American Masters.* This image has a long and distinguished history, but as Caroline Jones has pointed out, it was "crucial to the development of an international modern art in New York." It symbolized, often simultaneously, a variety of meanings, including "solitary retreat from the demands of society, sanctuary for private creation, metaphor for the individual artist, metonym for his psyche, . . . and invisible arena for the 'action painting' destined to become public statement of the quintessentially private act." Namuth's photographs, beginning with his images of Pollock, which were used again in O'Doherty's book, were central to perpetuating this myth and, as such, central to his role in visualizing American art history in the second half of the twentieth century.[188] For *American Masters,* Namuth photographed Edward Hopper—who described himself to O'Doherty as "looking like a large lizard"—sitting before his canvas in his Truro, Massachusetts, studio.[189] His ever-present wife Jo is behind him in the photograph, as she was in life [Plate 43]. Namuth saw in Stuart Davis's studio a three-dimensional kaleidoscope of images and objects with strong analogies to the artist's own post-Cubist two-dimensional work.[190] Namuth made new images of Willem de Kooning in his Springs studio, which in the book were integrated with pictures he had taken during the 1950s.

American Masters provided Namuth with his first opportunity to photograph the intensely private Mark Rothko, a man described by O'Doherty as one who "did not wear his self well."[191] Namuth photographed him twice in 1964, once in August in the studio he used while he was vacationing with his wife and two young children in Amagansett, and then later that fall in his studio at 157 East 69th Street [Plates 44 and 45].[192] Although Rothko's large Manhattan studio, like that of de Kooning's Long Island atelier, speaks of the wealth that has come to these two members of the post–World War II generation of painters, the earlier photograph is the more revealing. In it, Rothko is seated with his back to the camera, contemplating his massive canvases. Rothko was known to spend hours looking at his paintings, but the pose also speaks uncannily to the fact that shortly after this photograph was made, Rothko turned first from his family and, as his depression became greater, from the world, committing suicide in 1970.

Temperamentally, Robert Rauschenberg was Rothko's polar opposite. O'Doherty described him as one who had "a sunny disposition

that belied the seriousness of his early art."[193] Namuth's sequence of Rauschenberg photographs for *American Masters* begins with images taken in 1963 and concludes with a 1971 portrait of the artist standing next to months-old Hummingbird Takahashi, the daughter of an assistant, as he worked on a new print in his Captiva, Florida, studio [Plate 46]. This casual, informal image of one of the great late-twentieth-century printmakers reflects O'Doherty's further observation that Rauschenberg was "an individual in the midst of life and happily distracted by it."[194]

Namuth pursued Joseph Cornell for two years before he was able to get a sitting with the reclusive artist. He began his slow dance of seductive correspondence late in 1967. In February 1968 he followed his initial letter with another expressing his long-term admiration for the artist, as well as his willingness to let the artist see the images that he had taken. The latter was a reference to Cornell's well-known displeasure with the tone of the December 15, 1967, *Life* article that appeared shortly after his first major retrospective at the Guggenheim Museum. Namuth then began to send Cornell a series of postcards in an attempt to get the artist to subject himself and his home and studio on Utopia Parkway to the unflinching eye of the camera. On March 24, 1968, he sent a postcard showing J. M. W. Turner's *Sun Setting over a Lake* from the Tate Collection. On it, he wrote, "I am back, anxious to see you. Would you be free Friday afternoon?" On July 25, Namuth attempted to win Cornell's favor with *Diane de Poitiers* by François Clouet, a reproduction of a work in the National Gallery of Art in Washington, D.C. His message, very much in the spirit of Cornell, said, "Times goes and goes. Will we ever meet? I think of you (as of everything these days) with sadness in my heart" [Figure 21]. Namuth must have gotten a favorable response from Cornell, as his next letter to the artist, on September 26, was an apology for a session that did not go well. Namuth alleged that he had been "plagued with illness, assistant and money troubles, making for a horrible ten days." In December, Namuth mailed the artist a card from Guatemala—"my wife's country"—and hoped that he would see him soon. "My mission needs to be carried on: it is so important."[195] When his mission was completed, Namuth had recorded images of Cornell at home and on the windswept Westhampton beach near his sister's home that showed the artist as one distanced from the world, lost in time, and turned inward as he created elegant and ethereal dreams of the past [Plate 47].[196]

Namuth occasionally quarreled with O'Doherty over the artists to be included in the book.[197] He did not, for instance, care for Andrew Wyeth's art or his politics. Perhaps for this reason, the Wyeth photographs, which were taken at his home in Chadds Ford, Pennsylvania, are less allusive and thus less memorable than others Namuth made for this book. But in 1986, in anticipation of the "Helga" exhibition at the

Figure 21.

Hans Namuth's postcard to Joseph Cornell, July 25, 1968?, with image of *Diane de Poitiers* by Francois Clouet. Joseph Cornell Papers, Archives of American Art, Smithsonian Institution, Washington, D.C.

National Gallery, *Connaissance des Arts* commissioned Namuth to again photograph the artist. Namuth's dramatic portrait of the painter from this sitting, taken at his home in Maine, stands in opposition to the narrative images of a decade earlier. The sharp, crisp outlines of the figure, the careful delineation of the facial features, and the precise articulation of landscape details have much in common with the explicit, linear style of Wyeth's intensely realistic paintings [Plate 48].[198]

A sea change in Namuth's reputation as a photographer of note occurred in 1973, with the publication of *American Masters* and the portfolio *Fifty-two Artists: Photographs by Hans Namuth,* as well as the opening of his exhibition "American Artists" at the Castelli Gallery.[199] Now in his late fifties, and some twenty years after he took his groundbreaking Pollock photographs, Namuth's role as the "unsurpassed chronicler of American art's most towering era" was becoming visible beyond a small coterie of art-world admirers.[200] In January 1974, *Art in America* became the first art publication to undertake a story with Namuth as its subject. Subsequently, Namuth exhibitions and books began to be cited consistently in *Art Index,* a bible for art historical research.[201] Namuth's new stature was also symbolized by the commissions for cover photographs he received from *Art News.* Between 1971

and 1983, nineteen portraits by him appeared on the cover of this magazine. The importance of these commissions cannot be underestimated. At the time, *Art News,* under the editorship of Tom Hess from the late 1940s until 1972, and his successor Milton Esterow, was probably the most widely read of the specialized art publications, both among artists and those interested in art.

Namuth's selection of portraits for *Fifty-two Artists* and his "American Artists" exhibition underscores his involvement with the Abstract Expressionist generation. While the portfolio contains images of some younger artists, such as Marisol Escobar [Plate 49], the vast majority of images are of Namuth's acquaintances from an older generation who came to art world prominence in the 1950s. As O'Doherty, who worked with Namuth on *American Masters* for nearly a decade, observed, "These were his friends and he wholly absorbed their philosophical approach. He shared their angst, and their excesses as well. . . . What ever else he did, his psyche was rooted in Abstract Expressionism."[202]

Coincidentally or otherwise, Namuth's first cover for *Art News* was of sculptor Tony Smith, also a friend from this generation of artists. The Smith cover, published in April 1971, appeared virtually twenty years after *Art News* first used Namuth's photographs of Pollock painting as text illustrations. In it, Smith stands before his sheet-steel sculpture, *The Snake Is Out,* a work conceived in 1962 but not fabricated until 1970. As is often the case, the image Namuth saved for his own collection varies from that published on the cover. To complement its format, the magazine selected a vertical image; Namuth chose a horizontal one. But Namuth's intention in both photographs was similar: by letting the sculpture frame the artist, he was able to stress the scale and magnitude of Smith's ideas as they are manifested in this project [Plate 50].[203]

Two years later, Namuth produced the March 1973 cover on Jasper Johns. The photograph was taken at Tatyana Grosman's U.L.A.E. print workshop in West Islip, Long Island, the site where Namuth had first photographed the artist on June 30, 1962.[204] In the photograph from the 1962 session, Johns was caught unaware and appears startled by the photographer [Plate 51]; in the latter image and in Namuth's personal variant, the notoriously private Johns appears to merely tolerate the photographic session [Plate 52]. Marked by their relative blandness, their very ordinariness goes to the heart of Johns's well-known distaste for revealing himself to the world. Over the years, Johns sat for Namuth on twelve occasions, including a session for the October 24, 1977, cover of *Newsweek*.[205] His own words as well as the resulting images imply his ostensible indifference to these sessions and his relative reserve as a performer before the camera. When queried about Namuth and his working method, Johns wrote,

> Every now and then he would say that he had no recent photo-
> graphs of me and would make an appointment to come where I

was working and take some new ones. Usually he photographed without giving any instructions, but occasionally he would ask that some sort of gesture be repeated or that one hold still for a moment—that sort of thing.[206]

These two *Art News* covers were followed by those on collector Gerald Cantor (1974) and artists George Segal, Jim Dine (both 1977), and David Hockney (1988). Often the photographs of these artists in their studios, which accompanied the respective stories, were also taken by Namuth.[207] A comparison of the published portraits with those that Namuth maintained for his personal collection—those of Jim Dine are a good example—suggests that Namuth maintained an ongoing but silent dialogue with magazine art directors over which was the better image, which image was better in color and which in black and white, and how photographs should be cropped [Plates 53 and 54].

In 1979 Namuth had four *Art News* covers, featuring portraits of Alex Katz, Red Grooms, Louise Nevelson, and Mark Rothko.[208] The most dramatic of these was the one of Russian-born sculptor Louise Nevelson, as the would-be theater director and the aspiring actress-sculptor came together to produce a spectacularly striking image. The imposing artist, who was in her sixties before her career took off, stands before her work in the recently completed Erol Beker Chapel, which she designed for St. Peter's Lutheran Church in lower Manhattan. Nevelson's wood constructions were a blend of clarity and complexity, not unlike the artist herself. As she stands ramrod straight, staring proudly and intently above the lens of the unseen camera, the centrality of this image reinforces the commanding character of the woman. Her hair tied with a kerchief—an allusion to her Russian background—she wears a costume and jewelry that were clearly designed by her, for both echo the architectonic character of her sculpture. The suggestion is that the art and the artist are all of one piece—metaphorically, each cut from the same cloth [Plate 55].[209]

1980 was again a banner year for Namuth. His four commissions included portraits of Shusaku Arakawa, Chuck Close, James Rosenquist, and Romare Bearden.[210] The difference between the Bearden cover and the image in Namuth's personal collection underscores the difference between Namuth's understanding of the resonance of a portrait image and the often more didactic needs of a magazine cover. With the Nevelson portrait, these conditions converge; with the Bearden portrait, they take different courses. The Bearden image that *Art News* preferred shows the artist holding a work of art. Namuth favored for his personal collection the full-length figure of the artist, seated in his studio with a photographic portrait of his parents behind him, and no painting in sight [Plate 56].

Namuth's choice, which accompanied the story on Bearden, is both more appealing visually and more allusive than the cover image.

Like any good work of art, it immediately arrests the viewer's attention, but then allows the discovery of additional layers of fact and meaning. A quick glance at the ebullient Bearden reveals a great deal about the spirit and soul that underlies his art. The denim overalls Bearden wears speak not only to the messy tasks of an artist but also to his southern roots. This sense of heritage, also alluded to in the photograph of his grandparents, permeates his work. As Bearden, who moved to New York as an infant and lived there most of his life, freely admitted, he may have left his birthplace of Charlotte, North Carolina, physically, but he remained there psychologically.

In 1981 Namuth took the February cover portrait of Kenneth Snelson, and the magazine reused a 1955 photograph of Jackson Pollock and Lee Krasner for its December cover. Namuth's portrait of his longtime friend Robert Motherwell appeared on the March 1982 cover, and Frank Stella took pride of place in September. The latter portrait, which exudes enthusiasm and confidence, and the variant that Namuth retained for his own collection explode with color, as was true of Stella's own art of this period [Plate 57].[211]

Earlier in the summer, Art News had published Namuth's group portrait of Leo Castelli and his artists to celebrate Castelli's twenty-five years as an art dealer. Although less visually compelling than Namuth's other cover portraits for Art News, it was perhaps one of the more meaningful to Namuth, both professionally and personally [Plate 58].[212] As an image that brought together many of the artists who came to dominate American art in the late 1950s and early 1960s, it recalls Nina Leen's photograph of the Abstract Expressionists that Life magazine published in January 1951 [Figure 22]. Both images serve to illustrate the depth of Namuth's connections in the art world, for his portfolio includes portraits of thirteen of the fifteen artists in the Life photograph and eleven of the eighteen artists who showed at the Castelli gallery.[213]

This group photograph, as well as the portrait of Castelli—who is posed beside Andy Warhol's Marilyn—also speaks of a friendship that goes back to at least the early 1950s [Plate 59]. Although Castelli came from a more elevated social stratum, he and Namuth shared a European background, a taste for the good life, and an endless fascination with the New York art world, albeit from somewhat different perspectives. "We have always been friends," said Castelli, when asked to reminisce.[214]

Castelli was as integral a figure in the social and business life of the Abstract Expressionists as Namuth. It was his house in East Hampton where the de Koonings summered in 1952 and 1953, and it was he who organized the 1953 show of their work for Sidney Janis, the man who was the marketing wizard for the Abstract Expressionists. Castelli's genius, when he struck out on his own in 1957, was to ferret out the next generation of artists who would determine the course of

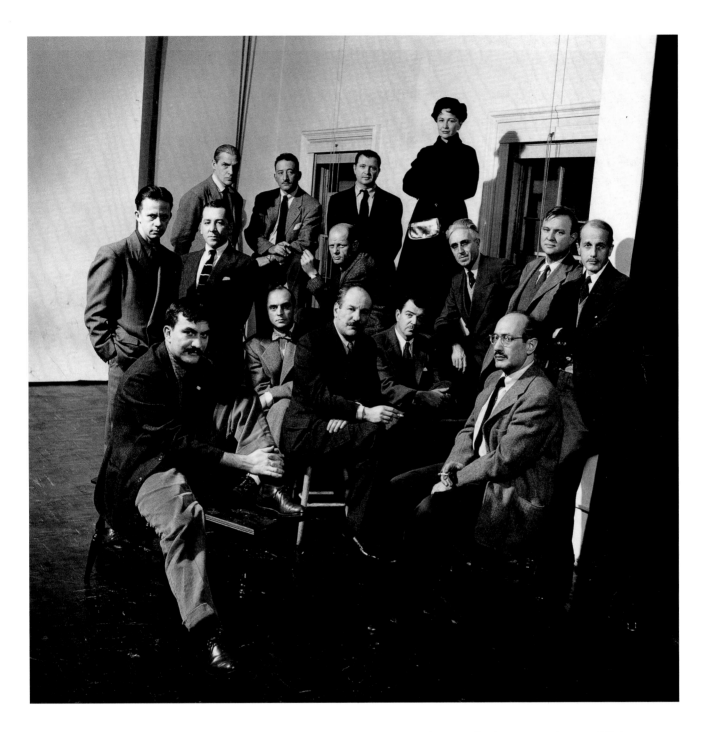

Figure 22.

Irascible Group of Advanced Artists by Nina Leen. Gelatin silver print, November 1950. Nina Leen/*Life* magazine. © Time, Inc.

American art. His shows of the work of Jasper Johns and Robert Rauschenberg in the late 1950s made him a leading force in contemporary art, and over the next ten years, he exhibited what was commonly acknowledged as the best art in the world.[215] Castelli was a primary link for Namuth to Robert Rauschenberg, Jasper Johns, Roy Lichtenstein, James Rosenquist, Ellsworth Kelly, and Andy Warhol—that is, to the most important artists in the generation that succeeded the Abstract Expressionists. In the 1980s Castelli was probably also a conduit for Namuth to the next generation of younger artists, such as Julian Schnabel and David Salle.

Ellsworth Kelly was Namuth's last cover for *Art News*.[216] Namuth felt that his reputation enabled him to demand a higher fee than the magazine had previously paid.[217] He may also have disputed the choice of the image for the Kelly cover. The photograph that he chose for his personal collection not only had greater élan, but was also more revealing. The striding image on the *Art News* cover contradicts the fact that Kelly's sculpture is about formidable mass, scale, and presence, rather than motion. Nothing emerges about the character of the artist in the cover photograph, while in the image Namuth preferred, Kelly's erudition is implied, as is his tolerance for, but not total engagement in, the photographic session [Plate 60].

The end of his successful and productive relationship with *Art News* meant that Namuth lost both the prestige of the association with this magazine and the contact with an audience that he valued. But the sting of this setback was mitigated, to some extent, by the relationship he developed with Philip Jodidio, the editor of *Connaissance des Arts*. The two met about the time of Namuth's 1982 exhibition of color photographs at Leo Castelli's 420 West Broadway Gallery. Jodidio was impressed by the power of the work and persuaded by Namuth's suggestion that his portraits would make important additions to the magazine's handsome coverage of art and architecture.[218] Throughout 1982 Namuth corresponded with Jodidio, proposing various selections of his work that might make successful stories, in particular his early portraits of artists.[219]

In January 1983, *Connaissance des Arts* published seven portraits by Namuth, accompanied by noted art critic John Russell's short essay.[220] From this auspicious start until his death in 1990, *Connaissance des Arts* published more than one hundred portraits of artists and other art world figures taken by Namuth, many specifically commissioned by the magazine.[221] The relationship with *Connaissance des Arts* allowed Namuth to rephotograph various artists, such as Willem de Kooning and James Rosenquist; to reproduce iconic images, such as those of Jackson Pollock and Mark Rothko; to republish some of his favorite portraits, such as those of Frank Stella and Jim Dine; to publish hitherto unpublished portraits from previous sittings, such as his portraits of George Segal and Roy Lichtenstein; to return to themes he had explored previously, such as portraits of architects; to photograph a new generation of artists, such as Julian Schnabel, David Salle, Ross Bleckner, Erich Fischl, and Jeff Koons; and to add European artists to his roster of subjects.[222] For its October 1990 issue, *Connaissance des Arts* featured ten portraits by Namuth of notable figures in the New York art world, among them art critics John Russell, Robert Hughes, and Hilton Kramer [Figure 23]. Little did Jodidio know that this collection of portraits would serve as a memorial tribute to the photographer.[223]

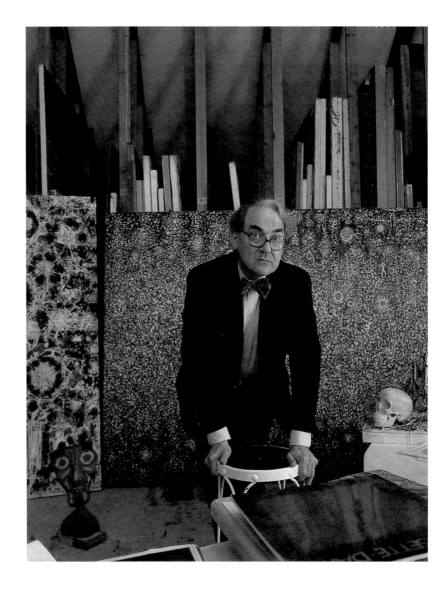

Figure 23.

Hilton Kramer by Hans Namuth, 1990. Estate of Hans Namuth, courtesy Center for Creative Photography, the University of Arizona, Tucson.

Namuth's 1980 portrait of George Segal was among the portraits published in his initial photographic collection for *Connaissance des Arts*.[224] The two, who met in the New York art world, "shared the excitement generated by the new ideas about art that were 'in the air.'"[225] One of the new ideas was the relationship between art and life and the need to act in "the gap in between."[226] Namuth captures Segal modeling a sculpture and moving through the real space occupied by his plaster creations, thus creating a photograph that is emblematic of the art/life philosophy inherent in Segal's work [Plate 61]. Although the medium is different—sculpture versus painting—and although the art work is vertical and three-dimensional as opposed to two-dimensional and horizontal as it is being created, this image, which shows the artist in the process of making art and being "in his art," has its antecedents in Namuth's photographs of Pollock painting done three decades earlier.

The April 1987 issue of *Connaissance des Arts* featured a portrait

of the Japanese-American sculptor Isamu Noguchi, who had recently opened his own museum in Long Island City, represented America at the Venice Biennale, and completed a commission for a Tsukubai fountain for the Japanese galleries at the Metropolitan Museum of Art [Plate 62].[227] In July 1988 *Connaissance des Arts* published a portrait of James Rosenquist standing on a ladder before his mammoth 17-by-47-foot painting *Through the Eye of the Needle to the Anvil,* which he had recently shown in an exhibition at Castelli's gallery on Greene Street [Plate 63].[228] A comparison of the Rosenquist and Noguchi portraits again demonstrates how Namuth was able to adjust his image to suit the style of the artist: the Rosenquist photograph underscores the oversized, explosive, and dynamic art for which the painter was known; the Noguchi image captures the calm, restrained, stable aura that the sculptor evoked using stone and wood—traditional, natural materials.

The ability to evoke the essence of the artist's style—which is what made the Pollock photographs so compelling—likewise manifests itself in Namuth's portraits of such diverse artists as Louise Bourgeois (1978), Julian Schnabel (1981), Roy Lichtenstein (1985), David Salle (1986), and Sam Francis (1989).[229] Namuth posed Bourgeois against a roughly textured wall with her hand cupped to her right ear as if she was listening to the distant sounds emanating from the horn-like black object beside her. Bourgeois is known for her enigmatic sculptures, which often evoke a dreamy, surreal world of autobiographical memories, and Namuth's trancelike portrait alludes to this sense of inferiority as the genesis of her artistic inspiration [Plate 64].[230] Schnabel, perhaps the best known of the "neo-expressionists"—a loosely allied group of young artists who came to prominence in the late 1970s and early 1980s and were known for their willingness to resume a personal and psychological involvement with the act of painting (an involvement eschewed by artists affiliated with the Pop and Photo-realist traditions of the 1960s and early 1970s)—appears to emerge from the canvas, creating a visual allusion to the mantra of his artistic ancestor, Jackson Pollock, that when he was painting, he was "in his painting" [Plate 65]. Lichtenstein's head is compressed in the shallow space between the painting and the photographic picture plane, just as in his paintings he compressed objects that originally were three-dimensional entities into flat, brilliantly colored shapes [Plate 66]. Salle, known for his paintings that incorporated real objects, appears as just another element in a three-dimensional collage composed of objects in his studio [Plate 67]. The portrait of Francis addresses the relationship between actions and ideas, not an inappropriate concept for Francis, an artist associated with the second generation of Abstract Expressionists [Plate 68].

Architectural Digest was another outlet for Namuth's work during the 1980s. At the time, it was the leading publication in the field of interior design. The editor, Paige Rense, secured the magazine's status

with articles on the lavish homes of celebrities. Namuth was eager to contribute and suggested numerous stories, implicitly recognizing the fact that in the post–World War II era, a few favored artists had emerged from the poverty and obscurity of the garret to become celebrities worthy of the kind of media attention usually given to the rich and famous in other fields. For the most part, Namuth's proposals emanated from his relationships with individuals whose portraits he had made previously, but on several occasions he suggested European artists or collectors. Among those he recommended for features were Francis Bacon, Sandro Chia, Diego Giacometti, Jane Freilicher, Alex Katz, Marisol Escobar, Louise Nevelson, Isamu Noguchi, Alfonso Ossorio, Robert Rauschenberg, Antoni Tàpies, Andrew Wyeth, Jerome Robbins, and Jack Lenor Larsen [Plate 69].[231]

Not all of Namuth's suggestions for picture essays were accepted, either by the magazine or the subject, and Namuth often encountered difficulties with those that were. Jasper Johns would not permit his house on the Carribean island of St. Martin to be photographed. "Hans," he told the photographer, "I like my privacy."[232] The session at Helen Frankenthaler's house was "aggravated by the extreme heat and humidity, the kind of ugly summer humidity which attacks body and machine alike. Several of my instruments went completely on the blink, including a camera, a lens, and two Polaroid backs."[233] Not all went smoothly with the magazine either. Namuth was unhappy with the Mark di Suvero layout, and he was not pleased when the session with Berenice Abbott was canceled.[234] He also was furious when he learned that another photographer had taken the photographs for a forthcoming story on Richard Diebenkorn. Namuth had suggested a story on this major painter in January 1985 and considered him "my territory" [Plate 70].[235] Nevertheless, during the mid-1980s, *Architectural Digest* published articles on George Segal, Mark di Suvero, William Styron, Louise Bourgeois, Helen Frankenthaler, André Kertész, Roy Lichtenstein, Kenneth Noland, Neil Welliver, Will Barnett, and the French artist Balthus that contained commissioned photographs by Namuth.[236]

In addition to the publication of monographs devoted to his portraits of artists and the burgeoning occasions for new commissions provided by the art and architectural magazines, Namuth increasingly had opportunities to exhibit his work during the 1970s and 1980s. Prior to the 1973 exhibition "American Artists" at the Castelli Gallery, shows of Namuth's work had been few.[237] This increased exhibition activity can be attributed partly to a new and growing interest in photography among a broader public, but also to the enthusiasm of Antoinette (Toiny) Castelli, Leo's second wife, who directed Castelli Graphics.[238]

But not all of Namuth's exhibitions and books during this period were devoted to his portraits of artists. His late 1975 exhibition, "Early American Tools," which opened at the Castelli Gallery, featured hand-

some photographs focusing on the compelling nature of these objects as abstract forms. While these inanimate shapes possibly represented for Namuth a brief and welcome respite from his involvement with personalities—an inherent aspect of his portraiture—they may also have reminded him of his early years as a photographer of fashionable objects.[239] In March 1977, Castelli Graphics presented the first exhibition of Namuth's 1936 Spanish Civil War photographs. Namuth was led to reexamine this body of work from the 1930s when Konrad Reisner, Georg's brother, discovered Namuth's 1936 diary and images among his brother's effects, and Namuth was able to locate additional work in the archives of émigré Max G. Lowenhertz.[240] These photographs, many of which show young citizen-soldiers rallying enthusiastically for the ensuing resistance, presumably found a sympathetic audience among those New Yorkers who eschewed the physical and psychological ravages brought about by American involvement in the recent war in Vietnam.

In the summer of 1977, the Elaine Benson Gallery in Bridgehampton held an exhibition featuring Namuth's portraits of couples. The success of the exhibition may have inspired Namuth to take his loving portrait of Julia and Paul Child, which was made on August 13 at Namuth's Water Mill home. Namuth had met the noted chef earlier that year in Boston and had photographed her in, among other locations, an Italian market in Boston's North End [Plate 72]. The instant rapport led Namuth to invite the Childs to Water Mill for a weekend of cooking. The photograph of the couple that was made, probably while the stew or some other delicacy was simmering, was among Child's favorites. "That is how," she later said, "I want to remember my dear Paul" [Plate 73].[241]

In 1979, "Todos Santos" celebrated Namuth's new work with the Guatemalan Indians. Namuth had originally encountered Mam Indians of Todos Santos Cuchumatan in late December 1946, during his first trip to Guatemala, where Carmen's family had a large estate.[242] Namuth initially photographed the Indians at the request of Maud Oakes, an American anthropologist, for her forthcoming book *The Two Crosses of Todos Santos*.[243] In 1978, thirty-one years after Namuth had made his first photographs, he returned to this village of 1,200. He found little changed. Over a five-day period he took sixty photographs of individuals, couples, and groups in a makeshift studio tent made of unbleached muslin.[244] These sensitive, dignified, and direct portraits provide an insightful counterbalance to Namuth's portraits of the hip New York art scene. They testify to his fascination with people, whether celebrities or individuals anonymous to the world at large [Figure 24].

In 1979 and 1980 Namuth exhibited his photographs of Pollock painting both in America and abroad. At the end of 1981, Milly Glimcher, who had just started a publications department for the Pace Gallery,

published *Artists 1950–81: A Personal View*. The accompanying exhibition at the gallery, which celebrated the book's publication, provided Namuth with an opportunity to publish a variety of images that had not appeared in earlier books or been seen in previous exhibitions.[245] In his essay for the catalogue, Namuth stressed his conviction—which was at the heart of his work—that the most important quality for a meaningful portrait was a meaningful relationship with the sitter.[246] But Namuth also noted the pitfalls of a relationship that was too intimate:

> There is the opposite extreme. Delving into other people's lives and souls can be an indiscretion. When a photographer says "hold" it, and clicks the shutter, he has imprisoned part of the other person in his little black box. Primitive people know this, and resent it. The Indians of Guatemala, with whom I spent much time, believe that the photographer is whisking away their very souls, and that they have to come back to retrieve them after they die. In New York City, the artist Saul Steinberg feels that way.[247]

Namuth's photograph of artist Lucas Samaras, who is represented by the Pace Gallery, and his dealer Arnold Glimcher was taken as Namuth was preparing for his exhibition at the gallery. The photograph shows the nude gallery dealer—a coyly posed male odalisque—seated in Samaras's studio, with the artist/photographer to the left, as if in the process of taking a photograph. The arrangement is a visual play on the portraits of other art world figures, called "Photo-Transformations," that Samaras was making about this time [Plate 71].[248]

Namuth followed his show at the Pace Gallery with a show of color portraits at the Castelli Gallery.[249] The poster for the exhibition featured Castelli artist and art world *enfant terrible* Andy Warhol.[250] In it, and the variant Namuth kept for himself, Warhol, centered in the lower third of the composition, is shown only from the waist up. He appears cool, calm, and disdainful. Just as in life he affected a posture of distance from the world, here he distances himself from the process of portrait-making and from the viewer-voyeur by wrapping himself in a protective gesture. Behind him is a Baroque-style backdrop, whose swirling lines create a visual metaphor that is at once amusing and apt—amusing as it alludes to a kind of art that was the antithesis of Warhol's own artistic style, but apt as it metaphorically evokes the intense energy and intelligence that lay behind the artist's bland and passive expression [Plate 74].[251]

While Namuth had taken color photographs since the early 1960s, his understanding of color's potential to enhance the meaning of a portrait clearly grew during the 1970s and 1980s as his magazine work called for him to work increasingly with this medium. The color in his 1962 Krasner photograph is merely descriptive; it lacks the icono-

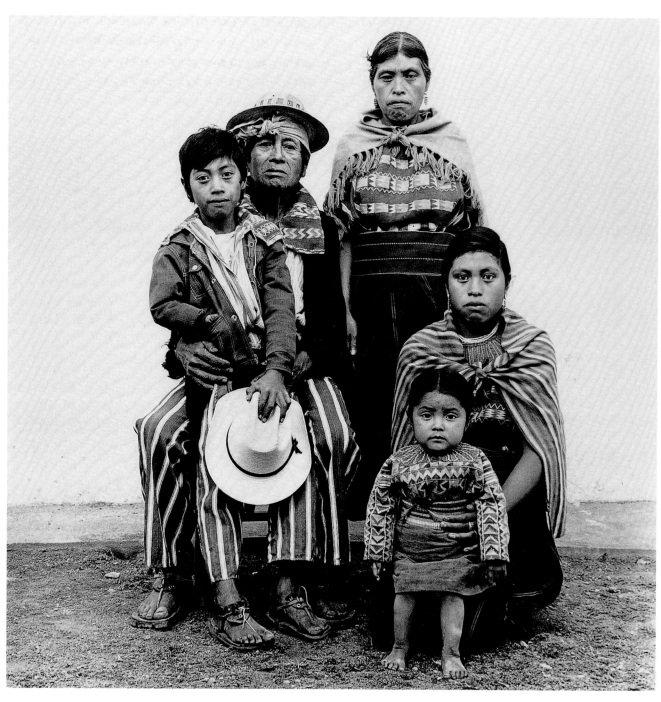

Figure 24.

Image from "Todos Santos" by Hans Namuth. Gelatin silver print, 1978. Estate of Hans Namuth, courtesy Center for Creative Photography, the University of Arizona, Tucson.

graphic power found in his later images. But Namuth's ability to use the compelling nature of color to reinforce the understanding of an artist and his or her work is readily apparent in the portraits of Louise Nevelson, Frank Stella, and Jim Dine, to mention only three of many examples.

Namuth, however, espoused the line, so characteristic of photographers of his generation, that color photography was suspect. Even when he was given an assignment in color, he always added some black-and-white shots. "These are *my* photographs," he remarked. "I prefer black-and-white, because to me black and white represents the true nature of photography."[252] But the Castelli show suggests the dichotomy between what Namuth said and what he did, as well as the importance he attached to his color portraits.[253] At some point, Namuth must have realized that his color portraits of artists taken in the 1960s and later were closer in feeling to the brilliantly colored art of these decades and hence more revealing of the artists who made this work.

In addition to publications, magazine commissions, and exhibitions, Namuth augmented his schedule in the 1970s and 1980s by making a substantial number of films with his longtime friend, film writer, editor, and director Paul Falkenberg. In all, the two made twelve films together, all but one of which were devoted to the work of an individual artist.[254] Filmmaking was for Namuth a way of extending and enhancing the work of documenting the creative personality that he had done with the still camera. As he stated in his 1950 Guggenheim Fellowship application, he wished to make films in order to show in "an honest, non-commercial way . . . the great contemporary masters at work."

Filmmaking had been part of Namuth's oeuvre since late August 1950, when he recognized the cinematic implications of the photographs of Pollock painting. At the end of the summer, Namuth, using his wife's home-movie camera, took a seven-minute black-and-white film of Pollock painting in his studio. Excited by what he saw, Namuth, who as a teenager had aspired to be a theater director, returned in late September with Falkenberg to make a more professional movie of Pollock at work. The film was shot outdoors because the two could not afford lights. A cement foundation at the back of Pollock's property, which remained after the barn that became Pollock's studio was moved, served as a staging area. As the film evolved, Namuth decided that it was important to show Pollock's face as he painted. To accomplish this, he persuaded Pollock to make a painting on a sheet of glass. The text of the voice-over was taken from Pollock's writings and recorded by him well after the film was completed. On the last day of filming, Pollock, stressed by the need to perform before the camera, chilled by the cold, and annoyed at Namuth's "Teutonic" directorial mode, came into his house, and, after two years of abstinence, poured

himself a drink. The tumultuous dinner that followed has been described by numerous witnesses.[255]

The Pollock film premiered at the Museum of Modern Art on June 14, 1951. It was shown again in August at a film festival in Woodstock, New York. Aline Louchheim gave it an unfavorable mention in the *New York Times,* saying that Pollock "belittled and denigrated his own work by a precious and pretentious presentation."[256] But despite her words, the film, like the photographs of Pollock painting, is now seen as an integral part of the artist's legend and a factor, like the photographs, in defining the intrinsic characteristics of Abstract Expressionism.

More than a decade later, Namuth and Falkenberg collaborated on *Willem de Kooning: The Painter.* Presumably, they hoped to get de Kooning to perform for the camera as Pollock had done, but he was not a particularly accomplished actor. The voice-over, which was based on an earlier radio interview with critic David Sylvester, only reinforced the stilted and awkward character of the film.[257] When Namuth and Falkenberg made a second film on de Kooning in 1971, they had learned their lesson. This time, the filmmakers were not only at a greater distance from the painter as he roamed through his studio, but they appear to have taken more footage, which permitted them to edit the visual narrative in a more coherent manner. The script was also specifically fashioned to fit the film.[258]

In 1969 Namuth and Falkenberg made *Homage to the Square,* a film about Yale University professor and artist Josef Albers. After working with Pollock and de Kooning, Namuth must have been startled by the studio and working methods of the meticulous Albers. Not only were they the antithesis of those of the Abstract Expressionists, but Albers was a cogent speaker, as careful and precise with his words as he was with the spatula he used to apply the paint to the Masonite surfaces on which he worked. *Homage to the Square*—the title comes from the name of a series of Albers's paintings—contains an interview with two of his pupils: Richard Anuszkiewicz, who took up Albers's precisionist call, and Robert Rauschenberg, who did not. Rauschenberg said that he originally went to Albers because he sought discipline, but that he left because he couldn't stand the discipline. "I was probably his worst pupil," the distinguished artist cheerfully admitted.

Both Namuth and Falkenberg wrote about making the Albers film. Falkenberg laid out the direction of the film:

> As all our films on modern artists, a film about Josef Albers, in particular, must be a confrontation rather than a purely cinematic representation.
>
> But there is one basic, immutable, inimitable element: The artist himself, in this case: Josef Albers. Personality as the living proof of what is said and done.

And what Albers says and does is characterized by wisdom, based on honest experience, by common sense which in turn is deeply rooted in an incorruptible craftsmanship.

These intangibles cannot be plotted, scripted or tricked. Albers' work exhales a puritanical, clean, sober atmosphere. This means, in my opinion, he has to be photographed directly, simply, frontally, without "gimmicks."

Scenes will neither be improvised nor too rehearsed. Just reasonably well prepared.[259]

Unlike Falkenberg, who wrote about how to make the film, Namuth wrote, characteristically, about the personality of the artist and its impact on him.

His youthfulness and his enthusiasm for a still undefined and financially uncertain project were refreshing. His whole being and personality impressed me. He seemed younger than anybody his age had a right to be. . . . Albers gave us generous portions of his time, his ideas, and most important of all, his humor. . . . It is a film about teaching, a subject he always considered to be more important than painting. Teaching art for him meant conveying the meaning of color as well as the magical relationships between colors.[260]

Their film about Alfred Stieglitz, while the recipient of glowing advance comments, was particularly difficult to make.[261] Georgia O'Keeffe had little faith in their abilities as filmmakers and would not cooperate with them. "My feeling is," she wrote, cooly dismissing Namuth, "that to capture Stieglitz on film would take an extraordinary person who understood the contradictions and complexities in Stieglitz's world. I am not willing to authorize you to do a Stieglitz film or to grant you permission to reproduce photographs from the major institutions."[262] Namuth had to explain to Dorothy Norman, a photographer and a Stieglitz confidante and disciple who had written an extensive narrative of her encounter with Stieglitz, "why the film did not develop along the lines we first set out to follow" and why "it so happened that the film progressed into a whole view of Stieglitz's life beyond the part that we had originally envisioned."[263] When Namuth wrote to photographer Ralph Steiner to ask him to participate because "Frankly, the film lacks sparkle up to this point, and I would like to ask you again, . . . to add your voice to the others," Steiner took the letter, circled the word "sparkle," and replied: "I think you may need a touch of acid. You might find it here." Steiner, who admired Stieglitz the photographer, but not Stieglitz the person, also suggested that the title of the film should be *Stieglitz: The Contradiction* rather than *Stieglitz: The Photographer.*[264] Namuth, who had endured more difficult obstacles throughout his life, did not let these hurdles stop him from finishing the film.

Falkenberg, twelve years older than Namuth, died in 1986. Namuth made only one film after his death. In 1990 Boston-based filmmaker Judith Wechsler and Namuth collaborated on a film about Jasper Johns called *Take an Object: A Portrait, 1972–1990.* The film makes use of earlier footage that shows Johns at work in his Houston Street studio in New York in 1972, and interweaves it with 1989 imagery of the artist making a print based on his painting. Wechsler and Namuth were particularly pleased with the film, because they felt that it went beyond the bounds of a more traditional documentary as it explored Johns's approach to his work.[265]

Until his mid-sixties, Namuth wrote relatively little about his own photography. He was most expansive in *Artists 1950–81: A Personal View,* and he subsequently contributed technical information about his work to the anthology *Darkroom2.* Surprisingly, considering its solitary nature, he professed to find the darkroom part no less exciting than taking pictures—referring to the moment when the image emerged from the developing tray as "sublime."[266] About this time, Namuth also began to think more about the work of other photographers who had, in one way or another, influenced him, among them Albert Renger-Patzsch—who had moved to Essen in 1928, the year his famous book, *Die Welt Ist Schön* (*The World Is Beautiful*), was published—and August Sander.[267] Namuth particularly admired Renger-Patzsch's ability to celebrate the beautiful in the banal. When Namuth photographed objects for his book/exhibition *Early American Tools,* he may have thought of Renger-Patzsch, not only because of his ability to render ordinary objects elegantly, but also for his formal clarity and precision.

Namuth was undoubtedly attracted as well to the formal precision of the portraits of August Sander, a German who lived in Cologne from 1910 until his death in 1964. In 1910, Sander, one of the great portrait photographers of the twentieth century, initiated a project in which he sought to document professional types by photographing individuals whom he believed represented these types. Over the next twenty-four years and again during the 1950s, he took more than 540 photographs illustrating his thesis that body type, gesture, and details of clothing all delineated a man's role in society as well as his character. While he in-cluded artists, architects, musicians, and writers among his categories, he was equally interested in butchers, bakers, and bricklayers.[268]

Namuth paid literal homage to this German master when he pho-tographed the architect and painter Hans Lüttgen and his second wife Renee during their 1975 visit to New York, for he modeled his com-position on Sander's photograph of Lüttgen and his first wife in 1928 [Figures 25 and 26]. Clearly Namuth believed, as did Sander, that details of gesture, expression, body type, and clothing could all be revealing of an individual's personality. But Namuth's photographs of the art world stand apart from Sander's portraits, if for no other reason than that

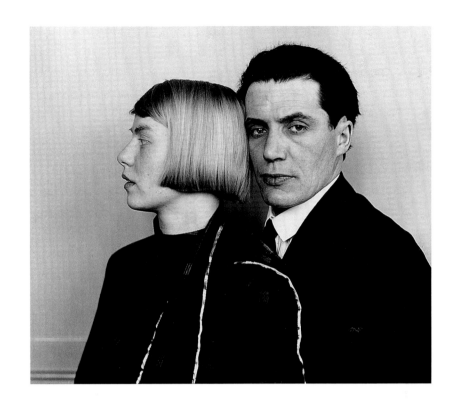

Figure 25.

Hans and Dora Lüttgen by August Sander.
Gelatin silver print, 1928. © 1999 August
Sander Archiv/SK-Stiftung Kultur,
Cologne/ARS, NY/VG Bild-Kunst, Bonn.

Figure 26.

Homage to August Sander (Hans and
Renee Lüttgen) by Hans Namuth. Gelatin
silver print, 1975. Estate of Hans Namuth,
courtesy Center for Creative Photography,
the University of Arizona, Tucson.

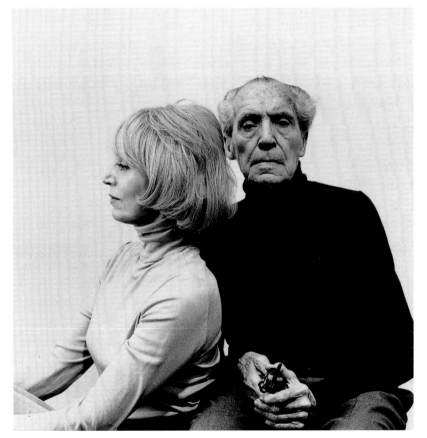

Namuth sought to underscore the uniqueness of the individual, rather than the universality of the artistic type.

In the summer of 1984, Namuth learned that he would have to leave his studio at 157 West 54th Street because of the impending demolition of the building. He had occupied this large and rather handsome space for twenty-seven years after his move from his first studio at Third and Seventy-second Street, which he had shared with painter George Sakier. At the end of the year, Namuth moved to his new, and last, studio on 20 West 22nd Street.[269] On September 9 of that same year, Namuth's wife Carmen was taken ill. Tests led to a diagnosis of lung cancer, and Carmen died on November 30.[270] "Carmen was," wrote friends and musicians Robert Fizdale and Arthur Gold, "a woman of rare charm, wit and distinction—and with all of these, complete modesty and a total lack of pretention" [Figure 27].[271]

Throughout their life together, Carmen had provided Namuth with financial and familial stability, and she had readily joined him in graciously entertaining friends at their home. He was devastated by her death, but outwardly his life changed little. He continued to receive portrait commissions and to travel to Guatemala and Europe. He dined out regularly and went to the theater often. A frequent companion was artist Helen Frankenthaler.[272] Namuth had known Frankenthaler since about 1951, when Clement Greenberg brought her to Springs to introduce her to Jackson Pollock. He had also photographed her on numerous occasions since 1964.[273] In 1987 he photographed her working on *Gateway IX,* a complex project started in 1982 and completed in 1988.[274] Namuth's portrait of Frankenthaler, which shows her enveloped by the vast space of the studio and surrounded by her work, is a loving tribute to this woman of intense energy and intelligence, and to their friendship of more than three decades [Plate 75].

Namuth's death on Saturday, October 13, 1990, was unexpected. Earlier that day he attended a presentation of his recent film *Take an Object: A Portrait, 1972–1990.* Afterward, forgoing a small dinner party that had been arranged to celebrate the occasion, he left for Sag Harbor. Just before 9:00 P.M., Namuth's vehicle and another car collided at the intersection of Long Lane and Stephen Hand's Path.[275] The irony that Namuth should die in an automobile accident on a country road not far from where Jackson Pollock died is a coincidence that cannot be lost on many.

●

Namuth's career as a photographer of distinction coincided with the rise of the artist as a celebrity in the last half of the twentieth century. As American art gained new and unprecedented stature nationally and internationally in the decades after World War II, the lives of painters and sculptors who made this art and achieved commercial success became a topic of interest, not only for the specialized art journals, but

also for the mass media. Namuth's portraits, which originated as a personal passion, became a useful adjunct to the verbal description of an artist and his or her work, because they rose above mere physical description to permit public insight into the private world of a creator in a graphically succinct and visually revealing manner. As such, his portraits became a major force abetting the role of the artist as a media hero.

The success of Namuth's portraits and the subsequent commissions and exhibitions they generated for him speak of the inextricable link between the fame of the subject and the fame of the photographer, a concept that has been well understood since the first days of photography. While this paradigm did not escape Namuth's notice, his quest for artistic and intellectual individuals as subjects was more than a midlife commercial aspiration. It had deep roots, reaching back to his teenage years in Essen, where as a seventeen-year-old he sought out writers, musicians, and politically concerned individuals. It was a tradition that he continued throughout the 1930s, first in Paris, then in Spain, and again in Marseilles. Moreover, his life in America was aimless and directionless until he created a body of work—his photographs of Jackson Pollock—that focused on the essence of artistic creativity.

Figure 27.

Carmen Herrera Namuth by Hans Namuth. Gelatin silver print, 1975. Courtesy Ruth Nivola.

He perceived the importance of the Pollock portraiture to his own sense of identity when he wrote in his Guggenheim Foundation application, shortly after he had completed photographing and filming the artist, that his goal was to "capture contemporary masters at work." Over the next forty years he relentlessly pursued this dream.

Namuth considered personal intimacy with his subjects as a key to successful portraiture. As he wrote shortly before his death,

> I must confess that I personally consider many of the photographs of these men and women the fruits of great rapport. They bring good memories, and offer a challenge too. It still fascinates me to go out there and meet new subjects, and try to persuade him or her to become entrapped—forever, I like to think—in my mystical little black box.

Without rapport, Namuth mused, "the photograph might just as well have been made in one of those booths that take passport pictures by machine."[276]

Namuth saw himself as an artist taking portraits of other artists. As he readily admitted, he liked photographing artists because "*We* are on common ground." Where artists were concerned, this was a concept fundamental to his rapport with them. Nevertheless, he struggled constantly with the notion that he might be perceived as a journeyman, a taskmaster merely carrying out a paid assignment. But if this percep-

tion existed, it probably arose out of the style of his portraiture, which on the whole was relatively simple and direct, and sought the essence of the artist's persona with a minimum of tricks. Namuth did not, like Irving Penn, strip his portrait subjects to their bare physiognomic bones; nor did he, like Richard Avedon in his work of the 1980s, seek out the bizarre in the guise of the mundane. Similarly, Namuth's portraits lack the high camp and self-mocking aura that permeates much of the work of the next generation of portrait-makers, such as Annie Leibovitz. The shocking, intrinsic to Herb Ritts's portraits, is also absent. Moreover, because he did respond to the needs of the magazines, he did not relentlessly photograph in black and white—the sure signifier, at least until the early 1980s, that a portrait was in the artistic rather than the merely representational mode.

Namuth also made his portraiture look too easy—not only to the observer, but also to the subject. The charming portrait of critic John Russell, with its mélange of details, could have come about as a matter of luck [Figure 28].[277] But Namuth did not create a body of work merely from fortuitous circumstances, although he did believe that accident was the photographer's silent partner.[278] While good fortune may have come his way, the experience of decades allowed him to see how the accidental connoted the essence. Namuth was not averse, either, to using his skills as a director to set up or exploit an environment or stage an action, if this could tell his intended audience more about an artist. Witness, for example, the portraits of George Segal, Jim Dine, and Helen Frankenthaler. But as Frankenthaler correctly perceived, "Hans's pictures were always felt and telling. They were never arty."[279]

The look of Namuth's oeuvre might best be compared to a successful Abstract Expressionist painting, one in which there are areas of activity juxtaposed with areas of painterly calm, one in which some spaces recede from the picture plane, while others rest on its surface; one in which compositional and structural choices and those of color and detail are made depending on the mood and message to be conveyed. Thus the visible energy in the portrait of Isamu Noguchi contrasts with that in the portrait of Julian Schnabel, while the shallow space in the portrait of Roy Lichtenstein stands in opposition to the ample area encompassing the portrait of Sam Francis. Namuth selected a centralized composition for the portraits of Louise Nevelson and Frank Stella, perhaps to underscore their intense personalities and the brashness and daring of their art, but an asymmetrical arrangement suited him for the portraits of Leo Castelli and Ellsworth Kelly, perhaps as a way to express their more restrained eloquence. But regardless of how he chose to represent an individual, Namuth's goal was always the same—that is, to create an iconic portrait of the artist that would speak to present and future generations.

Figure 28.

John Russell by Hans Namuth, 1986. Estate of Hans Namuth, courtesy Center for Creative Photography, the University of Arizona, Tucson.

• NOTES

1. Hans Namuth, *Artists 1950–81: A Personal View* (New York: Pace Gallery, 1981), n.p.

2. Ibid.

3. John Simon Guggenheim Memorial Fellowship application, November 1, 1950, Hans Namuth Collection, Center for Creative Photography, Tucson, Arizona.

4. Primary sources for information about Hans Namuth include Hans H. Namuth, Records of the Office of Strategic Services, Record Group 226, Office of Strategic Services Central File, Entry 92, National Archives, Washington, D.C. (hereafter Namuth Papers, OSS/NA); Namuth Personal Papers, 1934–1947 (mostly correspondence to and from Hans Namuth), collection of Peter Namuth and Tessa Namuth Papademetriou (hereafter NPP); Hans Namuth Collection, Center for Creative Photography (hereafter Namuth Collection, CCP); Hans Namuth, interview with Paul Cummings, August 12 and September 8, 1971, Hans Namuth Papers, Archives of American Art, Smithsonian Institution, Washington, D.C., roll 3198, frames 865–92 (hereafter Namuth to Cummings, AAA). Tessa Namuth Papademetriou, Peter Namuth, and Philip Herrera have provided additional biographical material. The most complete published biographical source is "Hans Namuth" in Martin Marix Evans, *Contemporary Photographers* (3rd ed., New York and London: St. James Press, 1995), pp. 817–19.

 Adolf Namuth (July 21, 1889–July 1, 1953) was born in Lenne (Brunswick); Anna Namuth (February 11, 1885–December 30, 1968) was born in Frankfurt am Main (Hessen), Germany. At the time of Namuth's military application, his father was a merchant. After the war, he managed a dairy in Lenne (Adolf Namuth to Hans Namuth, c/o Mr. Gräbe, November 8, 1945, NPP). A September 4, 1980, copy of Namuth's birth certificate issued by Der Standesbeamte des Standesamtes, Essen, gives the complete names of both Namuth and his father. Namuth's sister, Else Sophie Gretel (Maussie) Namuth (van Hasselt) Rutkowski (born May 16, 1918) immigrated to Canada with her second husband and two sons (Dierk van Hasselt, born 1940, and Peter Rutkowski, born 1948) in 1951. Mrs. Rutkowski graciously provided the lifedates for her family.

5. "Untitled Statement" [after 1985], manuscript, Namuth Collection, CCP; Namuth to Cummings, AAA, roll 3198, frames 686–87; "Curriculum Vitae," April 19, 1941, NPP. According to Namuth, the primary activities of the German Youth group were singing, hiking, and traveling to other countries, but ultimately it evolved into a liberal, anti-Nazi organization. As a sixteen-year-old, Namuth found a class taught by curator Dr. Agnes Waldstein at the Museum Folkwang—known for its collection of French Impressionists and German Expressionists—a particularly memorable experience.

6. Namuth to Cummings, AAA, roll 3198, frames 867–68; Diethart Kerbs, "Zur Einführung," in Hans Namuth and Georg Reisner, *Spanisches Tagebuch, 1936: Fotografien und Texte aus den ersten Monaten des Bürgerkriegs* (Berlin: Nishen, 1986), p. 11. Dr. Kerbs based his biographical information on his 1984 interview with Namuth in New York in anticipation of a film he was producing on German photojournalists of the 1930s (Kerbs to the author, November 3, 1997).

7. "Curriculum Vitae"; Namuth to Cummings, AAA, roll 3198, frame 868. Several poems and stories written by Namuth during the 1930s can be found in his papers, attesting to his interest in writing. Lists of writers whose works he had read and admired are also among his papers.

8. Namuth to Cummings, AAA, roll 3198, frames 866–67. In "A Portfolio of Artists' Portraits: Hans Namuth," *Art International* 6 (spring 1989): 40, Namuth states that he was a communist, but ultimately his allegiance to the Communist Party was radically altered by his experiences in Spain in 1937. See Kerbs, "Zur Einführung," p. 16.

9. For Namuth's conflict with his father, see Lieutenant John A. Bross to Commander William H. Vanderbilt, August 19, 1942, Namuth, OSS/NA; Namuth to Cummings, AAA, roll 3198, frame 866; Kerbs, "Zur Einführung," p. 11.

10. Namuth to unidentified, March [?], 1934, NPP.

11. Rudolf Leonhard (1899–1953) to Namuth, January 11, 1933, NPP; Namuth to Cummings, AAA, roll 3198, frames 868–69; "Curriculum Vitae."

12. Namuth to Leonhard, July 5, 1934, September 7, 1935, and October 19, 1935, NPP. Among the other names that appear in Namuth's early letters are Gilbert Lessage, Magnus Hirshfeld, Lisa Hirshfeld, and Yvette. Lessage was Assurer-Conseil and Secretary of Entr'Aide Européenne at 55, Ponthieu, Paris 8e. Hirshfeld lived at 63, rue Jouffroy, Paris 17e. Catherine Savard (formerly Ilse Wiesenthal) to Namuth, August 19, 1937, NPP, refers to Lunte as the restaurant where Namuth worked as a dishwasher. When Savard wrote, she was working in New York at the Echo Publishing Company. She had recognized Namuth's name from a proposal he had submitted to the company.

13. On October 22, 1933, Namuth—who throughout his life would always enjoy a good party—and several others celebrated Capa's twentieth birthday at various cafés. See Richard Whelan, *Robert Capa: A Biography* (New York: Alfred A. Knopf, 1985), p. 55; Kerbs, "Zur Einführung," p. 11. In 1981 Namuth responded to an inquiry from Patricia Mitchell and Michael Rollens, who were working on a film about Robert Capa, that "he knew Robert Capa—Andre Friedman [*sic*] then—in Paris, before he [Namuth] became a photographer, in late 1933. We lost track of each other in the years that are of in-

terest to you, and I never laid eyes on Gerda Tara" (Capa's girlfriend, who was killed during the Spanish Civil War) (Namuth to Patricia Mitchell, April 21, 1981, Namuth Collection, CCP).

14. Namuth to Leonhard, October 19, 1935. Namuth writes that this letter is to be hand-delivered to Leonhard by Paul Falkenberg. It is possible that Namuth and Falkenberg first encountered each other in Majorca, but the inference is that they had met previously in Paris. A letter from Hans Sahl to Lotte Goslar, October 29, 1935, mentions Falkenberg's presence in Paris shortly after this date. I wish to thank Kenneth Keskinen, executor of the Lotte Goslar Seehaus estate, for this and other letters between Sahl and Goslar that added to my understanding of the circle of refugees that Namuth knew.

Paul Victor Falkenberg (1903–1986), a documentary filmmaker born in Berlin, left Germany in 1930 to enhance his career opportunities, not for political or religious reasons. During the next eight years, Falkenberg worked in Paris, London, Vienna, and Rome with numerous noted directors before he immigrated to America in 1938. In America, Falkenberg worked first in Hollywood and, when opportunities there became limited, returned to New York. From 1941 to 1945 he worked in the film department of the Museum of Modern Art before undertaking various freelance assignments (Mrs. Paul Falkenberg, interviewed by the author, March 10, 1998).

15. Namuth to Leonhard, July 5, 1934, NPP; Bross to Vanderbilt, August 19, 1942.

16. In Namuth to Leonhard, July 5, 1934, Namuth refers to his infatuation with Marianne (Janne) Stark, saying: "Do not be terrified dear Rudolf . . . [but] I must see Marianne again—before both of us continue our separate lives. . . . It is a force that I cannot escape from any more. And she is experiencing exactly the same, just much stronger and more painful than I. I therefore have every reason to believe that it was anything but a short lived affair." Namuth began his journey in Marseilles, where he went to deal with visa issues. In October, he was in Rome, after having stayed for a week or so in Florence, and he was in Athens from about January through July 1935 (Namuth to Leonhard, July 5, 1934; Gilbert Lessage to Namuth, October 4, 1934; unidentified to Namuth, July 13, 1938, NPP; and "Curriculum Vitae"). Although Stark was married, they continued to correspond. ([Namuth to Stark], May 15, 1937; Stark to Namuth, August 2, 1937, and September 12, 1938, NPP). In 1938 her address was Tel-Aviv, Flieser-ben ebuda 82. Namuth also spoke of this relationship in his interview for military service (Bross to Vanderbilt, August 19, 1942). As late as 1986, Namuth indicated that this romance was a defining event in his life (Namuth, "Untitled Statement").

17. Namuth to Leonhard, July 5, 1934.

18. Kerbs, "Zur Einführung," p. 10. See also "Georg Reisner"

(1911–1940) in Turner Browne and Elaine Partnow, eds., *Macmillan Biographical Encyclopedia of Photographic Artists and Innovators* (New York and London: Macmillan, 1984), pp. 503–4. Konrad Reisner, interviewed by the author, December 20, 1997.

19. Namuth to Leonhard, July 5, 1934.

20. Namuth to Leonhard, September 7 and October 19, 1935, NPP. These letters were written on the stationery of the Mar I Cel Hotel in Puerto Pollensa, Majorca. In this correspondence, Namuth mentions meeting Emil J. Gumbel, an anti-Nazi scholar who subsequently taught at Columbia University; the nephew of the German novelist and playwright Arnold Zweig and the nephew's wife Odette; a filmmaker, Alexander Maass; and a man named Trautner.

21. Namuth to Leonhard, September 7, 1935.

22. Kerbs, "Zur Einführung," p. 12.

23. For an overview of the growth of photojournalism, see Richard Lacayo and George Russell, *Eyewitness: 150 Years of Photojournalism* (New York: Oxmoor House, 1990). For brief biographies of each of these individuals, see Browne and Partnow, *Macmillan Biographical Encyclopedia.*

24. Namuth to Cummings, AAA, roll 3198, frame 870. Namuth notes in this interview that he and Reisner left everything they had behind in Puerto de Pollensa because Majorca was overrun by the Franco forces. Kerbs, "Zur Einführung," pp. 12–16. See also Namuth, "Spanisches Tagebuch (fragment)," in Namuth and Reisner, *Spanisches Tagebuch,* pp. 107–17. Namuth's Spanish Civil War diary, which is reproduced in the book, was found in the 1970s by Konrad Reisner with the few effects remaining in the estate of his brother Georg. An English translation by John Githans of Kerbs's text and Namuth's diary is in the Namuth Collection, CCP.

25. Namuth to Erica [?], Madrid, August 17, 1936, NPP. This letter was addressed to 56, rue Perronet, the address of the Reisner boardinghouse. Erica, who was either an actress or a dancer, probably boarded there.

26. According to Whelan (*Capa,* p. 101), Lucien Vogel was forced to sell *Vu* because its Republican sympathies had led to the loss of advertisers. Max Lowenhertz of the Three Lions agency was presumably also one of the individuals to whom Namuth and Reisner sent their photographs, for in 1977, when Namuth first exhibited these works, he obtained numerous negatives from Lowenhertz (Namuth to Lowenhertz, April 8, 1977; Lowenhertz to Namuth, May 10 and October 31, 1977; Namuth to Lowenhertz, May 20, 1976; June 2, October 7, and December 21, 1977, all CCP).

27. Kerbs, "Zur Einführung," pp. 14–15. In Namuth to Eddie [?], July 22, 1941, NPP, Namuth mentions that the Spanish War assignment was from *Vu* and that they also

worked for the Catalonian Propaganda Department and "a lot for Match and Ringier in Switzerland." For a more extensive discussion and analysis of Namuth and Reisner's Spanish Civil War photographs, see Sigrid Schneider, "Von der Verfügbarkeit der Bilder: Fotoreportagen aus dem Spanischen Bürgerkrieg," *Fotogeschichte* 8, no. 29 (1988): 29ff. esp. pp. 52–61. Dr. Schneider cites additional publications that featured the Namuth/Reisner photographs, and she also points out that some Namuth/Reisner photographs were used by both Fascists and Republicans for propaganda, but that different messages were achieved with different captions.

28. Schneider, "Fotoreportagen aus dem Spanischen Bürgerkrieg," p. 54; David Evans, *John Heartfield: Arbeiter-Illustrierte Zeitung Volks Illustrierte 1930–1938* (New York: Kent, 1993), pp. 391–92.

29. For an overview of the history of war photography, see George Lewinski, *The Camera at War: A History of War Photography from 1846 to the Present Day* (New York: Simon and Schuster, 1978).

30. Kerbs, "Zur Einführung," p. 13.

31. Namuth, "Statement" [probably a draft press release for the exhibition of Spanish Civil War photographs at Castelli Uptown, March 5–26, 1977], typescript, Namuth Collection, CCP. Also quoted in "Directions and Perspectives Lecture Series: The Photographers," International Center for Photography, press release, October 25, 1979, Namuth Collection, CCP.

32. Schneider, "Fotoreportagen aus dem Spanischen Bürgerkrieg," p. 53.

33. Kerbs, "Zur Einführung," p. 13; Namuth, "Statement." See also Hans Namuth, "Spanish Civil War Photographs," Castelli Uptown, March 1977, Peter Selz Papers, AAA, roll 4384, frame 455.

34. Kerbs, "Zur Einführung," pp. 13–14. For Borkenau's description of the war, see Franz Borkenau, *The Spanish Cockpit: An Eye-witness Account of the Political and Social Conflicts of the Spanish Civil War* (reprint, Ann Arbor: University of Michigan Press, 1963). For Capa's photograph, see Schneider, "Fotoreportagen aus dem Spanischen Bürgerkrieg," p. 54, illustration no. 3, and Whelan, *Capa*, p. 95.

35. Namuth to Cummings, AAA, roll 3198, frame 871; Kerbs, "Zur Einführung," p. 16. For Fischer's account of the war, see Louis Fischer, *Men and Politics: An Autobiography* (New York: Duell, Sloan and Pearce, 1941), pp. 351–414.

36. Namuth, "Untitled Statement."

37. In his "Curriculum Vitae," Namuth said he sold his pictures to *Regards, Paris Match, Paris-Soir,* and the Swiss magazines *Sie* und *Er.*

38. Namuth was particularly free and open with his feelings in numerous letters to his sister (Namuth to "Little Gret,"

April 15, 1937; Namuth to "My Little Gret," May 23, 1937; and Namuth to "Little One," June 3, 1937, all NPP). She was working as a governess in Toulouse. Heinz Königsbuch, a friend from Essen, found her the job with this family. In the spring of 1937, Namuth took pictures of Hélène, her employer. Maussie Rutkowski, interviewed by the author, December 10, 1997, identified Königsbuch and provided additional details about her position in Toulouse.

39. Namuth to "Little One," June 3, 1937.

40. Ibid. Namuth had seen *The Green Table* in 1932, when it was first presented in Essen. He initially met Jooss (1901–1979) when the latter was director of the dance department of the Folkwang School (Namuth, "Untitled Statement").

41. Namuth was particularly attracted to the poetry of Georg Trakl (1887–1914), whom he read daily, "just as other people read the bible." In his letters, he freely quoted the poet Klabund (pseudonym of Alfred Henschke) (1890–1928), Thomas Mann (1875–1955), and the novelist Henri de Montherlant (1896–1972). Namuth also sent his sister a monograph on Thomas Mann and a book by [?] Langhoff, whom he said he knew personally (Namuth to unidentified, July 17, 1938; Namuth to "My dear Girl," July 21, 1938; Namuth to unidentified, September 21, 1938; Namuth to "My little loved one," November 25, 1937, all NPP).

42. Namuth to "Little Gret," April 15, 1937. Namuth was particularly upset with the news from his mother that Erich Finler [?], one of his best friends from Essen, had been beaten to death. "Tears of outrage and disgust are coming to my eyes at the mere thought of it." Namuth speaks of the growing chaos in Europe and asks for help in coming to America in his letter to "Mon Cher ami" [Samuel L. M. Barlow], September 27, 1938, NPP.

43. Helen Frankenthaler, interviewed by the author, March 31, 1997.

44. Namuth to "Little Gret," April 15, 1937; Namuth to "My Little Gret," May 23, 1937.

45. Namuth to "Little One," June 3, 1937.

46. Namuth to Cummings, AAA, roll 3198, frames 871–72.

47. Namuth probably met Porter at the time of the Museum of Modern Art exhibition "Trois Siècles d'Art aux États-Unis," which opened at the Jeu de Paume. Porter had assisted with the organization of this exhibition, and he was undoubtedly on hand for its May 1938 opening (Russell Lynes, *Good Old Modern: An Intimate Portrait of the Museum of Modern Art* [New York: Atheneum, 1973], p. 106). When in September 1938, Namuth approached his friend Samuel L. M. Barlow (1892–1982) for assistance in coming to America, he asked if Porter or photographer George Platt Lynes could find him work (Namuth to "Mon cher ami" [Barlow], September 27, 1938).

Porter and Lynes had been in France in the early 1930s, returning to America about 1932. Porter, interviewed by Paul Cummings (May 24, 1967, typescript, p. 10, AAA), said that he never returned to Paris during the 1930s, and that he had "gotten it out of his system." In all likelihood, Porter forgot this relatively short trip he made abroad in the summer of 1938. Barlow, who had close ties to numerous individuals at the Museum of Modern Art, was probably the initial link between Porter and Namuth (Lynes, *Good Old Modern,* p. 204). Subsequently, Namuth gave Porter as a reference on his 1941 "Curriculum Vitae" and on the papers he filed with the U.S. Army (Namuth Papers, OSS/NA). Information at the Center for Creative Photography indicates that Namuth and Porter remained friends until the latter's death. No further mention of Lynes appears in Namuth's papers.

48. Joseph Roth to Namuth, March 29, 1939, NPP. Roth wrote from 18, rue de Tournon, Paris 6e, to request two more pictures of himself and a full-length portrait. Later that year, the painter Eugen Spiro wrote to Namuth seeking a detail of a group photograph that included the author, who had recently committed suicide. Spiro wanted to use the photograph of Roth, which today remains unlocated, as a source for a painting he intended to make to honor his friend (Spiro to Namuth, undated, NPP). Although Spiro's paintings were recovered from the Germans in 1949, the portrait of Roth—if it was ever undertaken—remains unlocated (Hildegard Bachert [Galerie St. Étienne] to the author, July 29, 1997; Peter Spiro to the author, October 26, 1997; and John Spalek to the author, December 10, 1997).

 Spiro, who wrote on the stationery of the Union of Free Artists, located at 31, rue de la Faisanderie, Paris 17e, states that he had seen the Roth photograph at Gisele Freund's, thus providing the link between Namuth and Freund, a photographer who was also a German expatriate. Whelan (*Capa,* p. 55) states that Capa met Freund in 1933 at the Protective Association of German Writers in Exile (Schutzverband Deutscher Schriftsteller im Exil [SDSE]). Given his own interests, Namuth may have met her through this organization, and as early as 1933 as well.

49. Hans Namuth, no. 488, *Vulu,* July 21, 1937, p. 980. Stamped photograph, Photographic Archives, Bibliothèque Historique de la Ville de Paris, Paris, France. I wish to thank Lisa Daum, curator of photographs, Bibliothèque Historique de la Ville de Paris, who kindly provided me with the information on these and seventeen other signed Namuth photographs in the collection (Lisa Daum to the author, January 24 and 28, 1997).

50. Namuth to Fé [?], September [?], 1939; Namuth to Cummings, AAA, roll 3198, frames 872–73. In the Cummings interview, the town in which Namuth was interned is identified as Villerbon.

51. Namuth to Cummings, AAA, roll 3198, frame 873.

52. Namuth to Fé, September 1939. As he wrote from Blois: "I do not know whether I will be here for 2 days, 2 months or two years. The outside world has not given me any sign of compassion or of interest. . . . There is only one possibility to get out of here: to sign a contract for a 5 year tour of duty in the Foreign Legion, and nobody can and wants to make that decision. I can't do it either."

53. Namuth Papers, OSS/NA; Namuth to Dr. Erich Stern, July 16, 1941, NPP.

54. For an overview of the chaos caused by Article 19, particularly for German artists and intellectuals, see the various essays in Stephanie Barron, ed., *Exiles + Emigrés: The Flight of European Artists from Hitler* (Los Angeles: Los Angeles County Museum of Art, 1997). This monograph also contains an excellent bibliography of both original and secondary sources related to the period. Also of use is Jarrell C. Jackman and Carla M. Borden, eds., *The Muses Flee Hitler: Cultural Transfer and Adaptation, 1930–1945* (Washington, D.C.: Smithsonian Institution Press, 1983).

55. Namuth Papers, OSS/NA.

56. When Fry arrived in Marseilles on August 5, 1940, he carried with him a list of artists at risk—among them Hans Arp, André Breton, André Masson, Marc Chagall, and Max Ernst—drawn up in part by the director of the Museum of Modern Art, Alfred H. Barr Jr. Thomas Mann, who had immigrated to America in 1938, gave Fry a similar list of literary figures who would be likely targets of the Gestapo, including publishers Kurt and Helen Wolff, and writers Walter Mehring, Hans Sahl, and Hans Siemsen. See Barron, "European Artists in Exile: A Reading between the Lines," in *Exiles + Emigrés,* pp. 11–29; Elizabeth Kessin Berman, "Moral Triage or Cultural Salvage? The Agendas of Varian Fry and the Emergency Rescue Committee," in *Exiles and Emigrés,* pp. 99–112; Bernard Nöel, *Marseille-New York* (Marseille: André Dimanche, 1985); Martica Sawin, *Surrealism in Exile and the Beginning of the New York School* (Cambridge: MIT Press, 1995), pp. 104–47; Varian Fry, *Surrender on Demand* (New York: Random House, 1945) and *Assignment Rescue: An Autobiography,* with an introduction by Albert O. Hirshman (circa 1968; reprint, New York: Scholastic, 1992); Columbia University Library, New York, "The Varian Fry Papers: The Fort Ontario Emergency Shelter Papers," ed. Karen J. Greenberg, in Henry Friedlander and Sybil Milton, eds., *Archives of the Holocaust: An International Collection of Selected Documents* (New York: Garland Press, 1990); Paul Cummings, interview with Margaret Scolari Barr (Mrs. Alfred H.), February 22–May 13, 1974, manuscript, AAA; Rona Roob, "From the Archives: Refugee Artists," *MoMA: The Members Quarterly of the Museum of Modern Art* 6 (1991): 18–19. Varian Fry (1907–1967) and the Emergency Rescue Committee have been the subject of several exhibitions.

"Assignment Rescue" was the inaugural exhibition at the United States Holocaust Memorial Museum in 1993. A variant of this exhibition traveled to the Jewish Museum, New York City, and the Field Museum, Chicago, in 1997 and 1998. An excellent bibliography on Fry and the Emergency Rescue committee can be found on the Web site http://www.almondseed.com/vfry/fryreso.htm.

57. Fry, *Surrender on Demand,* pp. 188–89. The ERC recruited numerous individuals to interview those petitioning for assistance. Among them was the German author Hans Sahl (Hans Sahl, interview, April 9, 1991, United States Holocaust Memorial Museum and Archives, Washington, D.C.). Namuth said he also assisted the committee (Namuth to Eddie, July 22, 1941). Namuth's name does not appear in any extant papers related to the ERC, but it is a well-known fact that many papers related to the committee were destroyed—or, for security reasons, never existed.

58. Fry, *Surrender on Demand,* p. 187; Namuth to Cummings, AAA, roll 3198, frames 874–75.

59. While in Martinique, Namuth did some sightseeing and, on the day he left, he took photographs with a borrowed Rolleiflex at the St. James Rum plantation. He also enjoyed "the excellent rum." In St. Thomas, he was interviewed by the governor. See Namuth to Eddie, July 22, 1941; Namuth to Cummings, AAA, roll 3198, frame 874; S. S. *San Jacinto* passenger manifest, Record Group 58, National Archives. In late March 1941, André Breton and his wife and daughter left Marseilles, following a route similar to Namuth's, as did André Masson and his family in April (Nöel, *Marseille–New York,* pp. 51–54 and 58–62).

60. Namuth to Eddie, July 22, 1941. The S.S. *San Jacinto* passenger manifest, National Archives, contains the names of six members of the Schachter family, mostly from Crakow, Poland, who also sailed from Marseilles on February 18, 1941. They were sponsored by Herman Younglieb, a New York businessman who owned an advertising agency. Lily Younglieb, interviewed by the author, February 20, 1998, said that her husband sponsored more than forty Jewish refugees. As the Schachter family group were not known either as distinguished writers or artists, one can only surmise that they, like Namuth, were allowed to depart from France because they had their papers in order, money for passage, and a sponsor in New York.

61. Namuth to Dr. Erich Stern, July 16, 1941; Namuth to Eddie, July 22, 1941; Namuth to Cummings, AAA, roll 3198, frame 869. According to Konrad Reisner, interviewed by the author, January 10, 1998, Georg Reisner's visa arrived the day after his death on December 23.

62. Becker survived his ordeal (Namuth to Cummings, AAA, roll 3198, frame 869).

63. Barlow was a frequent traveler to Europe and usually spent about half of each year living abroad. In 1934 Bar-low's musical fantasy "Mon Ami Pierrot," which was derived from the children's song "Au Claire de la Lune," was performed at L'Opéra-Comique in Paris. The house at Èze, which Barlow developed into a center for artists and for concerts in support of liberal causes, was purchased in 1921 and remained in the family's possession until the early 1960s (Audrey Barlow Orndorff, interviewed by the author, February 12, 1998).

64. Namuth to Cummings, AAA, roll 3198, frame 875. In Bross to Vanderbilt, August 19, 1942, Bross states that Barlow and Namuth had known each other for eight years. In 1955, Namuth photographed Barlow in his Gramercy Park house standing beside the Houdon bust of his famous relative Joel Barlow, which is now in the White House collection (Namuth Collection, CCP).

65. Hans Namuth, "Album for Varian Fry," Archives, Department of Photography, Museum of Modern Art, gift of Annette R. Fry, p. 8, recto: "Mountaintop Village"; p. 9, recto: "Village Rooftops," verso: "Couple Lying on Beach"; p. 10, recto: "Old Buildings." Namuth also wrote fondly about the time he spent with Barlow in Montre-don (Namuth Diary, August 8, 1941, NPP). Barlow must have been Namuth's connection to the Countess Pastré (in whose château Namuth said he lived while in Marseilles), for she shared Barlow's interest in music, as well as in liberal and artistic causes. For additional information on the countess, see Nöel, *Marseille–New York,* pp. 44–50 and Sawin, *Surrealism in Exile,* p. 121; Jacques Nantet, "Souvenier de la Comtesse Pastré" in *La Revue des Deux Mondes,* September 1984, pp. 629–33. The château of the countess is now a ceramics museum. I wish to thank Danielle Maternati-Baldouy, chief curator, Musée Grobet-Labadie, for information on the countess.

66. Namuth to "Mon cher ami" [Barlow], September 27, 1938.

67. Namuth to Fé, September 1939.

68. Samuel L. M. Barlow, Diary 1940–1941, collection Audrey Barlow Orndorff, cited in Audrey Barlow Orndorff to the author, June 1, 1998.

69. Sumner Welles to Samuel L. M. Barlow, November 23, December 4, December 18, 1940; and Barlow to Welles, May 23, 1941, Sumner Welles Papers, box 56, folder 5, Franklin Delano Roosevelt Library, Hyde Park, New York. I wish to thank Robert Parks, archivist, for this information. Namuth had a visa to America in lieu of a passport, which was issued by the American consul in Marseilles. Namuth describes some of the events leading to his departure from France in Namuth to Eddie, July 22, 1941.

70. Namuth to Cummings, AAA, roll 3198, frame 573; Barlow Diary, 1941. Audrey Barlow Orndorff, interviewed by the author, January 21, 1998, and Ernesta Drinker Ballard (niece of Barlow's second wife), interviewed by the author, January 20, 1998, both stated that Namuth and Barlow maintained their friendship until the latter's death in 1982.

71. Hans Sahl to Namuth, July 7, 1941; Namuth to Sahl, July 17, 1941; Sahl to Namuth, July 22, 1941, all NPP. In the latter letter, Sahl (1902–1993), who had spent the previous Saturday evening with Namuth, confessed with considerable understatement that "you are the only memory of Marseilles, that I like to remember. All others did not survive the journey across the ocean." Sahl and Namuth were sufficiently close for Sahl to talk about his failed romance with a woman named Edith. Sahl, who had arrived in America in June 1941, was staying with his longtime friend, dancer and choreographer Lotte Goslar (who had immigrated to America in 1938 and was then was living at Cream Hollow Farm in West Cornwall, Connecticut, the home of Columbia University professor Hatcher Hughes). Namuth's ties to Siemsen (born 1891) during this period are detailed in Namuth to Hans Siemsen, July 29, 1941; Siemsen to Namuth, July 31, 1941, Siemsen to Namuth, August 4, 1941; Namuth to Siemsen, August 11, 1941, all NPP. Namuth got Siemsen's address from his relative [?], the art dealer Karl Nierendorf. Namuth, who sought Nierendorf's assistance for Germans still in France, considered the art dealer duplicitous and unforthcoming (Namuth to Becker, May 30, 1941, NPP; Namuth to Siemsen, July 29, 1941). Namuth arranged for Barlow to write an affidavit of support and to elicit an emergency visa from Sumner Welles for Andreas Becker, although he was unable to use them. Barlow also assisted with the immigration of Georg Reisner's brother Konrad and his wife, and his parents (Barlow [?] to Welles [?], after January 28, 1941, Sumner Welles Papers, box 57; Namuth Diary, Part 2, September 24, 1941; Konrad Reisner, interviewed by the author, January 12, 1998). Walter Lichtenstein was living in Marseilles with five family members in a one-room apartment and working as a street cleaner (Namuth to [?] Dessau, June 22, 1941, NPP).

72. Namuth to Andreas [Becker], May 30, 1941; Namuth to Dr. Erich Stern, July 16, 1941; Namuth to Lisa [Rothschild], July 16, 1941; Namuth to Eddie, July 22, 1941, all NPP.

73. Namuth to Cummings, AAA, roll 3198, frame 875; Namuth to Stern, August 15, 1941, NPP.

74. Namuth to Eddie, July 22, 1941.

75. In Namuth to Lisa [Rothschild], July 16, 1941, he wrote, "There is very little to report about my life here. It is the typical life in a small town. My 'work' is not strenuous but time-consuming. I am trying to stay in touch with the world and with my friends, which is quite difficult, because the world is large, confusing and confused." See also Namuth to Stern, July 16, 1941. Namuth's letter to Hans Sahl, July 17, 1941, is less upbeat. His mood vacillated, even in the same letter. "Life here is typical for a small town but one with a college. Gossip, boredom, drudgery and he who doesn't go to church on Sundays is in the dog house and done with for all times. The streets are broad and beautiful, lined with the most beautiful trees imaginable. Whatever traffic there is reminds me of France without gasoline."

76. Namuth to Hans Sahl, July 17, 1941. Although Namuth declined one public lecture, he ultimately spoke to the Lion's Club. The next day, the headline in the Albion paper read "German Youth Says America Should Enter the War" (Namuth to Cummings, AAA, roll 3198, frame 876).

77. Namuth to Lisa, July 16, 1941.

78. Namuth to unidentified, January 6, 1939, NPP; Namuth Diary, August 29, 1941.

79. Namuth to Eddie, July 22, 1941; Namuth to Lisa, July 16, 1941; Namuth to Stern, July 16, 1941; Namuth Diary, August 1–5, 1941.

80. Namuth to Stern, July 16, 1941; Erich Stern to Namuth, July 18, 1941, NPP. According to Alice Stern (widow of Dr. Stern), interviewed by the author, August 4, 1998, Stern also had been Namuth's physician in Essen.

81. Namuth to Eddie, August 10, 1941, NPP; Namuth to Stern, August 15, 1941; Namuth Diary, August 5, 1941.

82. Namuth to Stern, August 15, 1941.

83. Namuth Diary, August 18, September 1, 22, and 27, 1941.

84. Namuth Diary, August 26, 1941.

85. Namuth Diary, August 27, 28, 30, September 5, 1941.

86. Namuth Diary, September 3, 1941.

87. Namuth Diary, September 29, 1941.

88. Namuth Diary, October 1, 1941.

89. Namuth Diary, October 10, 1941.

90. Namuth to Cummings, AAA, roll 3198, frame 876; Namuth Papers, OSS/NA. His last day with Stone-Wright, which was located at 225 Fourth Avenue (now Park Avenue South), was November 26 (Namuth Diary, November 26/27, 1941).

91. Namuth credited Plucer with teaching him about "the American ways of photography and dealing" (Namuth to Cummings, AAA, roll 3198, frame 876; Namuth Papers, OSS/NA).

92. Namuth Papers, OSS/NA. Namuth's income from these jobs allowed him to leave Barlow's house and rent from a Mrs. Doscher at 117 East 19th Street between December 1941 and August 1942, and to subsequently live at 51 Manhattan Avenue.

93. Namuth Diary, October 1, 20, November 11, 19, 29, 1941. Hans Sahl, Hans Siemsen, Paul Falkenberg, and the Russian expatriates Tamara and Zizi were among those Namuth saw in the first months back in New York.

94. Fry, Surrender on Demand, pp. 220–35. Fry was recalled from France by the American government but ignored repeated entreaties to leave. In September 1941, he

was ousted by the French government as "an undesirable alien" for protecting Jews and anti-Nazis.

95. Namuth Diary, May 3, 1942.

96. John S. Russell to [William H.] Vanderbilt, May 18 and 19, 1942; John S. Russell to W. J. Horrigan, August 4, 1942; Bross to Vanderbilt, August 19, 1942, all Namuth Papers, OSS/NA. Namuth obtained his naturalization papers at the Mercer Pennsylvania County Court House (Namuth Papers, OSS/NA).

97. "Album for Varian Fry," Archives, Museum of Modern Art. See also Namuth to Cummings, AAA, roll 3198, frame 875. Namuth's portrait of Pablo Casals could have been taken at the time of the cellist's May 1937 performance in Paris, but more likely it was taken in late 1940 or early 1941, when the musician was performing a series of concerts on behalf of the Red Cross in the south of France (H. L. Kirk, *Pablo Casals: A Biography* [New York: Holt, Rinehart, and Winston, 1974]), pp. 415–16).

98. At Camp Ritchie, Namuth was one of more than 600 soldiers—including more than 140 officers—in the tenth class to be trained for overseas intelligence as a French specialist. From July 23 to September 20, Namuth took classes in French history, economics, geography, and culture. His grades were always above 90, and his instructors' remarks complimentary. They noted that Namuth was very serious, a good student, and that he created a good impression. Other positive qualities were his ability to speak French well, to drive, and to type! (Namuth Papers, OSS/NA).

99. Namuth Papers, OSS/NA; Namuth to Cummings, AAA, roll 3198, frame 878.

100. Tessa Namuth, interviewed by the author, September 30, 1997; Phillip Herrera, interviewed by the author, June 10, 1997; Peter Blake, interviewed by the author, September 17, 1997; Barbara Hale, interviewed by the author, September 30, 1997; Ruth Nivola, interviewed by the author, September 30, 1997; Namuth to Cummings, AAA, roll 3198, frame 878; Namuth Papers, OSS/NA. Herrera had separated from her first husband, Camilo de Brigard, and was living with her mother, who had returned to her native America at the start of the war when her second husband, Captain Serge Fleury, was assigned to the French Military Mission in New York. Carmen's two sons by her first marriage remained with their father until they were nine and twelve and came to the United States for boarding school. Namuth said that he postponed entering the military at Carmen's request (Namuth to Cummings, AAA, roll 3198, frame 878; see also Bross to Vanderbilt, August 19, 1942). Immediately after their marriage, Carmen Namuth lived at 58 West 58th Street (Namuth Papers, OSS/NA).

101. Namuth to Cummings, AAA, roll 3198, frame 879. Namuth's military records from August 1943 through October 1945 are no longer at the National Archives. They were probably destroyed in a fire at the Archives Center in St. Louis, Missouri, on July 12, 1973 (L. Brooke to the author, March 9, 1998). William Gladstone, interviewed by the author, September 10, 1997, provided otherwise unavailable information on Namuth's military career. He said that he met Hans Namuth at Camp Ritchie and that the two left America together on the *Queen Mary* and arrived in Scotland in December 1943. While they were not always in the same divisions, they were together in Normandy and Brittany at various stages of the war, and in Czechoslovakia on May 7, 1945. Gladstone also recalled that Namuth went to Wetzlar, where Leicas were made, and that he purchased several cameras.

102. Namuth to Cummings, AAA, roll 3198, frames 879–80. Namuth also used this time in Germany, after the war was over, to search for his family. He had last heard from them in the summer of 1941, and on his military records he listed their address as unknown. See Carmen Namuth to Anna Namuth, September 20, 1945, and Adolf Namuth to Mr. Gräbe, November 8, 1945, NPP.

103. Namuth to Cummings, AAA, roll, 3198, frame 875.

104. Namuth to Cummings, AAA, roll 3198, frame 881; Guggenheim Fellowship application, November 1, 1950.

105. Namuth to Cummings, AAA, roll 3198, frames 877–78. Namuth presents contradictory information about his classes with Breitenbach (1896–1984). In the Cummings interview, he states that he took classes with Breitenbach in Paris, but on his 1950 Guggenheim application, Namuth writes that in Paris he was "self-taught." There is no mention of Breitenbach in any of Namuth's 1934–1942 letters. In the Cummings interview, Namuth said, "over a period of months, I took three evening classes with him—that's all." In his Guggenheim application, Namuth gives 1946 to 1949 as the dates during which he studied with Breitenbach. Breitenbach taught at both the Cooper Union and the New School for Social Research after the war (Mark Holborn, *Josef Breitenbach: Photographer* [New York: Temple Rock, 1986], p. 12). Peter C. Jones, interviewed by the author, June 19, 1998, confirmed that Breitenbach did not begin to teach at the New School until 1949, but he added that Breitenbach also taught small groups in his own studio. Namuth could have participated in classes Breitenbach gave at all these locations, although the casual description of his classes with Breitenbach suggests that he may have been one of the private students of this highly popular teacher.

Breitenbach left Munich, where he had been born, in late 1933. In 1934 he established a studio in Paris at 70 bis, rue Notre Dame des Champs. Like all German males living in France, Breitenbach was interned in 1939. In 1941 he immigrated to the United States, leaving Marseilles in May and arriving in New York, via Trinidad, on June 27. Breitenbach's papers are at the Center for Creative Photography.

106. *New School Bulletin,* Art Classes, 1947–1948, and yearly through 1951. There were two sessions: Tuesdays and Thursdays, 8:15–10:15 P.M.

107. For an overview of Brodovitch's (1898–1971) career, see Andy Grundberg, *Brodovitch* (New York: Harry N. Abrams, 1989).

108. The classes Namuth attended were held in the studio of Paul and Karen Radkai in the East Sixties. When Brodovitch was ill or otherwise unable to teach, Lillian Bassman (born 1917), a fashion photographer and editor of *Junior Bazaar,* substituted. Through these classes Namuth met, either as fellow students or as guest lecturers, numerous photographers and art editors whose lives would later intersect with his, among them William Hellburn, Ben Rose, Allen Harlburt, Frank Zachary (born 1914), David Attie (1920–1983), and Harvey Lloyd. See Namuth to Cummings, AAA, roll 3198, frames 881–82; Guggenheim Fellowship application; Namuth to Karim Sednaoui, March 30, 1974, Namuth Collection, CCP. Lillian Bassman, interviewed by the author, February 27, 1998, confirmed that she frequently substituted for Brodovitch and that she was instrumental in getting the Radkais to host classes. Richard Avedon to the author, April 16, 1998, confirmed that while his studio was the prime location of Brodovitch's classes, other studios were used from time to time.

109. Hans Namuth, "Untitled Statement." Numerous letters in the Namuth Collection, CCP, indicate that Namuth and Brodovitch remained friends until the latter's death.

110. Namuth to Cummings, AAA, roll 3198, frame 882.

111. See, for example, *Harper's Bazaar,* May 1949, p. 71; June 1949, pp. 29–32; July 1949, pp. 16–19; August 1949, p. 92; September 1949, pp. 134–39; November 1949, pp. 84–95; July 1950, pp. 16–17, 89, 97; August 1950, pp. 84–88; September 1950, pp. 152–59; October 1950, pp. 28, 116–26, 250–54, 256; March 1952, pp. 104–5 and p. 215; April 1952, p. 211. After this last date, Namuth's *Harper's Bazaar* commissions were primarily for portraits.

112. Namuth to Cummings, AAA, roll 3198, frames 882–83. Of his work with children he said, "Back in 1950, I actually coined the approach in children's fashions which is widely accepted now, but which at that time was still very revolutionary. I wanted children to be themselves instead of posing them in stiff poses. I took them out of doors. I spoke to them. I made them play games, and while they were forgetting they were being photographed, I photographed them. The pictures that came out of these sessions were very alive and very spontaneous instead of stilted." "Job Assignments for 1954, 1955, and 1956," Namuth Collection, CCP, lists, for example, the following commercial commissions: Ronson Lighters for the Weintraub Agency, Arbuck Furniture, Ford Motor Company, Saturday Evening Post for the Pix Corporation, Ellen Beth Dress Company, Shell Oil of Canada, Yale Truck Lift for Ruthoff and Ryan, Acrilan for Doyle, Dane and Berback [*sic*], and El Producto Cigars.

113. Namuth to Cummings, AAA, roll 3198, frames 883–84. Namuth wrote about his first meeting with Pollock and his experience photographing him in Hans Namuth, "Photographing Pollock," in *Pollock Painting,* photographs by Hans Namuth; edited by Barbara Rose; with essays by Hans Namuth, Francis V. O'Connor, Rosalind Krauss, Paul Falkenberg, William Wright, and Barbara Rose (New York: Agrinde Publications, 1980), n.p. In Namuth to Sednaoui, March 30, 1974, Namuth claims that he introduced Brodovitch to Pollock, suggesting that Brodovitch knew the work, but not the artist. See also Steven Naifeh and Gregory White Smith, *Jackson Pollock: An American Saga* (New York: Clarkson N. Potter, 1989), pp. 585–86; Namuth to Leta K. Stathacos, August 31, 1984, Namuth Collection, CCP.

114. The literature discussing these photographs and the occasion of their making is extensive and includes (in addition to Namuth, "Photographing Pollock"): Pepe Karmel, "Pollock at Work: The Films and Photographs of Hans Namuth," in Kirk Varnedoe with Pepe Karmel, *Jackson Pollock* (New York: Museum of Modern Art, 1999) pp. 87–137; Francis V. O'Connor, "Hans Namuth's Photographs of Jackson Pollock as Art Historical Documentation," *Art Journal* 39, no. 1 (fall 1979): 48–49 (also in *Pollock Painting*); Barbara Rose, "Hans Namuth's Photographs and the Jackson Pollock Myth, Part One: Media Impact and the Failure of Criticism," *Arts* 53 (March 1979): 112–16 (also in *Pollock Painting*); Naifeh and Smith, *Pollock,* pp. 618ff.; Jeffrey Potter, *To a Violent Grave: An Oral Biography of Jackson Pollock* (New York: G. P. Putnam's Sons, 1985), pp. 128–29ff.; B. H. Friedman, *Jackson Pollock: Energy Made Visible* (New York: McGraw-Hill, 1972), pp. 160–66ff.; Ellen G. Landau, *Jackson Pollock* (New York: Harry N. Abrams, 1989), pp. 182–83.

115. "Jackson Pollock: Is He the Greatest Living Painter in the United States?" *Life,* August 8, 1949, p. 45; Helen A. Harrison, letter, *New York Times,* April 26, 1998, p. 46.

116. O'Connor, "Hans Namuth's Photographs."

117. Namuth, "Photographing Pollock."

118. Inge Bondi, "Some Relationships between Photography and Artists," *Journal of the Archives of American Art* 9, no. 2 (April 1969): 13, quotes Namuth on the circumstances of this painting. "I had been very ill. I had an operation and almost died. I came out of the hospital still weak, and I had a new camera, a Linhof, clumsy and unwieldy, my first big camera. I took it over to Pollock to try it out. Pollock loved old Fords. He crossed the country in different models several times. When I got the picture, I knew immediately what I had got." Bondi dates this photograph to 1952; the estate dates it to 1950. Here, as elsewhere, I have accepted the dating of the estate,

when no additional evidence provides conclusive proof of an alternative date. This photograph was published in Clement Greenberg, "Jackson Pollock's New Style," *Harper's Bazaar,* February 1952, p. 175. Given the time lapse that usually occurred between the making of an image and its publication, it is likely that this photograph was taken no later than 1951. This photograph also served as the cover for the Pollock memorial issue of *Evergreen Review* 1, no. 3 (fall 1957).

119. Landau, *Pollock,* pp. 17–18; Naifeh and Smith, *Pollock,* pp. 575–76.

120. Namuth, "Photographing Pollock." For an overview of Steichen's photographic preferences during the time that he was curator of photography at the Museum of Modern Art, see Christopher Phillips, "The Judgment Seat of Photography," *October* 22 (fall 1982): 27–63. Steichen, who preferred traditional photojournalism with subject matter that readily communicated to broad masses of people, never changed his mind about Namuth's work. He did not give him a solo exhibition, nor did he include him in his landmark 1955 exhibition "The Family of Man." As Phillips points out, pp. 53ff., John Szarkowski, Steichen's successor, had no interest in continuing Steichen's emphasis on photography as a social instrument and preferred instead to focus on the medium's aesthetic nature. However, he never purchased any Namuth photographs for the museum's permanent collection. The several Namuth photographs in the archives of the photographic department, in addition to those in the Varian Fry album, are gifts.

121. "Jackson Pollock," *Portfolio: The Annual of the Graphic Arts* (Cincinnati: Zebra Press, 1951), n.p.

122. Robert Goodnough, "Pollock Paints a Picture," *Art News,* May 1951, pp. 38–41ff. In March 1952, the photographs of Pollock painting appeared as part of an exhibition of Pollock's work in France at the Studio Paul Facchetti. See Naifeh and Smith, *Pollock,* p. 681.

123. Harold Rosenberg, "The American Action Painters," *Art News,* December 1952, pp. 22–23 and 48–50. See also Naifeh and Smith, *Pollock,* pp. 701–5, and Rose, "Hans Namuth's Photographs and the Jackson Pollock Myth: Part One."

124. Harold Rosenberg, *The Intrasubjectives* (New York: Samuel Kootz Gallery, September 14–October 3, 1949).

125. Namuth, "Pollock Painting." For the chaos that pervaded Pollock's life beginning about January 1951, see Naifeh and Smith, *Pollock,* pp. 656ff.

126. Numerous monographs on artists who were prominent in the 1950s and early 1960s describe the social as well as professional interrelationships between the various artists who lived in New York and summered on eastern Long Island. An overview of these relationships is provided by John Gruen, *The Party's Over Now: Reminis-cences of the Fifties—New York's Artists, Writers, Musicians, and Their Friends* (reprint, New York: Viking Press, 1978). Interviews by the author with longtime Springs residents David Porter, Barbara Hale, and Ruth Nivola, September 30, 1997, as well as with East Hampton resident Jeffery Potter, September 23, 1997, and former area resident Peter Blake, September 17, 1987, all described a social scene in the 1950s, of which the Namuths were a part, that was fluid, open, and quite jolly. The parties given by Hans and Carmen, noted for good food, good wine, and good conversation, remain vivid in the memories of their friends.

127. Namuth, "Photographing Pollock"; Namuth to Cummings, AAA, roll 3198, frames 886–87. For an overview of the relationship of these individuals to Jackson Pollock and to each other, see Naifeh and Smith, *Pollock,* pp. 506ff. According to the "Inventory of Portrait Photographs—Artists" and "Inventory of Portrait Photographs—Non-Artists," Namuth Collection, CCP (hereafter Namuth: Inventory of Portraits), Namuth photographed these artists in the following years: James Brooks (with Pollock in 1950, and solo in 1962, 1975); Constantino Nivola (1952, 1954, 1955, 1956, 1960, 1961, 1962, 1963, 1964, 1965, 1967, 1971, and 1972); Clement Greenberg (1950 and 1963); Franz Kline (1954); John Little (1952, 1954, 1972, 1973, and 1990); Conrad Marca-Relli (1958, 1964, and 1982); Barnett Newman (1951 and 1952); Alfonso Ossorio (1952, 1962, 1967, 1969, and 1971); and Tony Smith (with Pollock and Newman in 1952 and solo in 1971).

128. Namuth to Cumming, AAA, roll 3198, frame 883; Hans Namuth, interview with Michael Auping, September 27, 1986. I wish to thank Michael Auping for graciously providing me with a copy of this interview. Namuth never again photographed Still, although in the summer of 1955 the artist and his daughter lived in East Hampton in a cottage on Alfonso Ossorio's estate, the Creeks, which the latter had purchased in 1952 from the family of artist Albert Herter. See John P. O'Neill, *Clyfford Still* (New York: Metropolitan Museum of Art, 1979), p. 193.

129. Hans Namuth, "Introductory Statement," *Fifty-two Artists: Photographs by Hans Namuth* (Scarsdale: Committee for the Visual Arts, 1973), n.p.

130. Namuth interview with Auping, September 27, 1986; Namuth, "Photographing Pollock."

131. Leo Castelli, interviewed by the author, March 20, 1997. Similar sentiments were expressed to the author by Jim Dine, interviewed on March 12, 1997; George Segal, interviewed on March 12, 1997; Julian Schnabel, interviewed on March 26, 1977; James Rosenquist, interviewed on March 28, 1997; Roy Lichtenstein, interviewed on March 28, 1977.

132. Diane Waldman, *Willem de Kooning* (New York: Harry N. Abrams, 1988), pp. 146–47; Judith Wolfe, "Glimpses of a

Master," in *Willem de Kooning: Works from 1951–1981* (East Hampton: Guild Hall Museum, May 23–July 19, 1981), p. 7; Lee Hall, *Elaine and Bill: Portrait of a Marriage* (New York: HarperCollins, 1993), pp. 161–64.

133. Clement Greenberg, "Art," *The Nation,* April 24, 1948, p. 448; Henry McBride, "Abstract Report for April," *Art News,* April 1953, p. 18; "Big City Dames," *Time,* April 6, 1953, p. 80; "Exhibition at Sidney Janis Gallery," *New Yorker,* April 4, 1953, p. 96. The de Kooning exhibition appeared at the Janis Gallery from March 16 to April 11, 1953.

134. In the relatively few images taken by Namuth of Pollock with his wife, Krasner usually appears reticent or demure. See, for example, Landau, *Pollock,* pp. 17, 157. On p. 261, n. 13, Landau also states that Krasner never went to Pollock's studio without an invitation from him. The photograph on p. 17, which shows Krasner in the studio, represents a rare occasion, one that was probably arranged specifically for the photographic session. See also Namuth to Stathacos, August 31, 1984, in which the photographer wrote, "I believe that even Lee Krasner . . . rarely, if ever, was present when her husband worked."

135. Wolfe, *Willem de Kooning,* p. 8. This catalogue contains several photographs taken August 23, 1953. I wish to thank Judith Zilczer, curator of painting and sculpture at the Hirshhorn Museum and Sculpture Garden, who confirmed that the painting in this photograph was either painted over or destroyed.

136. Hall, *Elaine and Bill,* pp. 185ff.

137. This photograph was used, for instance, as a primary illustration accompanying Willem de Kooning's obituary in the *New York Times,* Thursday, March 20, 1997, A36.

138. After 1953, Namuth photographed de Kooning in 1962, 1968, 1969, 1971, 1974, 1979, 1980, 1981, and finally in 1983, the year of de Kooning's important retrospective at the Whitney Museum of American Art, New York (December 15, 1983–February 26, 1984).

139. After his initial session in 1953, Motherwell was photographed by Namuth in 1958, 1968, 1972, and 1982 (Namuth: Inventory of Portraits).

140. Phil Patton, "Robert Motherwell: The Mellowing of an Angry Young Man," *Art News,* March 1982, pp. 70–77.

141. For a recent overview of Robert Motherwell's career and contribution to the history of American art, see Dore Ashton, "Motherwell: The Painter's Life as a Banquet," in *Motherwell* (Barcelona: Fundació Antoni Tàpies, 1996), pp. 15–45. When Motherwell married his second wife, artist Helen Frankenthaler, in 1958, Namuth took the wedding photographs. While they follow a traditional format—the bride and groom emerging from the ceremony, eating cake, being showered by rice, etc.—Namuth's photographs transcend the ordinary to capture the inner happiness radiating from this dynamic young couple. Although the two divorced in 1971, Namuth remained lifelong friends with both of them.

142. Without additional evidence, it is difficult to determine whether the Namuth Collection at the Center for Creative Photography possesses archival images of these individuals. Early photographs may be misdated. Namuth: Inventory of Portraits lists the following photographic sessions for artists not cited in previous footnotes: Alexander Brook (1962), Enrico Donati (1953), Justine Fuller (1953), Caroline Gordon (none listed), Balcomb Greene (1953, 1954, 1975, 1980), Buffie Johnson (1952, 1955), Gina Knee (1953, 1962), Guitou Knoop (1953, 1954, 1962, 1964, 1970, 1971), Lee Krasner (1950, 1951, 1957, 1962, 1964, 1970, 1971), George Sakier (1952, 1958, 1971, 1977), Saul Steinberg (1950, 1952, 1962, 1963, 1965), Gerald Sykes (1952, 1959, 1965), Allen Tate (1952, 1953), and Wilfrid Zogbaum (1950, 1953).

143. Namuth photographed Stamos in 1951 and 1956, Goldberg in 1959, and Porter in 1952 and 1954 (Namuth: Inventory of Portraits).

144. The drawing that Lindner presented to Namuth now belongs to the German artist Paul Wunderlich (Judith Zilczer to the author, April 17, 1998). Lindner's history before he came to America is similar to Namuth's. As a German living in France, he was interned in the Sports Palace in 1939, was placed in a camp near Blois, and immigrated to America with the assistance of the Emergency Rescue Committee (Judith Zilczer, *Richard Lindner* [Munich and New York: Prestel, 1977], p. 35, nn. 12–36). Ruth Nivola, interviewed by the author, September 30, 1997, said that her husband, Lindner, and Steinberg were part of a group that frequently met in New York at the Italian restaurant Del Pezzo. German-born photographer and longtime Namuth friend Evelyn Hofer, interviewed by the author, March 3, 1997, said this was where she first met the photographer.

145. Sam Hunter, *Larry Rivers* (New York: Harry N. Abrams, 1969), p. 46. In addition to these two sessions in 1959 and 1965, Namuth photographed Rivers in 1955, 1970, 1978, 1980, and 1989 (Namuth: Inventory of Portraits).

146. For information related to Namuth's photographs taken for the United States Pavilion at the 1958 Brussels World's Fair, see Namuth Papers, AAA, box 1. In addition to those named in the text, James Boynton, Lawrence Calcagno, Nicolas Carone, Jimmy Ernst, Sonia Gechtoff, Grace Hartigan, Ellsworth Kelly, William Kienbusch, Conrad Marca-Relli, George Mueller, Kyle Morris, and Bernard Perlin were photographed by Namuth. Of this group, Namuth rephotographed only Calcagno (1963), Diebenkorn (1982), Kelly (1983, 1984), Marca-Relli, and Motherwell (Namuth: Inventory of Portraits).

147. For a recent overview of Lee Krasner's career, see Robert Hobbs, *Lee Krasner* (New York: Abbeville Press,

1993) and Ellen G. Landau, *Lee Krasner: A Catalogue Raisonné* (New York: Harry N. Abrams, 1995), pp. 10–16. Rose, "Hans Namuth's Photographs and the Jackson Pollock Myth: Part One," n. 1, points out that the large scale "inherent" in Krasner's style emerged only when she moved into Pollock's studio.

148. Namuth to Cummings, AAA, roll 3198, frames 886–87; Naifeh and Smith, *Pollock,* pp. 587ff. Namuth and Blake remained in contact for well over a decade. In 1950 Namuth listed Blake as a reference on his Guggenheim Fellowship application, and in the spring of 1958, he had him design the modifications to his studio at 157 West 54th Street (Namuth to Blake, January 18, 1965; Namuth to Benjamin Falk, April 27, 1962; Namuth to Renata Gobel, January 21, 1985, all Namuth Collection, CCP). Namuth moved to this studio in late December 1957, after having shared a studio space with painter George Sakier (Namuth Appointment Diary 1957, Namuth Collection, CCP). Blake also remodeled the modest Water Mill farmhouse that Namuth bought in 1952, adding a kitchen and family room in the late 1950s (Blake to Namuth, April 14, 1958, Namuth Collection, CCP). Between 1952 and 1965, Namuth photographed nine houses designed by Peter Blake in addition to his other architectural work.

Blake, who was born in Berlin in 1920, immigrated to America via England in 1940. Like Namuth, he was in military intelligence during World War II, albeit not the same unit or the theater of operation as Namuth, although they both trained at Camp Ritchie. After the war Blake served as a curator of architecture and design at the Museum of Modern Art from 1948 to 1950. From 1950 to 1972 he held various editorial positions at *Architectural Forum.*

149. Blake to the author, September 17, 1997.

150. Namuth, "Untitled Statement." Although Namuth's oeuvre is dominated by portraiture, he nevertheless continued to be sufficiently interested in issues of architecture and design to photograph houses throughout his career. In Namuth to Cummings, AAA, roll 3198, frames 887–89, the photographer spoke at length about his interest in architectural photography: "I have always been interested in design and architecture. I've always felt it was a challenge, and to this day . . . I give a great deal of my time to architectural photography." He also enjoyed the fact that each house posed a different problem. "In fact, I welcome that. I don't like routine assignments. As I usually forget what I did the last time, everything is a new experience and a new, agonizing challenge." For Namuth there were only two or three ways to photograph a building. "You can easily distort it to make it ugly or you can redesign it in a way by choosing the best possible moment of the day, the best light, the best angle. I think that the honest way is always the best way, no tricks, no gimmicks." For architectural

work, Namuth usually used a 4 x 5″ view camera, although the 8 x 10″ remained his favorite for this purpose. "There is something exquisite about working on that large ground glass . . . [where] every shot counts." In addition to his work with Blake, Namuth's credit line appears beside architectural and interior photographs in *Vogue* in the early 1960s, in the *New York Times* during both the 1960s and 1970s, and in *Architectural Digest* in the 1980s. See, for example, "Private Lives—with Art," *Vogue,* January 15, 1964, pp. 86–95 (featuring the collections of Mr. and Mrs. William A. M. Burden, Helen Frankenthaler and Robert Motherwell, and Mrs. and Mrs. Clement Greenberg); "Everything We Want from a House," *Vogue,* February 1, 1961, pp. 198–205 (the Robert Osborn house); "A Home Moves to a Family," *New York Times Magazine,* August 7, 1960, pp. 48–49; "Factory into Home," *New York Times Magazine,* April 8, 1962, pp. 110–11.

151. Blake to the author, September 17, 1997.

152. "The Grand Old Men of Modern Architecture," *Harper's Bazaar,* June 1952, pp. 68–71. A head-only shot from this sitting accompanied the article "Gropius Appraises Today's Architect," *Architectural Forum* 96 (May 1952): 111. The Miró mural commissioned by the Harvard Corporation for the Harkness Commons is now in the collection of the Museum of Modern Art. See Carolyn Lanchner, *Joan Miró* (New York: Museum of Modern Art, 1994), p. 426, cat. no. 191.

153. Namuth to Cummings, AAA, roll 3198, frame 887; "They Raised the Roof in New Canaan," *Holiday,* August 1952, pp. 48–53. Zachary was art editor at *Holiday* from 1953 to 1963, and during his tenure Namuth received frequent portrait assignments. After Zachary left, Namuth's assignments became more sporadic, ceasing altogether about 1967. Zachary owned a home in Amagansett in the 1950s and 1960s and knew Namuth socially. Frank Zachary, interviewed by the author, February 27, 1998, said he selected photographers to fit the subject, using Arnold Newman, Bill Brandt, and the whole Magnum group as was appropriate. He remembered Namuth as "terribly positive, always with a smile, good natured, and good company."

154. Namuth, in "Pollock Painting," n.p., claims that he met Breuer when the architect collaborated with Blake on the design of a glass model of a museum for Pollock's paintings. Naifeh and Smith, *Pollock,* make no mention of Breuer's involvement with Blake's glass museum, although Blake and Breuer clearly knew each other. In December 1949, Blake took Breuer to Pollock's show at the Parsons Gallery, following which Breuer commissioned a mural from Pollock for the Bertram Geller house (ibid., p. 600). Breuer houses dot the East Hampton and Connecticut landscapes and Namuth's diary indicates that as late as 1966 he received commissions to photograph them for the *New York Times* and *House*

Beautiful (Namuth Appointment Diary 1966, October 10, November 15, and December 22, Namuth Collection, CCP).

155. Peter Blake, "Eero Saarinen: Master Builder," *Harper's Bazaar,* September 1954, pp. 230–31. A variant of the Saarinen portrait subsequently appeared in "Old Hands at Odd Shapes," *Life,* March 14, 1955, p. 82. Namuth was commissioned by *Architectural Forum* to photograph Saarinen's recently completed arch for St. Louis, Missouri, but no portrait of the architect was included in the essay on the architect (*Architectural Forum* 128 [June 1968]: 33–37). Namuth Appointment Diary 1954, Namuth Collection, CCP, shows that Namuth photographed Saarinen on June 24. Namuth also received a commission from *Harper's Bazaar* to photograph Paul Rudolph. The session, according to Namuth's Appointment Diary, took place on June 9, 1954. Namuth Appointment Diary 1955, Namuth Collection, CCP, indicates that he again photographed Paul Rudolph for *Holiday* on February 7. But neither commission appears to have been published in either *Harper's Bazaar* or *Holiday.*

156. *Harper's Bazaar,* October 1959, pp. 182–83; Namuth Appointment Diary 1959, Namuth Collection, CCP; Robert W. Marks, *New York Times Magazine,* August 23, 1959, p. 14.

157. Namuth Appointment Diary 1958, Namuth Collection, CCP. It appears that *Holiday* never published this or any other Wright photograph from this session.

158. Namuth: Inventory of Portraits; Blake to the author, September 17, 1997.

159. Among the architects in Namuth's portrait pantheon, some of whom he photographed repeatedly, are Peter Blake (1950, 1952, 1954, 1955, 1957, 1958, 1959, 1960, 1962, 1965); Marcel Breuer (1952, 1959, 1961); Gordon Bunschaft (1963); Peter Eisenman (1990); James Ingo Freed (1986); Buckminster Fuller (1959); Michael Graves (1981); Walter Gropius (1952); Helmut Jahn (1986); Philip Johnson (1953, 1956, 1965, 1986, 1987, 1988); Louis Kahn (1965, 1972); Ludwig Mies van der Rohe (1965); Manolo Nuñez (1990); Nathaniel Owings (1965); I. M. Pei (1952, 1957, 1965, 1986); Paul Rudolph (1954, 1965, 1967); Eero Saarinen (1954); José Luis Sert (1963); Robert A. M. Stern (1983); Edward Durrell Stone (1962, 1965); Pedro Ramirez Vasquez (1966); John Carl Warneke (1965, 1983); Harry Weese (1965); Paul Wiener (1953, 1959); Jean-Michelle Wilmotte (1990); Frank Lloyd Wright (1954, 1958); Minoru Yamasaki (1965) (Namuth: Inventory of Portraits).

160. Philip Jodidio, "Philip Johnson," *Connaissance des Arts,* February 1987, p. 64; *Connaissance des Arts,* cover, July/August 1988.

161. Henry Russell Hitchcock and Philip Johnson, *The International Style: Architecture since 1922* (1932; reprint, New York: W. W. Norton, 1995). Johnson was curator of architecture at the Museum of Modern Art from 1930 to 1936 and again from 1946 to 1954.

162. Philip Johnson and Mark Wigley, "Deconstructivist Architecture," Museum of Modern Art, June 23–August 30, 1988. For a review of this exhibition, see Steven Holt and Michael McDonough, *Art News,* summer 1988, pp. 79–80. For an overview of Johnson's late career, see Diana Ketcham, "'I'm a whore': Philip Johnson at Eighty," *New Criterion* 5, no. 4 (December 1986): 54–67.

163. Although Brodovitch resigned as art director of *Harper's Bazaar* in 1958, the magazine continued to commission work from Namuth through about 1963. Among the portraits commissioned by or published in *Harper's Bazaar,* not otherwise mentioned in the text, are Jackson Pollock, February 1952, p. 175; André Malraux and Mrs. Malraux, and Edward Hopper, March 1954, pp. 154–57; Eleanor Barry Lowman, May 1954, p. 169; Robert Stephens, January 1959, p. 147; Buckminster Fuller, Frederick Kiesler, October 1959, p. 183; and Igor Oistrakh, November 1963, p. 169.

Holiday frequently used Namuth's portraits to illustrate the "Antic Arts" column. A selected list of portraits commissioned by *Holiday,* not otherwise mentioned in the text, includes Dave Garroway, February 1955, p. 14; Clifton Fadiman, December 1956, p. 6; Judy Holliday, March 1957, p. 111; Perry Como, March 1957, p. 113; Alistair Cooke, April 1957, p. 43; Charles Van Doren, May 1957, p. 115; Julie Andrews, June 1957, p. 119; Faye Emerson, September 1957, p. 37; Mike Wallace, November 1957, p. 119; Bert Lahr, February 1959, pp. 60, 61; Milton Berle, February 1958, p. 97; Anthony Perkins, May 1958, p. 111; Margaret O'Brien, March 1959, p. 111; John Huston, May 1959, p. 111; Joanne Woodward and Paul Newman, July 1959, p. 91; Thelma Ritter, March 1960, p. 115; Phil Rizzuto, July 1960, p. 89; Art Carney, November 1960, p. 125; Edward Albee, September 1961, p. 89; Jimmy Durante, January 1962, p. 113; Tammy Grimes, February 1962, p. 99; Vittorio de Sica, March 1962, p. 143; Anthony Quinn, May 1962, p. 123; Sidney Poitier, June 1962, p. 103; Jackie Gleason, December 1962, p. 131; Gower Champion, February 1965, p. 87; Sandy Dennis, March 1965, p. 131; Leo Castelli and family, June 1965, p. 95. His last portraits for *Holiday* included Leo Castelli, Jasper Johns, Willem de Kooning, Marisol Escobar, Larry Rivers, Alexander Calder, George Segal, and Richard Anuszkiewicz. These images accompanied the article by Harold Rosenberg, "From Pollock to Pop: Twenty Years of Painting and Sculpture," *Holiday,* March 1966, pp. 96–104.

164. For Namuth's work in *Vogue,* see n. 150. According to Namuth's Appointment Diary 1954, Namuth Collection, CCP, he photographed Ava Gardner for *Cosmopolitan* on September 29, 1954. He photographed a bust of Alexander Hamilton for the article by K. Hamill, "Was Hamilton the First Keynesian?" *Fortune,* August 1957,

pp. 128–29. His photographs of David Rockefeller, Leigh Block, George Struthers, and Vincent Price appeared in the essay by Charlotte Willard, "The Corporation as Art Collector," *Look,* March 23, 1965, pp. 67–72.

165. William Backhaus, *Harper's Bazaar,* July 1954, p. 43; Arnold Gamson, *Harper's Bazaar,* January 1959, p. 147; and Gian Carlo Menotti, *Harper's Bazaar,* February 1955, p. 138. Namuth Appointment Diary 1954, Namuth Collection, CCP, shows that Menotti was photographed on August 13. Namuth published another image of Menotti in *Holiday,* June 1963, p. 101.

166. *Holiday,* February 1959, p. 91.

167. William K. Zinsser, "On Stage: Stephen Sondheim," *Horizon,* July 1961, pp. 98ff. Namuth Appointment Diary 1960, Namuth Collection, CCP, shows that the portrait was taken the previous November. Sondheim met Namuth for the first time on the day of the shoot and never since. See Sondheim to Fred Ulrich, curatorial assistant, July 30, 1997. The published version of the photograph is cropped significantly, compared to the version Namuth kept for his own collection.

168. Jill Johnston, "Happenings: A Cast of Characters," *Harper's Bazaar,* August 1963, pp. 124–25. In addition to Cage, this composite photograph featured Robert Dunn, Philip Corner, Jackson MacLow, Jasper Johns, Morton Feldman, Merce Cunningham, Allan Kaprow, Robert Rauschenberg, David Tudor, and Robert Morris.

169. *Time,* April 13, 1962, p. 55.

170. Jerome Robbins to Fred Ulrich, August 12, 1997, in response to a query about the sitting, replied, "1978 is too far behind me now to have any memories. I remember sitting for him but can't remember where or why. I met him out in Bridgehampton, New York." For Namuth's habit of visiting artists and taking their portraits without a specific assignment, see Jim Dine, interview with the author, March 12, 1997, and Julian Schnabel, interview with the author March 26, 1997.

171. Namuth's Appointment Diaries 1956 and 1962, Namuth Collection, CCP, show, for example, that in 1956 he photographed authors Helen MacInnes, Jessamyn West, and Anselm Burns. A portrait of Niccola Tucci was taken in 1962.

172. No absolute proof is available to contradict the dating of this photograph by the Namuth estate to 1952. But if the date is accurate, Namuth's portrait of Tate was taken after the author had assumed a teaching position at the University of Minnesota. This date thus suggests that Namuth either traveled to Minnesota for the portrait session (unlikely), or that Tate had briefly returned to New York. It is entirely possible that this is the photograph of Tate to which Namuth refers in his 1950 Guggenheim Fellowship application.

173. Namuth to Tate, May 6, 1948; Namuth to Tate, February 23, 1950, Allen Tate Papers, Department of Rare Books and Special Collections, Princeton University Library, Princeton, New Jersey. For Tate's paragraph for this small brochure, see *Recent Work by Buffie Johnson* (March 27–April 15, 1950), Betty Parsons Papers, AAA, roll N68–65, frames 526–37, introduction frame 527. For Tate's photograph of Namuth, see "New Members," *Infinity: American Society of Magazine Photographers,* July 1951, p. 2. Florence Reiff, wife of Hal Reiff, Namuth's last employer before he left for military service, interviewed by the author, March 11, 1998, stated that early meetings of the society were held in the studios of Price Picture News at 10 West 47th Street. Reiff may have encouraged Namuth's participation, although Namuth may have been motivated to join this organization because of his recent success with fashion and advertising photography.

174. Namuth to Cummings, AAA, roll 3198, frames 890–91. "The Housatonic," *Horizon,* May 1960, pp. 10–29 (Cowley portrait, p. 22). This essay also included Namuth portraits of Norman Rockwell, Ted Shawn, William Styron, Louis Untermeyer, and James Thurber. Namuth Appointment Diary 1959, Namuth Collection, CCP, shows that he took the portraits of Styron and Cowley in September. Although Namuth kept a black-and-white print for his personal collection, the original photograph was taken as a color slide.

175. "In Quest of America," *Holiday,* July 1961, p. 26; John Steinbeck, *Travels with Charley: In Search of America* (New York: Viking Press, 1962), p. 9; Steinbeck is quoted in Jackson J. Benson, *The True Adventures of John Steinbeck, Writer* (New York: Viking Press, 1984), p. 897.

176. An image of Liebling and Stafford from the same sitting is featured in William K. Zinsser, "Far Out on Long Island," *Horizon,* May 1963, pp. 4–27. Other Namuth portraits in this article include those of actors Eli Wallach and Anne Jackson; dancer Gwen Verdon; artists Alexander Brook, Lee Krasner, Constantino Nivola, Jane Wilson, and Saul Steinberg; architects Peter Blake, Gordon Bunschaft, and Edward D. Stone; clarinetist David Oppenheim; cartoonist Charles Addams; guitarist Carlos Montoya; and authors Marya Mannes and Helen MacInnes, the latter with professor Gilbert Highet.

177. Namuth often took personal pictures along with the shots for magazines. James Rosenquist, interview with the author, March 28, 1997, said that during his first photography session with Namuth, he also took pictures of his then-girlfriend, who later became his wife. Similarly, Jim Dine, interview with the author, March 12, 1987, said that Namuth took photographs of his son when he was five years old as a favor to him, and that he later used an image from this sitting as the basis of several works.

178. Wilfrid Sheed, quoted in David Roberts, *Jean Stafford: A Biography* (Boston: Little, Brown and Company, 1988), p. 335.

179. Namuth Appointment Diary 1963, Namuth Collection, CCP. Namuth also photographed O'Hara in 1962 (Namuth: Inventory of Portraits).

180. E. B. White, quoted in Paul L. Montgomery, "John O'Hara, the Novelist, Dies in His Sleep at 65," *New York Times,* April 12, 1970, sec. 1, p. 88, col. 1.

181. Peter Lynn, "The Antic Arts: The Amazing Bobby Fischer," *Holiday,* May 1963, p. 125. Namuth Appointment Diary 1963, Namuth Collection, CCP.

182. Namuth began to arrange the sitting with Albee, which took place on June 4, 1980, as early as May 17 (Namuth Appointment Diary 1980, Namuth Collection, CCP). Namuth photographed only two writers after 1980: author William Styron (1983) and poet Cynthia McDonald (1989) (Namuth: Inventory of Portraits).

183. Namuth Appointment Diary 1980; "I Am the Lady from Dubuque . . . ," *New York Times,* January 27, sec. 2, p. 1, col. 5.

184. In addition to this 1980 sitting, Namuth photographed Albee in 1960, 1961, 1963, and 1965 (Namuth: Inventory of Portraits).

185. Brian O'Doherty, *American Masters: The Voice and the Myth,* photographs by Hans Namuth (New York: Random House, A Ridge Press Book, 1973).

186. Brian O'Doherty, interview with the author, March 31, 1998.

187. Hans Namuth to Ben Shahn, December 30, 1964, Shahn Papers, AAA, roll 5012, December 30, 1964. I wish to thank Howard S. Greenfeld for this letter documenting Namuth's visit to the artist.

188. Caroline A. Jones, *Machine in the Studio: Constructing the Postwar American Artist* (Chicago and London: University of Chicago Press, 1996), p. 20. For a broader discussion of the role of the studio in Abstract Expressionism, see pp. 1–113.

189. O'Doherty to the author, March 31, 1998.

190. O'Doherty, *American Masters,* pp. 58, 61, and 63.

191. O'Doherty to the author, March 31, 1998.

192. For biographical information on Rothko and the time he spent in the East Hampton area, see James E. B. Breslin, *Mark Rothko: A Biography* (Chicago and London: University of Chicago Press, 1993), pp. 379ff. From time to time, different published dates have accompanied the photograph taken in Amagansett. The original slide from the session is dated August 24, 1964. The transparency made from the slide is dated May 1977. See Namuth Collection, CCP.

193. O'Doherty to the author, March 31, 1998.

194. O'Doherty to the author, March 31, 1998. Namuth photographed Rauschenberg in 1963, 1964, 1965, 1969, 1970, and 1971 (Namuth: Inventory of Portraits).

195. See Joseph Cornell Papers, AAA, roll 1056, frames 586, 591, 592, 658, 659, 678, 716, 717, 718, 719, 1054, and 1055; also roll 1055, frames 148, 150, 151, 152, and 153. In addition to those cards mentioned in the text, Namuth sent Cornell a photograph of his children and a card of Joachim Patinir's *Saint John the Baptist Preaching* from the Metropolitan Museum of Art.

Namuth must have seen Cornell's correspondence, objecting to the way he had been portrayed by David Bourdon, in "Enigmatic Bachelor of Utopia Parkway," *Life,* December 15, 1967, pp. 63ff. I wish to thank Stephanie Taylor for bringing the *Life* article to my attention. For a discussion of the impact of this essay on Cornell, see Deborah Solomon, *Utopia Parkway: The Life and Work of Joseph Cornell* (New York: Farrar, Straus and Giroux, 1997), pp. 334–35.

196. O'Doherty, *American Masters,* p. 281. In "Interview," n.d., Namuth Collection, CCP, the photographer described the circumstances of his last encounter with Cornell: "From time to time, I took him in my car to Westhampton, Long Island, to visit one of his two sisters. One day, we found the house door locked. While waiting for his sister's return, we went to the beach. He was impatient. The drive from the city had worn him out. That day, one year before he died, I photographed him as if it were to be the last time that we would see each other." A variant of this statement appears in Jain Kelly, ed., *Darkroom2* (New York: Lustrum Press, 1978), p. 82. Namuth also refers to his experience photographing Cornell in "A Portfolio of Artists' Portraits: Hans Namuth," p. 49.

197. O'Doherty to the author, March 31, 1998. Namuth was eager to incorporate more artists from the Abstract Expressionist generation. In the end, the choice of subjects remained O'Doherty's, although he distanced himself from the selection of pictures. This he left to Namuth and the art editors, Albert Squillace and Harry Brocke.

198. *Connaissance des Arts,* November 1986, p. 76; "Andrew Wyeth: The Helga Pictures," National Gallery of Art, May 24–September 27, 1987.

199. Namuth, *Fifty-two Artists.* According to Allon Schoener, interview with the author, March 21, 1998, this portfolio of photographs was distributed free to nonprofit institutions as a way of getting art to a broader public. The collaboration of Namuth and Schoener on the portfolio was clearly the impetus for Hans Namuth, "Interview with Allon Schoener," *Infinity,* December 1972, pp. 5–6.

200. Andy Grundberg, "Hans Namuth, 75, Photographer Whose Art Captured Artists, Dies," *New York Times,* October 15, 1990, sec. B7, p. 50.

201. "Namuth's Artists," *Art in America* 62 (January 1974): 116–17, cited the recent publication of *Fifty-two Artists* and reproduced five photographs from the portfolio. L. Furman, "Leo Castelli Downtown Gallery: Hans

Namuth Exhibit," *Art News,* March 1974, p. 98, citing *Fifty-two Artists* and the Namuth exhibition at Castelli's, discusses the symbiotic relationship between the photographer and the image, as well as the appropriation of identity of the artist for the photographer's own identity, an issue clearly at the heart of Namuth's work and life. Namuth received only two citations in *Art Index* prior to 1974. To locate his published work in magazines before 1974, it was necessary to know whom he photographed, and look up the references for that individual.

202. O'Doherty to the author, March 31, 1998.

203. *Art News,* April 1971, cover, and Lucy R. Lippard, "Tony Smith: Talk about Sculpture," pp. 48ff.

204. *Art News,* March 1973, cover, and Vivien Raynor, "Jasper Johns: 'I have attempted to develop my thinking in such a way that the work I've done is not me,'" pp. 20–22. For a chronology of Johns's activities during the summer of 1962, see Kirk Varnedoe, *Jasper Johns: A Retrospective* (New York: Museum of Modern Art, 1996), p. 196. In both the *Art News* cover image and in Namuth's personal variant, Johns stands over his 1972 color lithograph *Cup IV, Picasso.*

205. Mark Stevens with Cathleen McGuigan, "Jasper Johns: Super Artist," *Newsweek,* October 24, 1977, cover, and pp. 67ff. Namuth photographed Johns in 1962, 1963, 1969, 1970, 1973, 1976, 1977, 1980, 1986, 1988, 1989, and 1990 (Namuth: Inventory of Portraits).

206. Jasper Johns to the author, April 9, 1997.

207. Gerald Cantor, *Art News,* April 1974, cover, and Albert Elsen, "A Major Gift of Rodin Sculpture," pp. 28ff.; George Segal, *Art News,* February 1977, cover, and Albert Elsen, "'Mind Bending' with George Segal," pp. 34ff; Jim Dine, *Art News,* September 1977, cover, and John Gruen, "Jim Dine and the Life of Objects," pp. 38ff.; David Hockney, *Art News,* March 1978, cover, and Roy Bongartz, "David Hockney: Reaching the Top with Apparently No Great Effort," pp. 44ff. Invoices to *Art News* in the Namuth Collection, CCP, indicate that Segal was photographed in December 1974 and that Jim Dine was photographed on June 27, 1977.

208. Mark Rothko, *Art News,* January 1979, cover, and Joseph Liss, "Willem de Kooning Remembers Mark Rothko," pp. 41ff. (the Rothko cover is based on a 1964 photograph); Louise Nevelson, *Art News,* May 1979, cover, and Barbaralee Diamonstein, "Louise Nevelson: 'It Takes a Lot to Tango,'" pp. 69–72; Alex Katz, *Art News,* summer 1979, cover, and Ellen Schwartz, "Alex Katz: 'I See Something and Go Wow!'" pp. 42–47; and Red Grooms, *Art News,* September 1979, cover.

209. Namuth previously photographed Nevelson in 1959, 1960, 1967, and 1977 (Namuth: Inventory of Portraits).

210. Shusaku Arakawa, *Art News,* May 1980, cover, and Paul Gardner, "Arakawa: 'I am looking for a new definition of perfection,'" pp. 60–65; Chuck Close, *Art News,* summer 1980, cover, and Barbaralee Diamonstein, "'I'm some kind of slow-motion cornball,'" pp. 112–16; James Rosenquist, *Art News,* September 1980, cover; Romare Bearden, *Art News,* December 1980, cover, and Avis Berman, "Romare Bearden," pp. 60–67. Namuth took Bearden's portrait in October, according to the date on the color slide used for the portrait (Namuth Collection, CCP).

211. Kenneth Snelson, *Art News,* February 1981, cover, and Richard Whelan, "Kenneth Snelson: Synthesizing Art and Science," pp. 68–73; Lee Krasner and Jackson Pollock, *Art News,* December 1981, cover, and Grace Glueck, "Scenes from a Marriage: Pollock and Krasner," pp. 57–62; Robert Motherwell, *Art News,* March 1982, cover, and Patton, "Robert Motherwell," pp. 70–76; Frank Stella, *Art News,* September 1982, cover.

212. *Art News,* summer 1982, cover, and Meryle Secrest, "Leo Castelli: Dealing in Myths," pp. 66–71.

213. On November 24, 1950, *Life* magazine, ever alert to a lively story about a potentially controversial topic, commissioned staff photographer Nina Leen to photograph those who had signed a letter protesting the Metropolitan Museum of Art's policy regarding an exhibition of contemporary art. The now-famous photograph taken that day, captioned "Irascible Group of Advanced Artists Led Fight Against Show," was published in *Life,* January 15, 1951, p. 34. Of the fifteen people in this photograph, only Hedda Sterne and Bradley Walker Tomlin were not subsequently captured by Namuth's camera. With the exception of Richard Pousette-Dart (who was photographed in 1990), William Baziotes, James Brooks, Willem de Kooning, Jimmy Ernst, Adolph Gottlieb, Robert Motherwell, Barnett Newman, Jackson Pollock, Ad Reinhardt, Mark Rothko, Theodore Stamos, and Clyfford Still were all photographed by Namuth during the 1950s or early 1960s.

Among those "under the sign of Leo" whom Namuth photographed were Richard Artschwager (1988), Jasper Johns, Ellsworth Kelly, Robert Rauschenberg, James Rosenquist, Salvatore Scarpitta (1965), Richard Serra (1989), Mia Westerlund (1981), and Andy Warhol (1981). Those in Castelli's stable featured here whom Namuth did not photograph include Robert Barry, Nassos Daphnis, Dan Flavin, Cletus Johnson, Joseph Kosuth, Claes Oldenberg, Keith Sonnier, and Lawrence Weiner.

214. Leo Castelli to the author, March 19, 1997.

215. Philip Leider, in David Whitney, ed., *Leo Castelli: Ten Years* (New York: Leo Castelli, 1967). This Namuth portrait of Castelli was also featured in the catalogue *Homage to Leo Castelli* (Zurich: Galerie Bruno Bischofberger, June–September 1982), n.p., and it was reproduced as an advertisement for the Zurich exhibition in *Artforum* (summer 1982): 6–7.

216. Ellsworth Kelly, *Art News,* March 1983, cover, and Vivien Raynor, "Ellsworth Kelly Keeps His Edge," pp. 52–59. In addition to the 1983 session for *Art News,* Namuth photographed Kelly in 1958 (for the World's Fair in Brussels) and in 1984 (Namuth: Inventory of Portraits).

217. Invoices in the Namuth Collection, CCP, reveal that Namuth received the following fees for his *Art News* covers: George Segal, photographed December 1974, $225 plus expenses; Chuck Close, photographed April 16, 1980, $400 plus expenses.

218. Philip Jodidio to the author, February 23, 1998. In Jodidio to the author, March 18, 1998, the editor describes the affinity between the two: "Although we saw each other only during relatively brief visits of Hans to Paris, or my stays in New York, there was a kind of 'father and son' rapport between us. His love for contemporary art, his sense of the structured image, and indeed his enthusiasm in general were vital to me in my work."

219. Namuth to Jodidio, February 18, 1982; Namuth to Jodidio, November 17, 1982, both Namuth Collection, CCP.

220. John Russell, "L'homme qui laisse parler le modèle," *Connaissance des Arts,* January 1983, pp. 44–51. The seven portraits, most of which had been made on previous assignments (although not necessarily previously published), include Wilfredo Lam (1952), p. 45; Joseph Beuys (1980), p. 46; George Segal (1980), p. 47; Roy Lichtenstein (1977), p. 48; Frank Stella (1981), p. 49; Jim Dine (1977), p. 50; Mark Rothko (1964), p. 51. Namuth had originally suggested Calvin Tompkins's text in *Artists 1950–81* as a useful introduction to his work, but Jodidio rejected the idea. Namuth then proposed John Russell, who at the time was working with him on several films. See Namuth to Jodidio, February 18, 1982.

221. The magazine also published a selection of Namuth's Guatemalan photographs (John Russell, "Todos Santos," *Connaissance des Arts,* July/August 1988, pp. 26–31).

222. See, for example (in addition to the Namuth portraits mentioned in a previous note), Frank Stella, *Connaissance des Arts,* June 1987, cover, and p. 11; Willem de Kooning, *Connaissance des Arts,* June 1984, cover, and p. 50; David Salle, July/August 1986, p. 47; James Rosenquist, *Connaissance des Arts,* July/August 1988, p. 34; Julian Schnabel, *Connaissance des Arts,* January 1987, p. 5, and July/August 1989, p. 14; Ross Bleckner, *Connaissance des Arts,* October 1987, p. 98; Erich Fischl, *Connaissance des Arts,* November 1988, p. 127; Jeff Koons, *Connaissance des Arts,* September 1989, p. 108. French artists Louis Cane, Robert Combas, Louis Jammes, Loïc Le Groumellec, and Jean-Charles Blais were featured in *Connaissance des Arts,* April 1990, pp. 77–83.

223. Philip Jodidio, "Les U.S.A. Face à l'Art," *Connaissance des Arts,* October 1990, pp. 108–38.

224. Russell, "L'homme qui laisse parler le modèle," pp. 44–51. This elegant image of George Segal was taken in 1980, but it had not been previously published by a major art magazine. A variant from this session appeared, however, in Arlene Bujese, ed., *Twenty-Five Artists* (Frederick, Md.: University Publications of America, 1982). Namuth photographed Segal on eight occasions: 1965, 1967, 1969, 1971, 1976, 1979, 1980, and 1990 (Namuth: Inventory of Portraits). Namuth's September session with Segal to photograph the artist's sculpture for a forthcoming book was his last scheduled appointment with an artist (Namuth Appointment Diary 1990, Namuth Collection, CCP).

225. George Segal, interviewed by the author, March 12, 1997.

226. This attitude, pervasive among the generation that emerged after the Abstract Expressionists, was best articulated by Robert Rauschenberg when he said, "Painting relates to both art and life. Neither can be made. (I try to act in that gap between the two.)" See Rauschenberg, quoted by John Cage, "On Robert Rauschenberg, Artist, and His Work," in Ellen Johnson, *American Artists on Art* (New York: Harper and Row, 1982), p. 82.

227. Philip Jodidio, "La Réconciliation Orient-Occident," *Connaissance des Arts,* April 1987, pp. 46–47.

228. The photograph was taken April 27, 1988 (Namuth Appointment Diary 1988, Namuth Collection, CCP). This photograph stands in sharp contrast to the more conventional image of the painter that Namuth took for the September 1980 *Art News* cover.

229. While Namuth photographed Bourgeois, Schnabel, Lichtenstein, and Salle for *Connaissance des Arts,* the only image of the three that he retained for his personal collection, from those that appeared in this French magazine, was the portrait of David Salle.

230. Namuth had known Bourgeois and husband Robert Goldwater, a noted primitive art scholar, since the early 1950s. But despite the length of their friendship, Namuth did not always find it easy to photograph the sculptor. As he wrote about a subsequent session: "She is a difficult woman, though a great artist. . . . I have rarely met with this kind of attitude, persisting against being photographed at the same time wanting it" (Hans Namuth to Debra Bond, March 22, 1984, *Architectural Digest* file, Namuth Collection, CCP).

231. Hans Namuth to Gayle Rosenberg, December 19, 1983, February 7, 1984, April 1, 1984, and January 14, 1985, all Namuth Collection, CCP.

232. Namuth to Rosenberg, January 14, 1985.

233. Namuth to Rosenberg, August 13, 1984.

234. Rosenberg to Namuth, January 12, 1984, Namuth Collection, CCP; Namuth to Debra Bond, April 25, 1984, Namuth Collection, CCP.

235. Namuth to Kenneth de Bie, January 28, 1986, Namuth Collection, CCP. See John Gruen, "Artist's Dialogue: Richard Diebenkorn, 'Radiant Vistas from Ocean Park,'" *Architectural Digest,* November 1986, pp. 52–61. Leo Holub took the photographs of Diebenkorn for this article.

236. Among the *Architectural Digest* articles illustrated with portraits by Namuth are Constance W. Glenn, "Artist's Dialogue: A Conversation with George Segal," November 1983, pp. 66–76; Carter Ratcliff, "Artist's Dialogue: A Conversation with Mark di Suvero," December 1983, pp. 192–200; "Guest Speaker: William Styron: Children of Brief Sunshine," March 1984, pp. 32–44; Judith Thurman, "Artist's Dialogue: Passionate Self-Expression—The Art of Louise Bourgeois," November 1984, pp. 234–36; Jean Clair, "The Lure of Chassy: A Legacy of Balthus in the Morvan Hills of France," December 1984, pp. 186–94; Joanna Shaw-Eagle, "Architectural Digest Visits: Helen Frankenthaler," March 1985, pp. 170–75; Avis Berman, "Artist's Dialogue: The Timeless Eye of André Kertész," May 1985, pp. 72–84; Avis Berman, "Artist's Dialogue: Neil Welliver, 'Unveiling the Wilderness,'" June 1985, pp. 68ff.; Phyllis Tuchman, "Architectural Digest Visits: Kenneth Noland," July 1985, pp. 110–15, 149; John Gruen, "Artist's Dialogue: Roy Lichtenstein, 'Bold Strokes of Wit and Wisdom,'" September 1985, pp. 52ff.; "Artist's Dialogue: Will Barnet," March 1986, pp. 62ff. Vanessa Kogevinas graciously verified Namuth's published work for this magazine.

237. His first exhibition, "Guatemala: The Land and the People," which consisted of fifty photographs, opened in 1948 at the American Museum of Natural History. It moved to the Pan-American Union (now the Organization of American States) in 1950, and was circulated by the American Federation of Arts in 1950 and 1955. In 1959 the Stable Gallery displayed the seventeen portraits of artists that Namuth had made for the 1958 American Pavilion at the Brussels World's Fair. In 1967, in conjunction with its major Pollock retrospective, the Museum of Modern Art created a thirty-foot-long montage mural of Namuth's photographs of Pollock painting and exhibited them in the glass-walled corridor connecting the two galleries in which the artist's paintings were exhibited. I wish to thank Pepe Karmel for providing me with a copy of the 1967 Museum of Modern Art press release for the exhibition of Jackson Pollock's paintings, which includes a description of the installation of Namuth's photographs. Clearly, this didactic installation focused on Pollock as a subject rather than on Namuth as a photographer.

238. Castelli Graphics, at 4 East 77th Street, opened in 1969. The gallery moved to 578 Broadway in 1988, after the death of Mrs. Castelli in 1987. Namuth's exhibitions appeared in these two locations, as well as in the Castelli Gallery at 420 West Broadway.

239. Marshall B. Davidson, *Early American Tools,* photographs by Hans Namuth (Verona, Italy: Olivetti, 1975). Olivetti Corporation sponsored the exhibition and book as an American Bicentennial project. The venture originated while Namuth was filming Olivetti's American manufacturing headquarters in Ephrata, Pennsylvania, for his film on the noted architect Louis Kahn, according to Gil Wintering, interviewed by the author, April 13, 1998. The work was featured in *Craft Horizons* 35 (December 1975): 28–35, and the book was reviewed by Phil Patton in *Artforum* 14 (January 1976): 66; and by Gerrit Henry in *Art News,* January 1976, p. 117.

240. Namuth acknowledged the roles of Konrad Reisner and Max Lowenherz in the March 1977 press release for the Castelli Exhibition (Namuth Collection, CCP). No catalogue accompanied this exhibition. The photographs were first published in *Spanisches Tagebuch, 1936* in 1986. According to Diethart Kerbs in a letter to the author, November 3, 1997, he persuaded Dirk Nishen, his publisher, to undertake the book as a memorial commemorating the fiftieth anniversary of the outbreak of the Spanish Civil War.

241. Namuth Appointment Diary 1977, Namuth Collection, CCP; Julia Child, interviewed by the author, January 29, 1997. Child did not recall the source of the original commission that brought Namuth to Boston.

242. Throughout their marriage, Namuth, Carmen, and the two children made frequent visits to this country, which they all loved for the beauty of its landscape and the charm of its native people.

243. Maud Oakes, *The Two Crosses of Todos Santos: Survivals of Mayan Religious Ritual* (New York: Pantheon Books, 1951).

244. See "Hans Namuth" in Kelly, *Darkroom2,* p. 82; "Hans Namuth," *Camera,* January 1979, pp. 16–21; John Russell, "Todos Santos," *Connaissance des Arts,* July/August 1988, pp. 26–31; and A. Hopkinson, "Los Todos Santeros: A Family Album of Mam Indians," *British Journal of Photography* 136 (March 16, 1989): 18–19ff.

245. "Artists 1950–81: A Personal View." The exhibition that celebrated the publication of the book of the same title was held at the Pace Gallery from December 11, 1981, to January 9, 1982. Milly Glimcher, interviewed by the author, March 30, 1998. Barbara Cavaliere, "Hans Namuth," *Arts* 56 (February 1982): 5, reviewed the show, saying that "they blend many layers of candor as only a director as astute as Namuth could." The exhibition was a bit of an aberration for the gallery, as it did not, as it does today, show photographs. But Mrs. Glimcher was convinced of the importance of Namuth's work, and she convinced her husband, gallery owner Arnold Glimcher, that an exhibition was an appropriate way to focus on the fact that the gallery now had an active publications department.

246. Namuth, *Artists 1950–81,* n.p.

247. Ibid.

248. Although Glimcher found Namuth's presence "unobtrusive," Samaras refused Namuth's request for additional sittings. He found the posed session "phony," and he did not wish a photograph of him to become an "art world cliché." Arnold Glimcher, interviewed by the author, April 9, 1997; Lucas Samaras, interviewed by the author, April 9, 1997.

249. The portraits of Frank Stella, Jim Dine, and Romare Bearden, which are now in the National Portrait Gallery collection, were among those shown in this exhibition.

250. Warhol sat for his portrait on October 8, 1981, at 4:00 P.M. (Namuth Appointment Diary 1981, Namuth Collection, CCP).

251. George Dwight, attorney for the family at the time of Carmen's death, interviewed by the author, December 12, 1997, recalled that the backdrop featured in this photograph belonged to Warhol and that when Warhol's belongings were put on sale at Sotheby's (May 2 and 3, 1988), Namuth sought to purchase it, but he could not find it among the items for sale. John Smith, archivist for the Warhol collection, has been unable to locate this item in the Warhol collection (Smith to the author, August 13, 1998).

252. "A Portfolio of Artists' Portraits: Hans Namuth," p. 43. In Namuth, *Artists 1950–81,* n.p., Namuth justified his predisposition for the more somber tonalities of black and white by quoting photographer Robert Frank, who stated that "black and white are the colors of photography. To me they symbolize the alternatives of hope and despair to which mankind is forever subjected."

253. "Hans Namuth: Artists, 1950–80," Pace Gallery, December 11, 1981–January 9, 1982; "Hans Namuth: Color Photo Portraits," Leo Castelli Gallery, January 9–30, 1982. According to Joanna Stasuk, archivist for the gallery, the exhibition was extended to February 13.

254. Namuth and Falkenberg collaborated on *John Little: Image from the Sea* (1950), *Willem de Kooning: The Painter* (1964); *Josef Albers: Homage to the Square* (1969); *The Brancusi Retrospective at the Guggenheim Museum* (1970); *The Matisse Centennial at the Grand Palais* (1971); *De Kooning at the Modern* (1971); *Louis I. Kahn: Architect* (1974); *Alexander Calder: Calder's Universe* (1977), a commission from the Whitney Museum of American Art; *Alfred Stieglitz: Photographer* (1982); and *Balthus at the Pompidou* (1984). *Edo Dance and Pantomime* (1972) was the only film by these Namuth and Falkenberg that did not focus on a single artistic personality. For a review of *Calder's Universe* and *Alfred Stieglitz: Photographer* see Denise Hare, "Film," *Craft Horizons* 38 (February 1978): 6 and 64. A master copy of these films is maintained by the Film Archive of the Museum of Modern Art, New York. Not all films proposed by Namuth and Falkenberg came to fruition. In 1985 Namuth developed a script and budget for a film on Lichtenstein painting his mural for the recently completed Equitable Building in New York. Namuth never was able to raise the $75,000 budgeted for the film (Namuth, "Brushstrokes," manuscript, Namuth Collection, CCP).

255. Namuth, "Photographing Pollock"; Namuth to Cummings, AAA, roll 3198, frames 884–86; Barbara Rose, "Hans Namuth's Photographs and the Jackson Pollock Myth, Part Two: Number 29, 1950," *Arts* (March 1979): 117–19; Naifeh and Smith, *Pollock,* pp. 647–53; Friedman, *Jackson Pollock,* pp. 162–66; Potter, *To a Violent Grave,* pp. 128–41; Potter to author, September 23, 1997. For the importance of these films in the history of late-twentieth-century art, see Jones, *Machine in the Studio,* pp. 72–80. In his interview with the author, September 17, 1977, Blake stated that he, rather than Namuth, conceived the idea of Pollock painting on glass. However, Naifeh and Smith (*Pollock,* p. 649) write that Blake's role was to order the glass from Pittsburgh Plate Glass.

256. Aline B. Louchheim, *New York Times,* September 9, 1951, sec. 2, p. 8, col. 4. The Woodstock Film Festival, September 1–3, was the first art film festival in America. See "Photographing Pollock."

257. Jones, *Machine in the Studio,* p. 77.

258. Gabriella Drudi wrote the text for *De Kooning at the Modern,* while noted professor of American art Barbara Novak sanctioned its content and served as the narrator. Beginning in 1971, Namuth and Falkenberg began to work with scholars noted for their knowledge of the film's subject. Art historian and curator for the Brancusi retrospective Sidney Geist wrote the script for the Brancusi film; Pierre Schneider, curator of the Matisse show, shaped the words for the Matisse film; while Michael Peppiatt performed this role for the Balthus film. Art critic John Russell wrote the scripts for *Calder's Universe* and *Alfred Stieglitz: Photographer.* These texts gave a professional demeanor to these later films, but they also diminished, to a degree, the raw authenticity of the early Pollock and de Kooning films.

259. Paul Falkenberg, "Notes for a Film on Josef Albers," Namuth Papers, AAA.

260. Hans Namuth, "Josef Albers," Namuth Collection, CCP.

261. Cornell Capa, Rosamond Bernier, and Michael Hoffman, quoted in publicity release for Museum at Large, Ltd. (Namuth and Falkenberg's film distribution company), February 1983, Peter Selz Papers, AAA, roll 4384, frame 463.

262. Georgia O'Keeffe to Hans Namuth and Paul Falkenberg, February 27, 1978, Namuth Papers, AAA.

263. Namuth to Dorothy Norman, February 9, 1981, Namuth Papers, AAA.

264. Hans Namuth to Ralph Steiner, n.d.; Steiner to Namuth, February 6, 1980, Namuth Papers, AAA. For amplification of Steiner's attitude toward Stieglitz, see Ralph Steiner, "A Point of View," *American Photographer* 1, no. 5 (October 1978): 28–29.

265. Judith Wechsler, interviewed by the author, February 10, 1998.

266. Kelly, *Darkroom2,* pp. 79–95.

267. Hans Namuth, "Albert Renger-Patzsch: The World Is Beautiful," *Art News,* December 1981, p. 136; "Namuth," in Kelly, *Darkroom2,* p. 82.

268. *August Sander: Citizens of the Twentieth Century,* edited by Gunther Sander, text by Ulrich Keller (Cambridge: MIT Press, 1986); August Sander, *Men Without Masks: Faces of Germany, 1910–1938,* introduction by Gunther Sander (Greenwich: New York Graphic Society, 1973).

269. Namuth to Eggert, August 22, 1984; Namuth to Renata Gobel, January 21, 1985, both Namuth Collection, CCP; Namuth to Cummings, AAA, roll 3198, frame 884.

270. She was buried after a service at Christ Episcopal Church in Sag Harbor on Wednesday, December 4. Namuth Appointment Diary 1985, Namuth Collection, CCP, records the dates of her hospitalization.

271. Quoted in "Happy Birthday, Carmen," privately printed by Hans Namuth.

272. Namuth's Appointment Diaries for 1986, 1987, 1988, and 1989 note her exhibition openings, her birthday, the dinner parties at her house, and the occasions when they dined out (Namuth Collection, CCP).

273. Helen Frankenthaler, interview with the author, March 31, 1997. In "A Portfolio of Artists' Portraits: Hans Namuth," p. 44, Namuth states that he met Frankenthaler in 1953, and that after that he met Newman, Still, and Ad Reinhardt. This chronological sequence is undoubtedly a copy error. Although Namuth had photographed Frankenthaler's wedding to Robert Motherwell in 1958, his earliest photograph of her as an artist was in 1964. He photographed her again in 1968, 1974, 1984, 1985, and after 1987, in 1988 and 1989 (Namuth: Inventory of Portraits).

274. The National Gallery of Art, Washington, D.C., owns a version of this print (1993.14.1). This project, which was a collaboration with Tallix Foundry and Tyler Graphics, consists of a three-part, twenty-eight-color print that is mounted on a three-panel screen, which had been cast in bronze using the lost-wax method. The prints are placed on the front of the bronze panels, while the verso of each panel is sandblasted and hand-painted with brushes, sponges, and mops. I wish to thank Nancy Yeide, who provided me with information about the print in the collection of the National Gallery.

275. "Hans Namuth in Car Crash," obituary, *The East Hampton Star,* October 18, 1990; Andy Grundberg, "Hans Namuth, 75, Photographer Whose Art Captured Artists, Dies," *New York Times,* November 15, 1990.

276. Hans Namuth, "Artists 1950–81: A Personal View," in "Midsummer Gala," Parrish Art Museum, Saturday, July 14, 1990.

277. Philip Jodidio, "Douze personnalités à New York," *Connaissance des Arts,* February 1987, p. 57.

278. Carol Strickland, "Camera and Action," in *Art and Antiques,* September 1991, p. 78.

279. Helen Frankenthaler, quoted in ibid., p. 77.

PLATES • THE PORTRAITS OF HANS NAMUTH

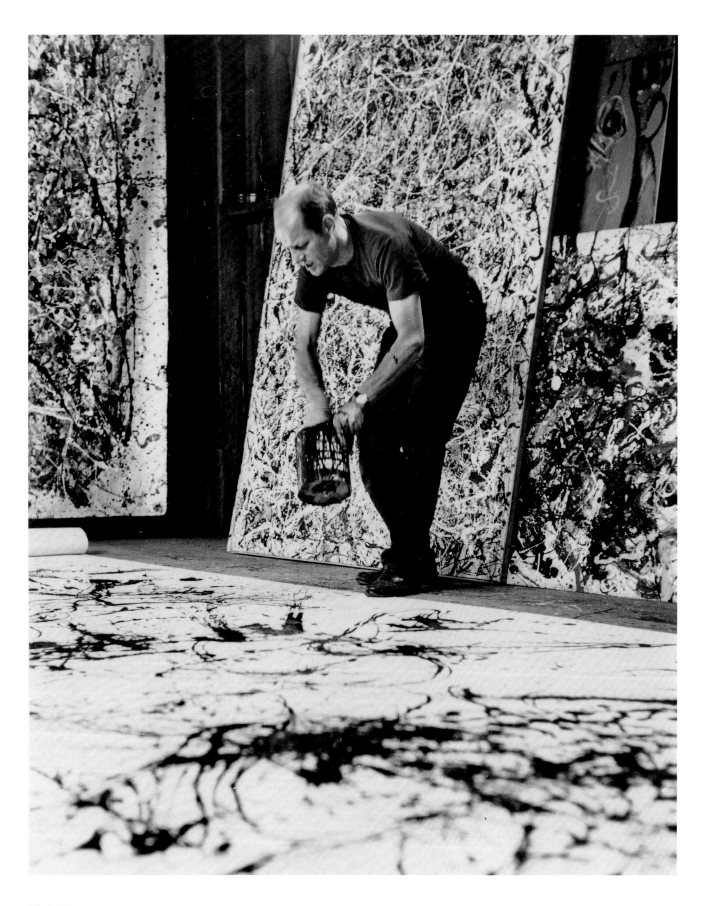

Plate 2.

Jackson Pollock, 1950

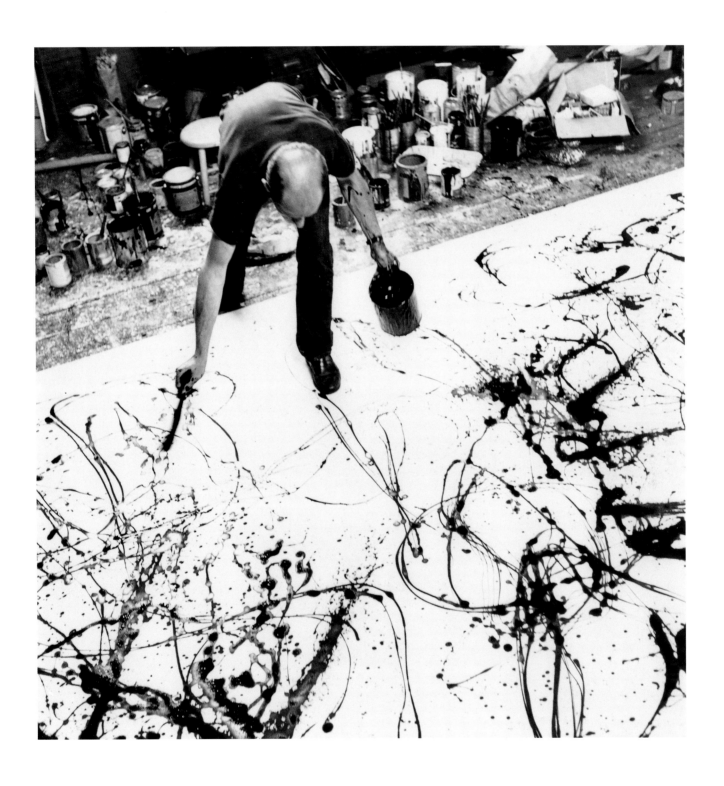

Plate 3.

Jackson Pollock, 1950

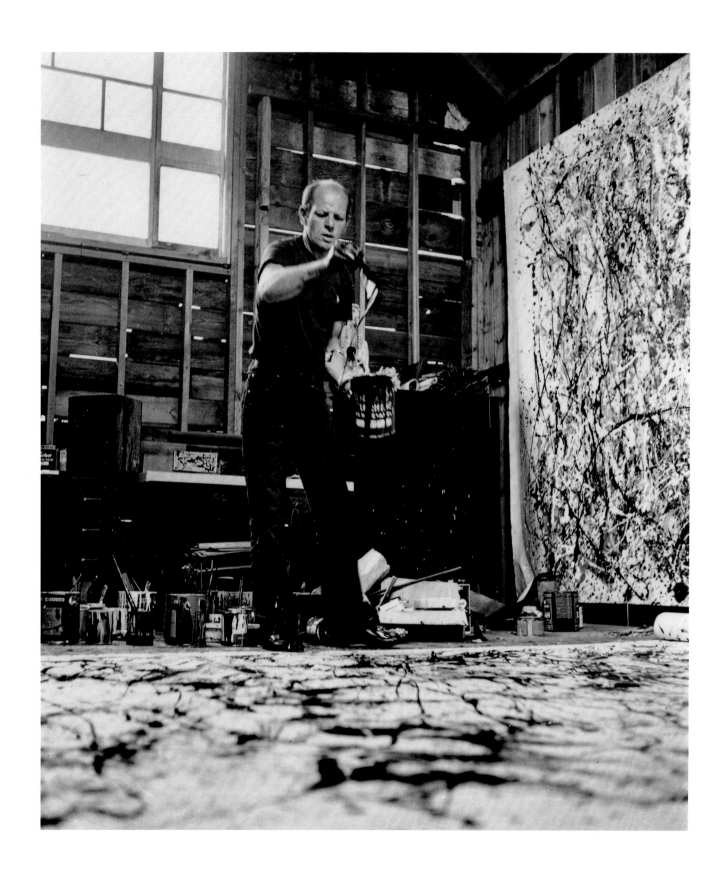

Plate 4.

Jackson Pollock, 1950

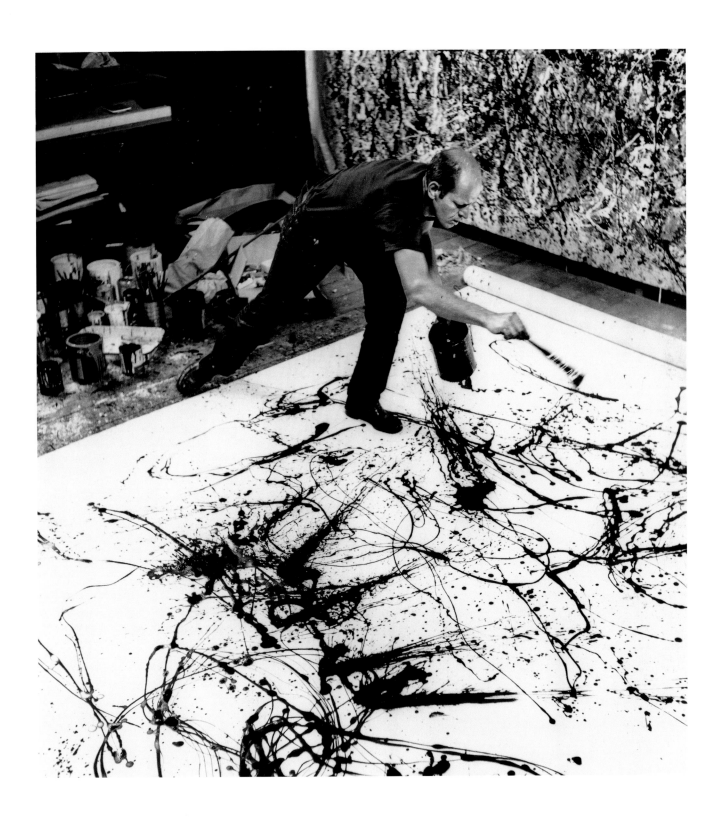

Plate 5.

Jackson Pollock, 1950

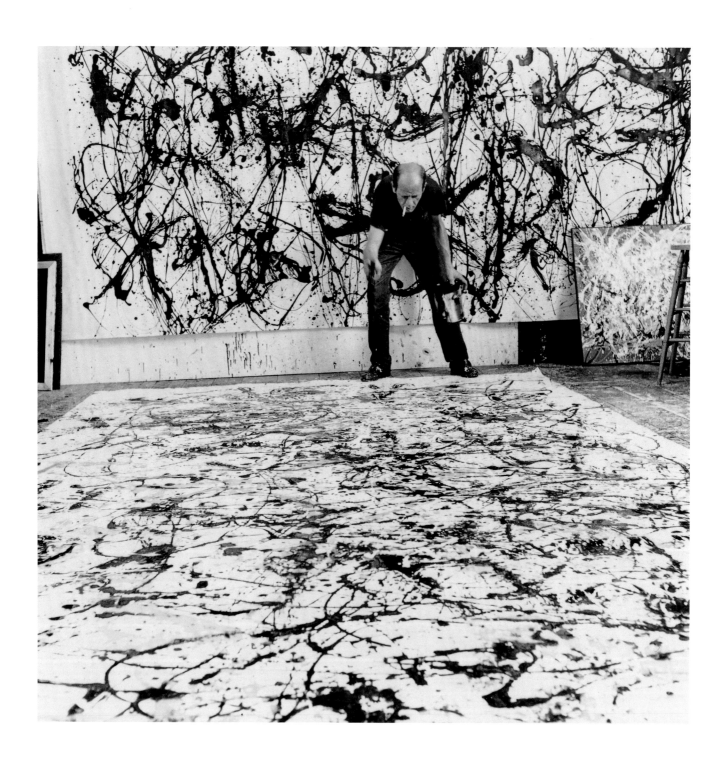

Plate 6.

Jackson Pollock, 1950

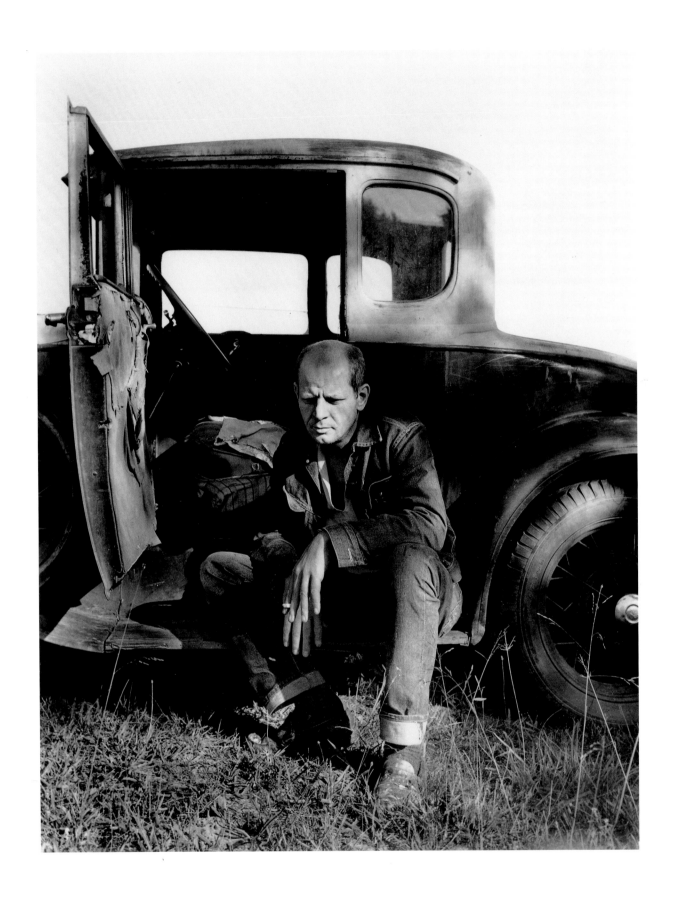

Plate 7.

Jackson Pollock, 1950

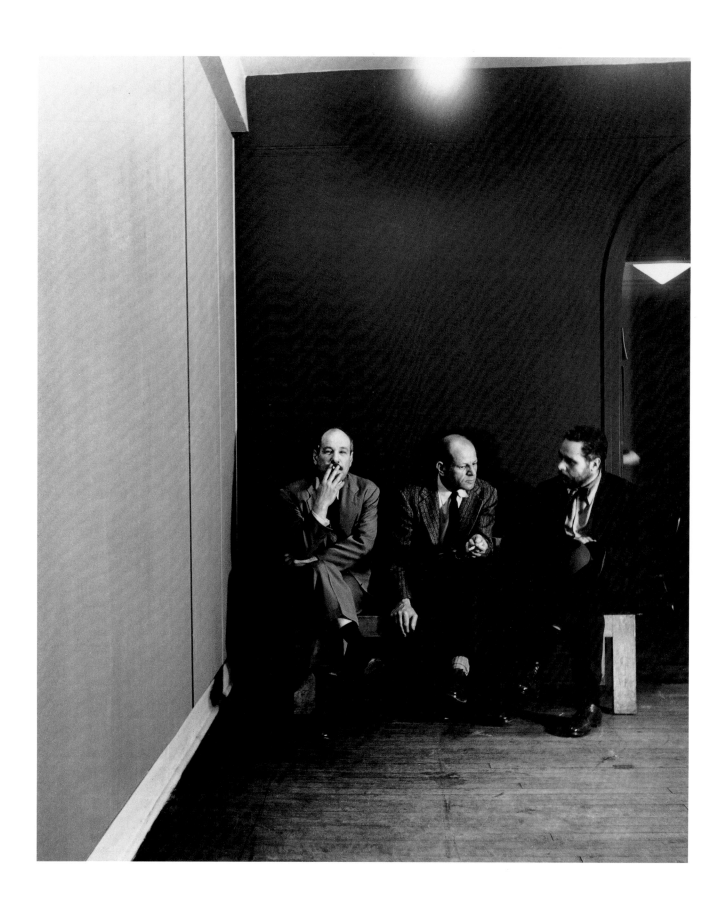

Plate 8.

Barnett Newman, Jackson Pollock, and
Tony Smith, 1951

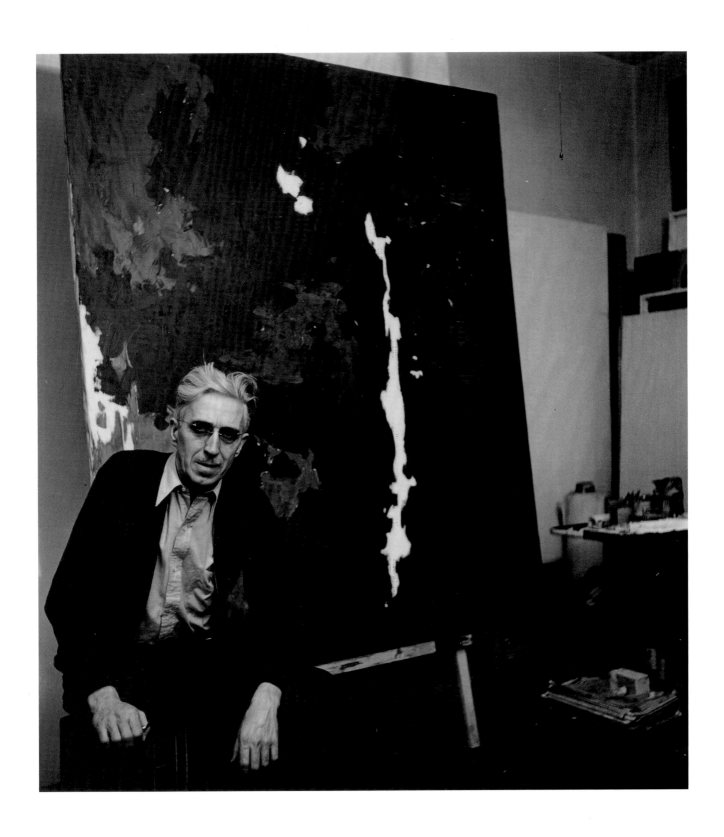

Plate 9.

Clyfford Still, 1951

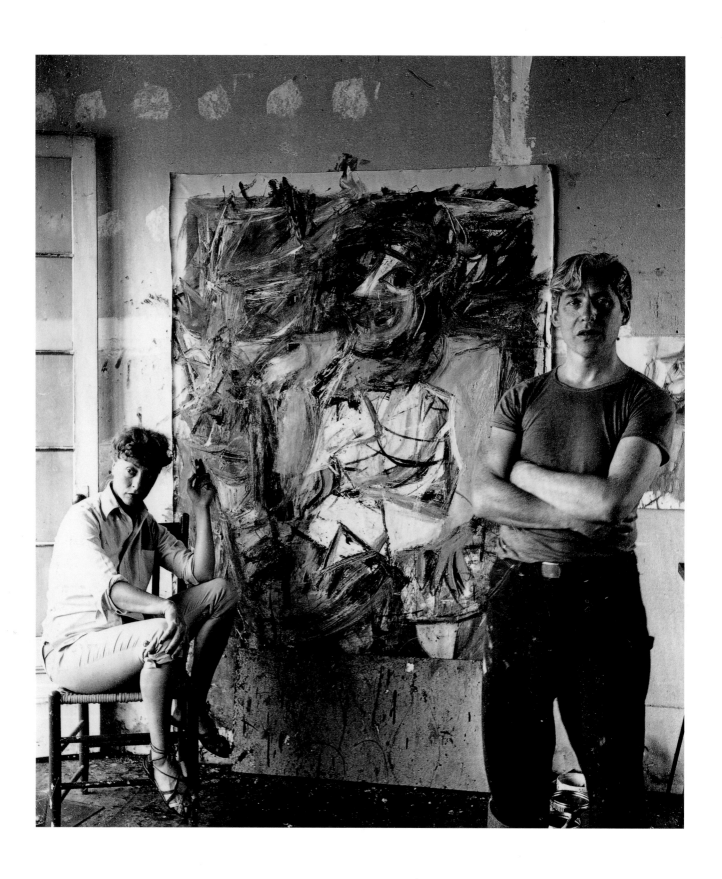

Plate 10.

Elaine de Kooning and Willem de Kooning, 1953

92

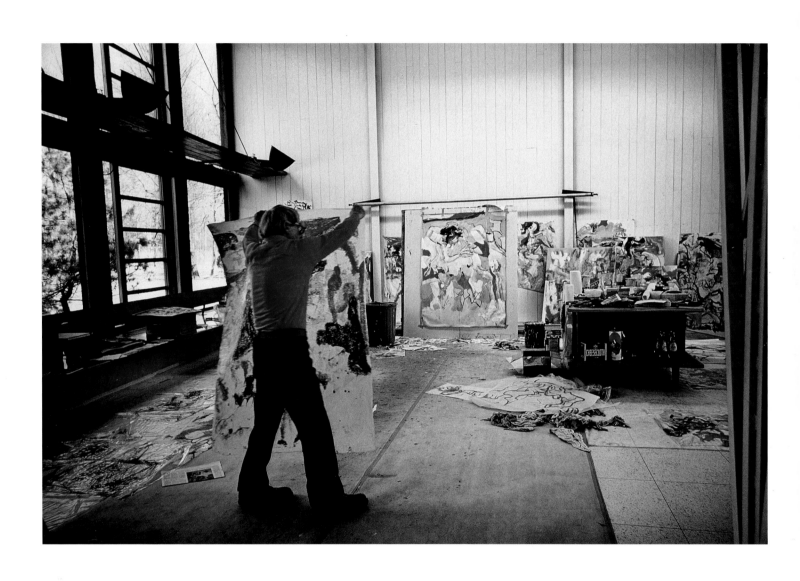

Plate 11.

Willem de Kooning, 1968

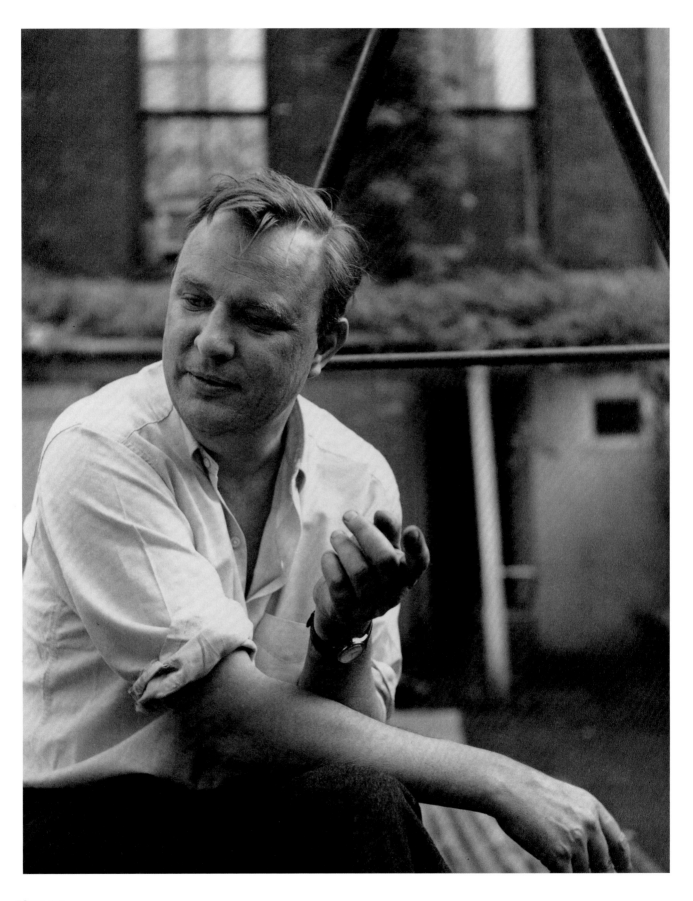

Plate 12.

Robert Motherwell, 1953

Plate 13.

Robert Motherwell, 1982

Plate 14.

Saul Steinberg, 1952

Plate 15.

Frank O'Hara and Larry Rivers, 1958

Plate 16.

Larry Rivers, 1965

Plate 17.

Lenore Krasner, 1962

Plate 18.

Walter Gropius, 1952

Plate 19.

Marcel Breuer, 1952

Plate 20.

Eero Saarinen, 1954

102

Plate 21.

Buckminster Fuller, 1959

Plate 22.

Frank Lloyd Wright, 1958

Plate 23.

Ludwig Mies van der Rohe, 1965

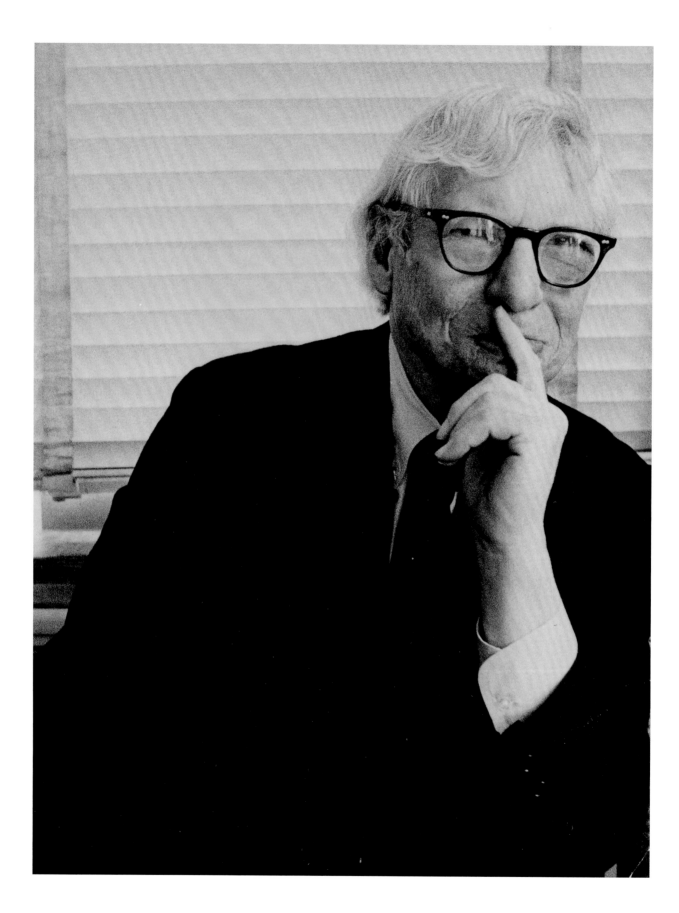

Plate 24.

Louis Isadore Kahn, 1971

Plate 25.

Philip Cortelyou Johnson, 1987

Plate 26.

Philip Cortelyou Johnson, 1987

Plate 27.

Gian Carlo Menotti, 1954

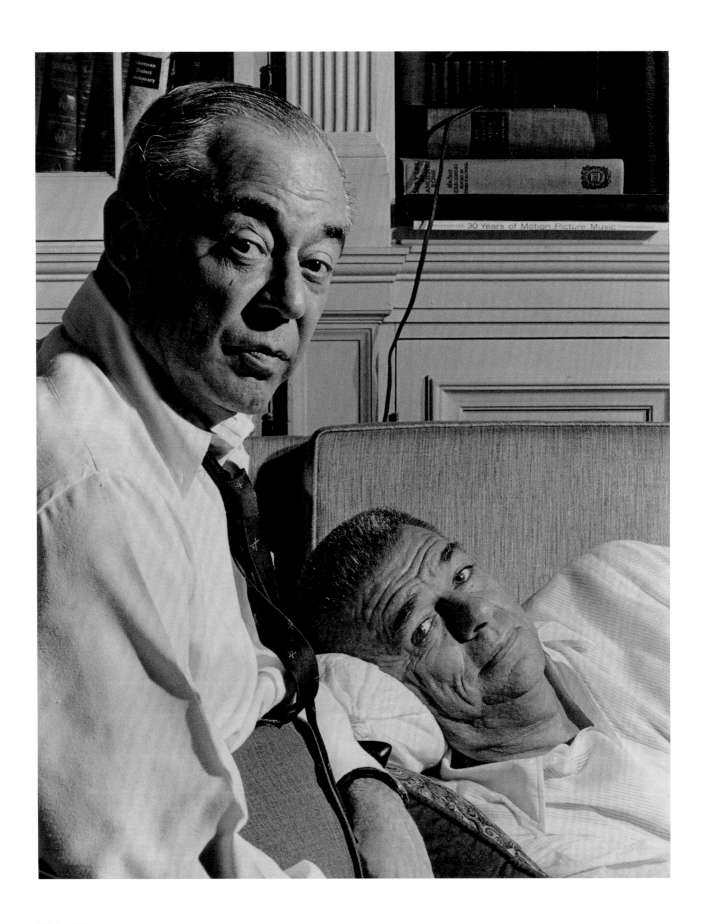

Plate 28.

Richard Rodgers and Oscar Hammerstein II, 1958

Plate 29.

Stephen Sondheim, 1960

Plate 30.

John Cage, 1963

Plate 31.

Jerome Robbins, 1978

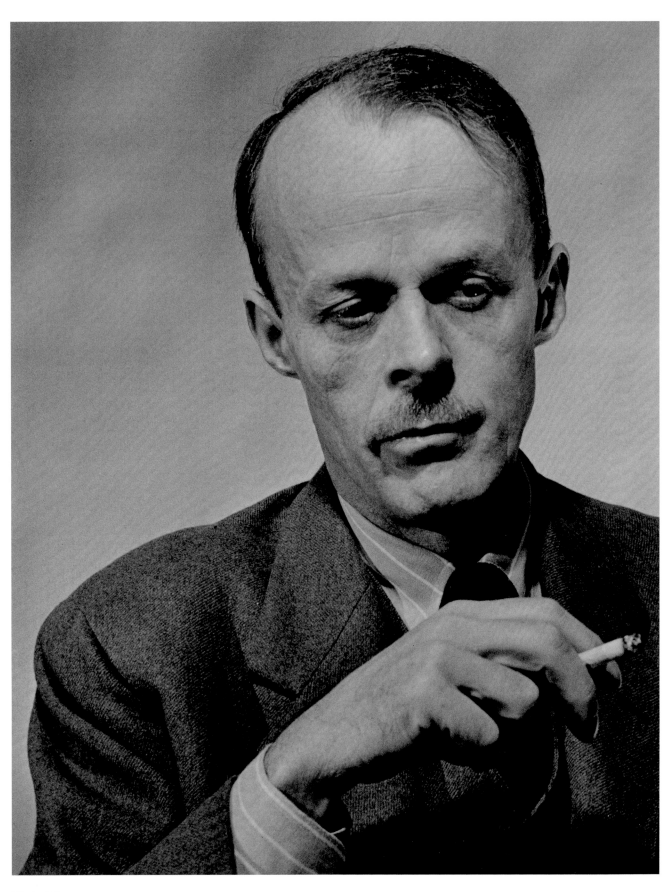

Plate 32.

Allen Tate, 1952

Plate 33.

Malcolm Cowley, 1959

Plate 34.

John Steinbeck, 1961

Plate 35.

A. J. Liebling and Jean Stafford, 1962

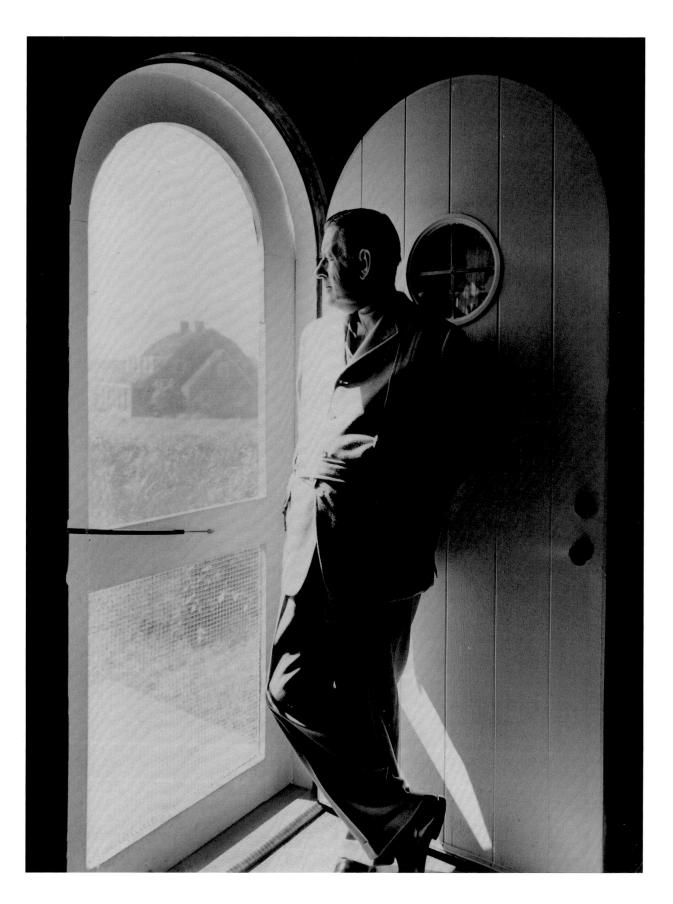

Plate 36.

John Henry O'Hara, 1963

Plate 37.

Bobby Fischer, 1963

Plate 38.

Edward Albee, 1980

120

Plate 39.

Hans Hofmann, 1963

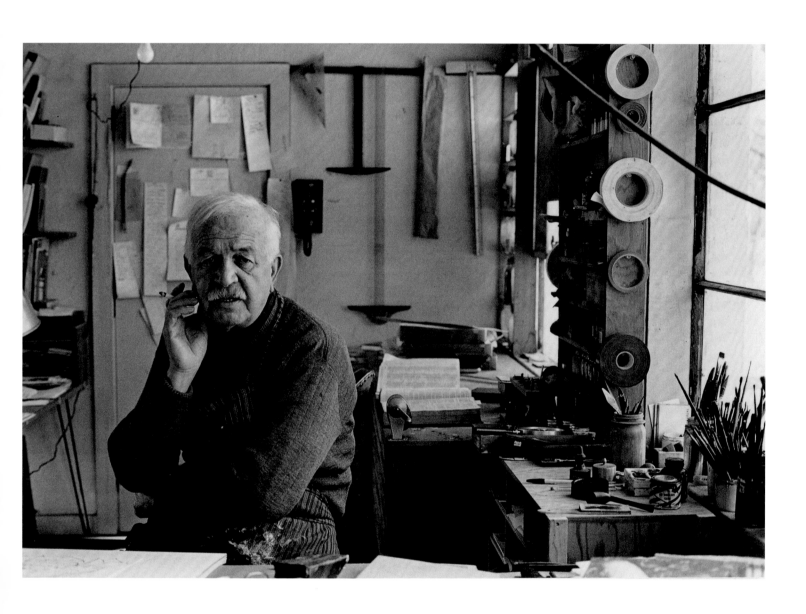

Plate 40.

Ben Shahn, 1964

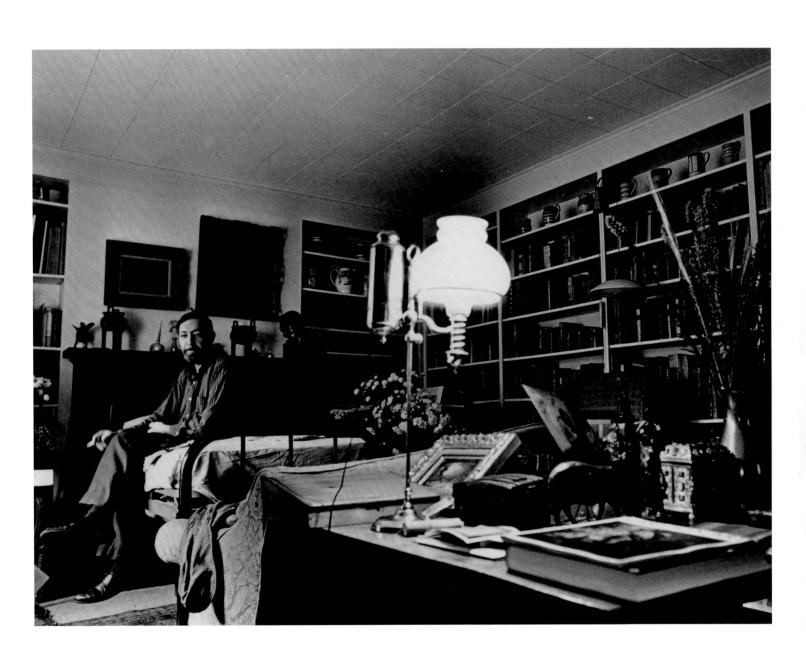

Plate 41.

Leonard Baskin, 1964

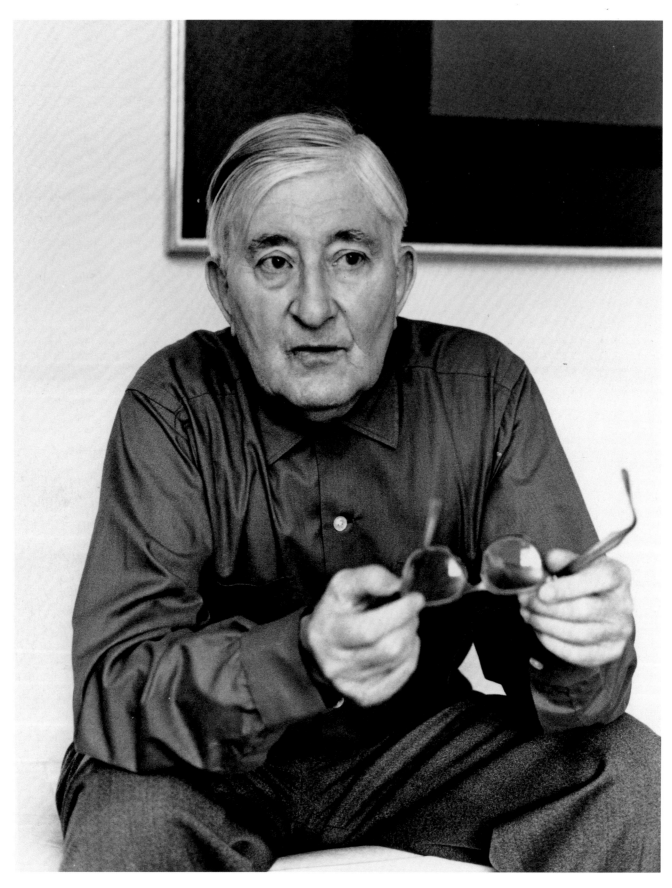

Plate 42.

Josef Albers, 1971

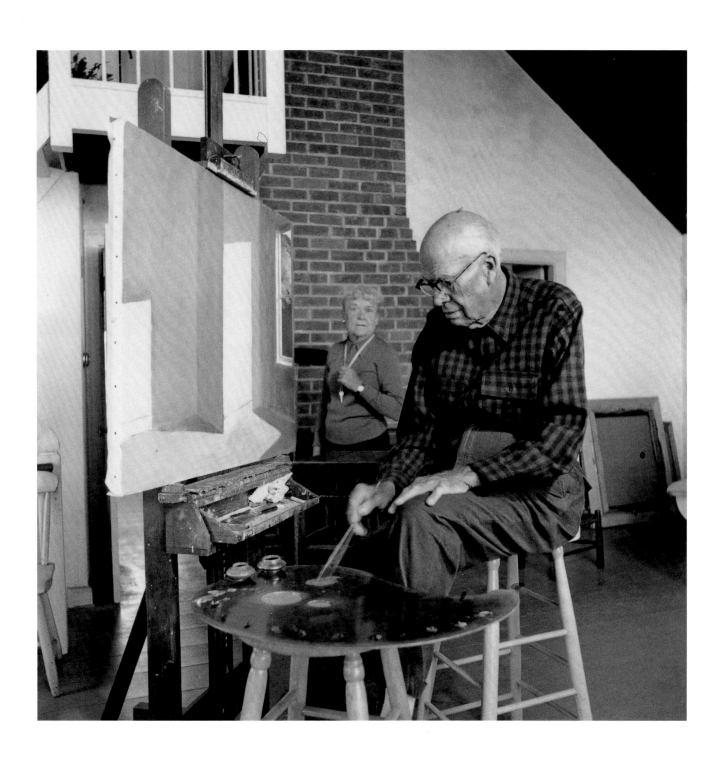

Plate 43.

Josephine Verstille Hopper and Edward Hopper, 1964

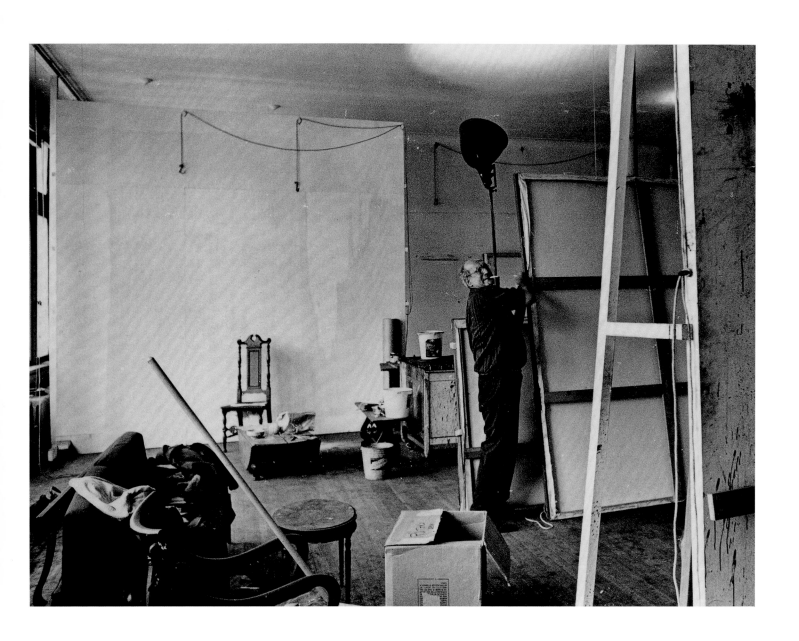

Plate 44.

Mark Rothko, 1964

126

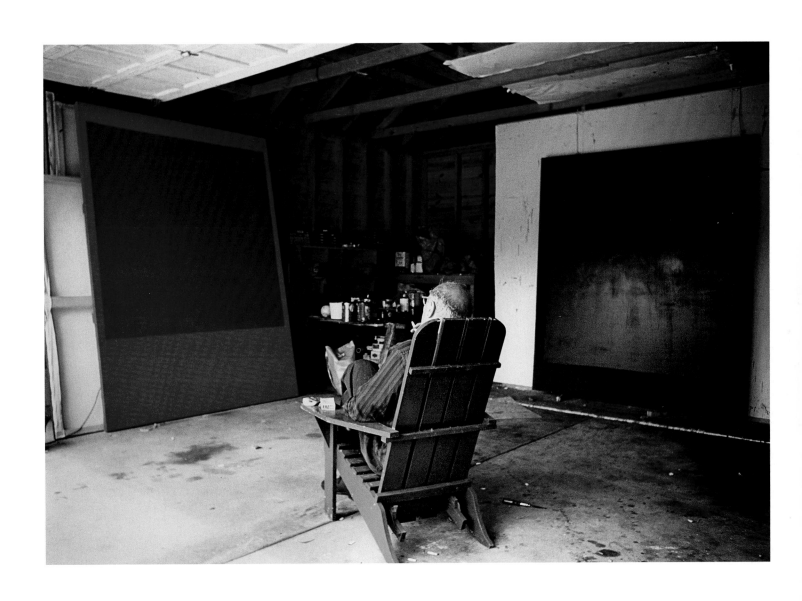

Plate 45.

Mark Rothko, 1964

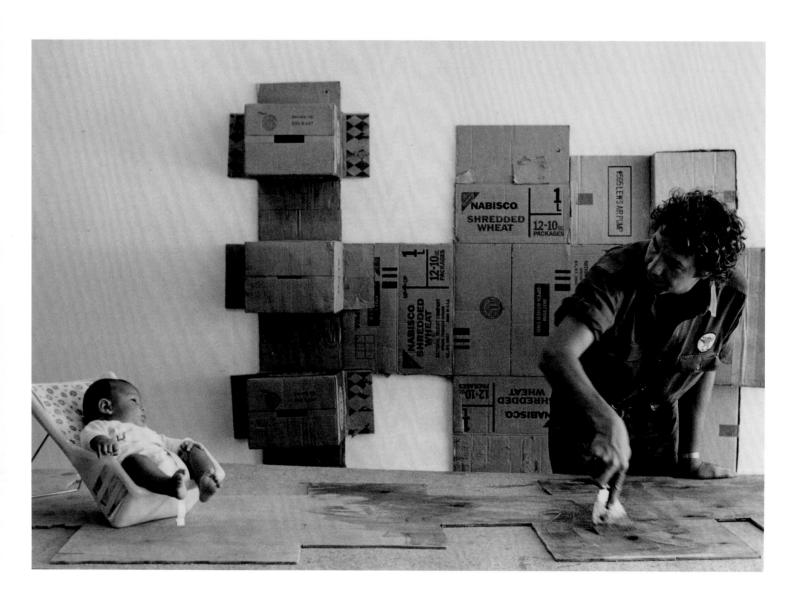

Plate 46.

Robert Rauschenberg with

Hummingbird Takahashi, 1971

128

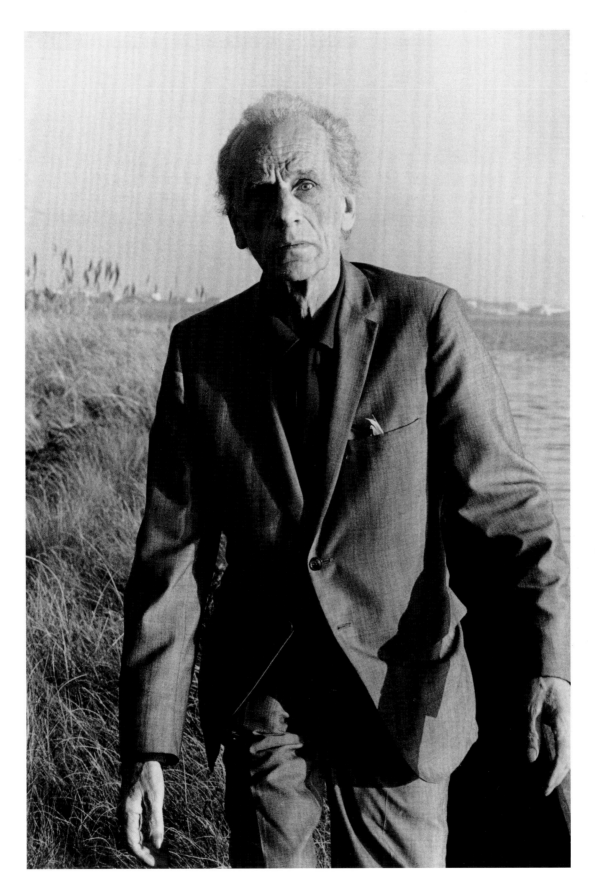

Plate 47.

Joseph Cornell, 1971

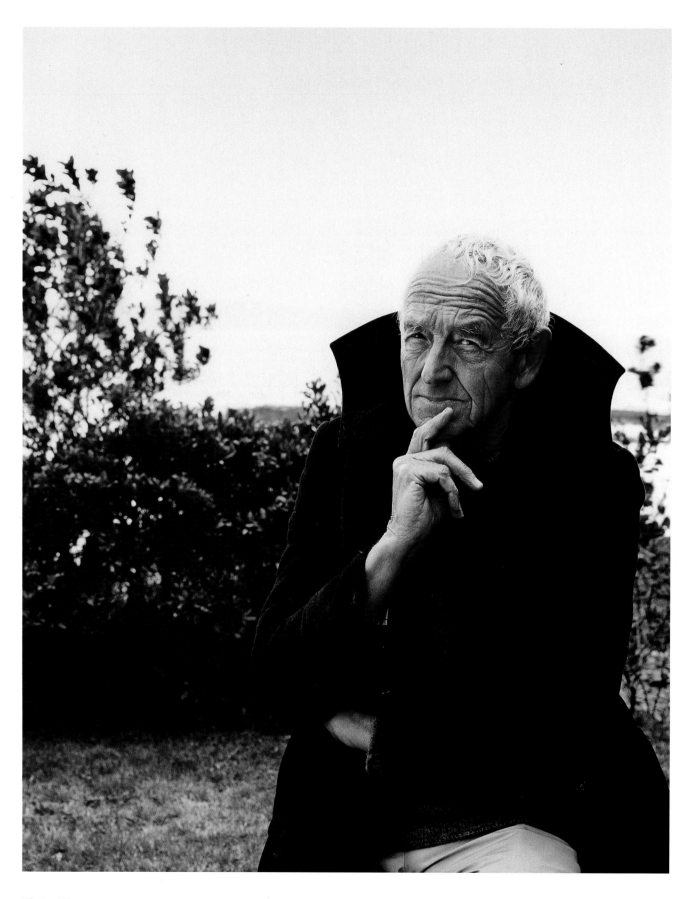

Plate 48.

Andrew Wyeth, 1986

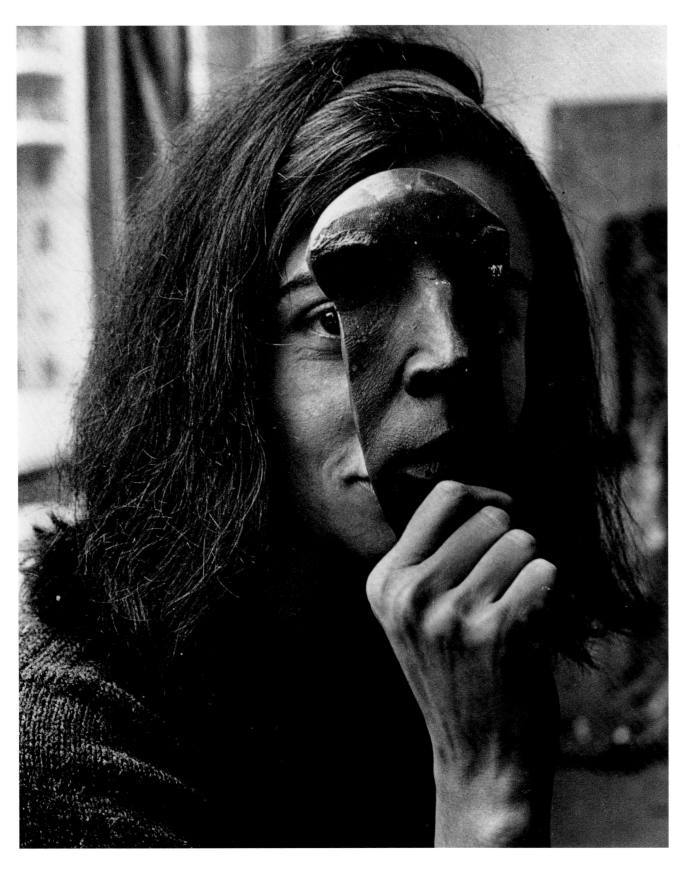

Plate 49.

Marisol Escobar, 1964

Plate 50.

Tony Smith, 1970

Plate 51.

Jasper Johns, 1962

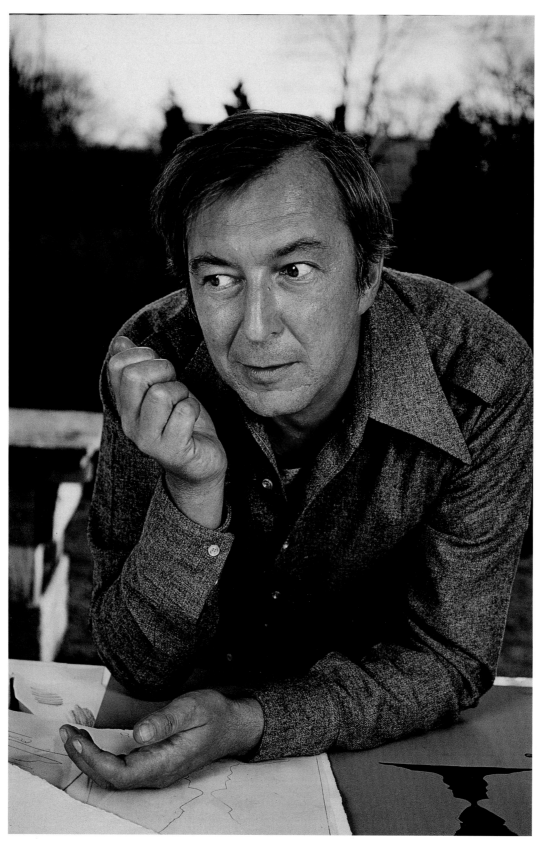

Plate 52.

Jasper Johns, 1973

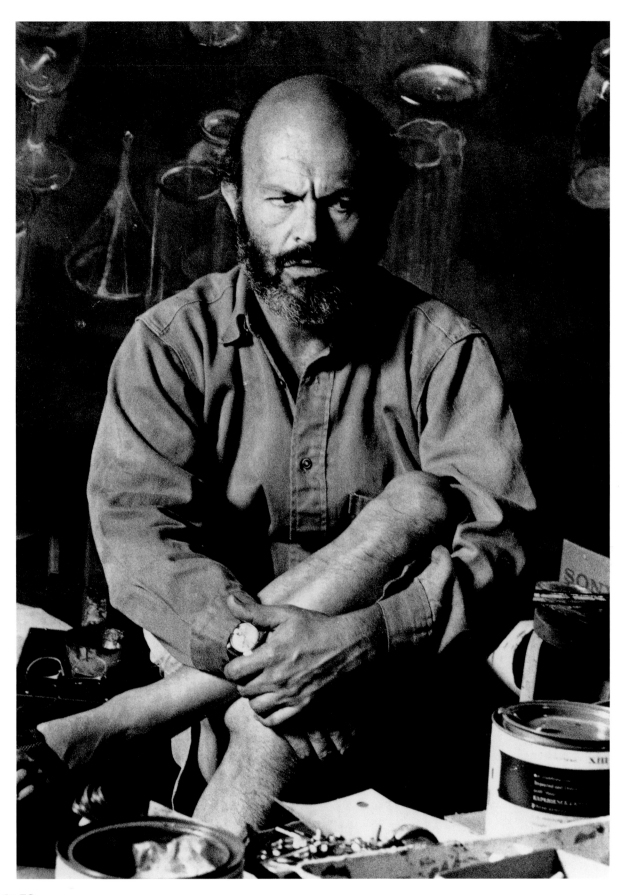

Plate 53.

Jim Dine, 1977

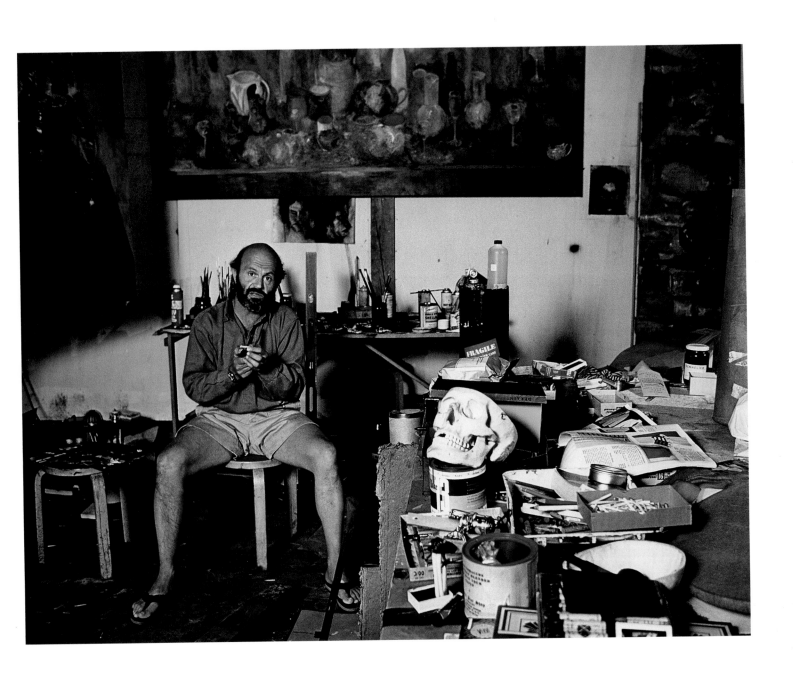

Plate 54.

Jim Dine, 1977

136

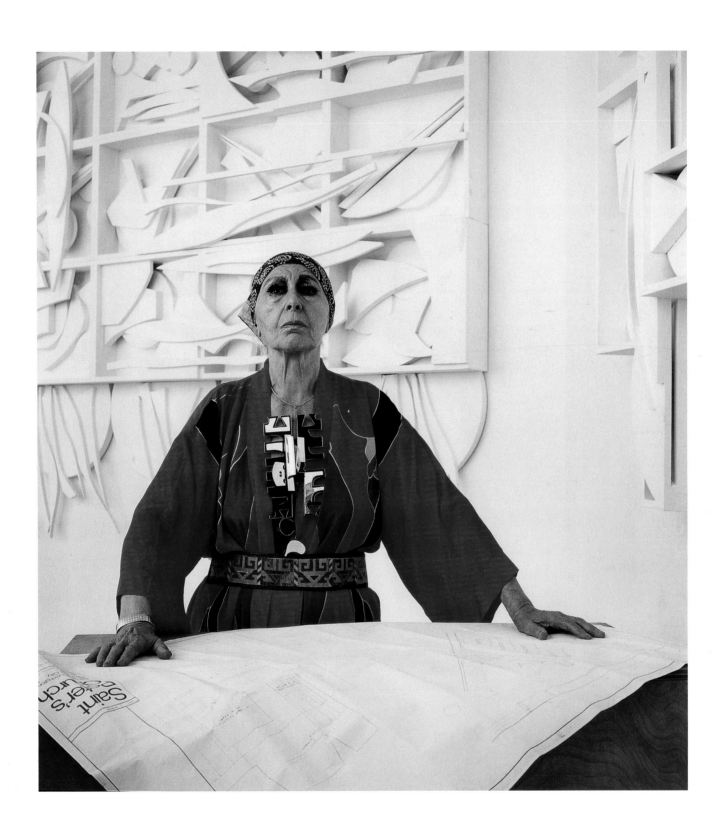

Plate 55.

Louise Nevelson, 1977

Plate 56.

Romare Bearden, 1980

138

Plate 57.

Frank Stella, 1981

Plate 58.

Leo Castelli and His Artists, 1982

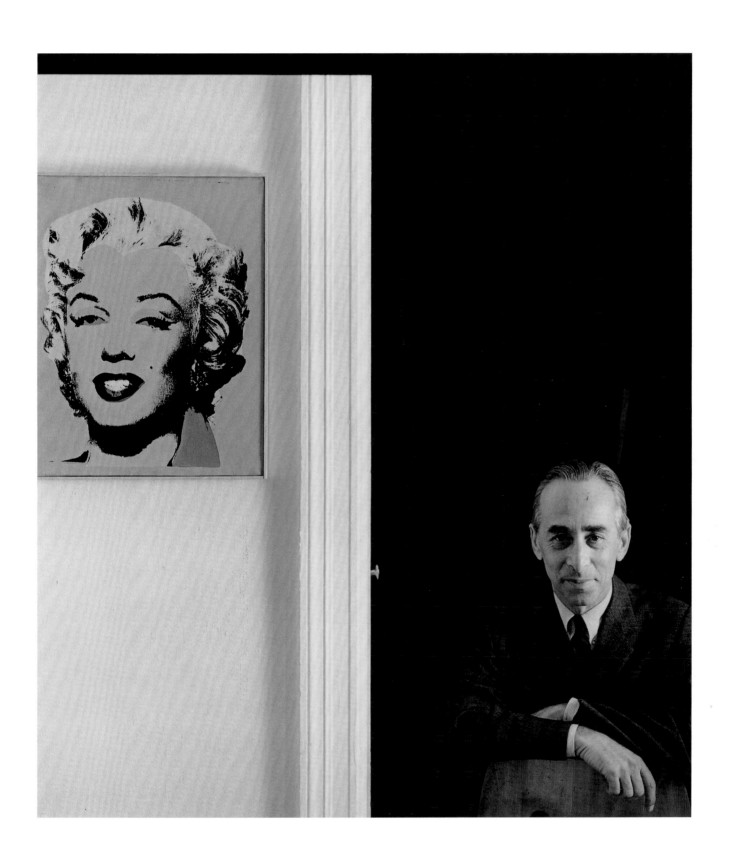

Plate 59.

Leo Castelli, 1982

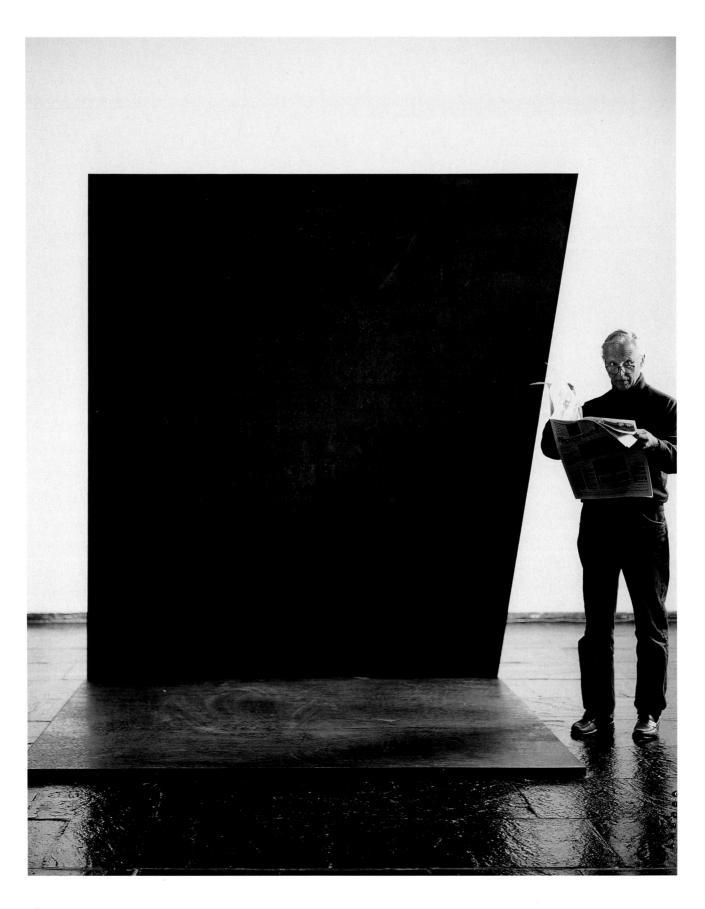

Plate 60.

Ellsworth Kelly, 1983

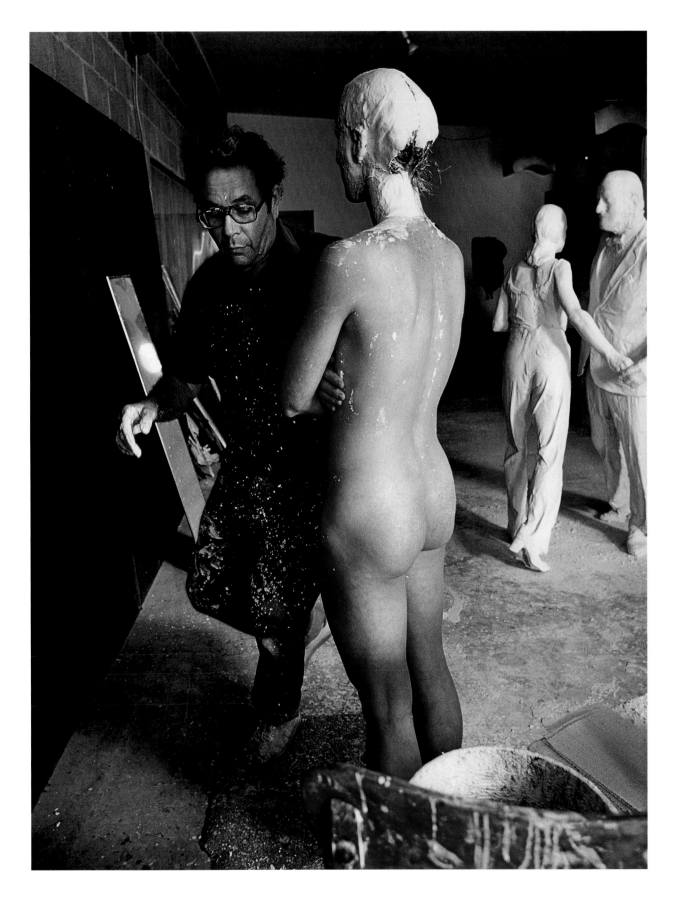

Plate 61.

George Segal, 1980

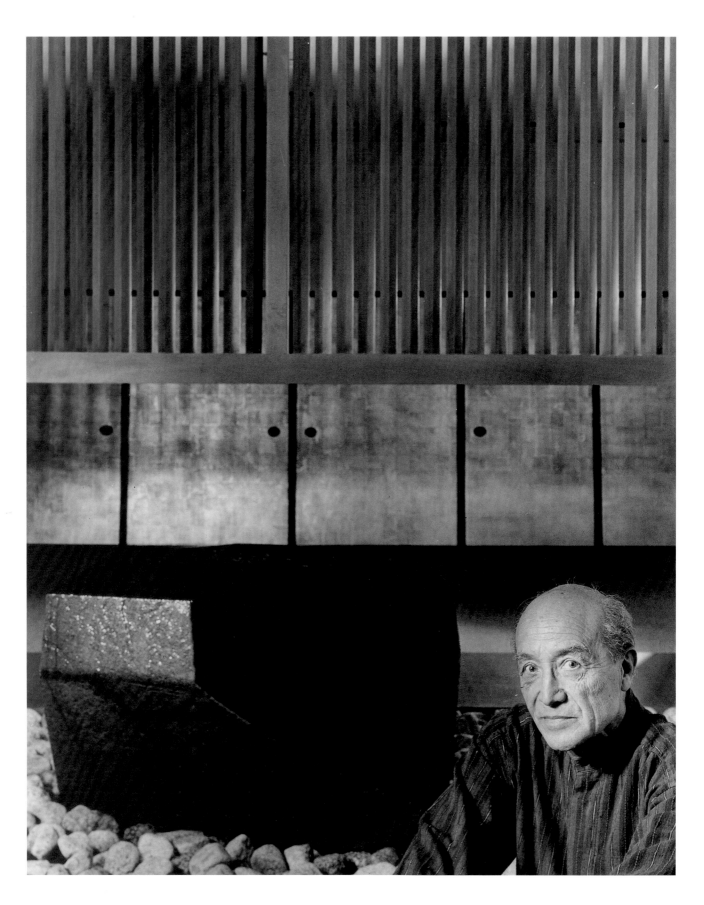

Plate 62.

Isamu Noguchi, 1987

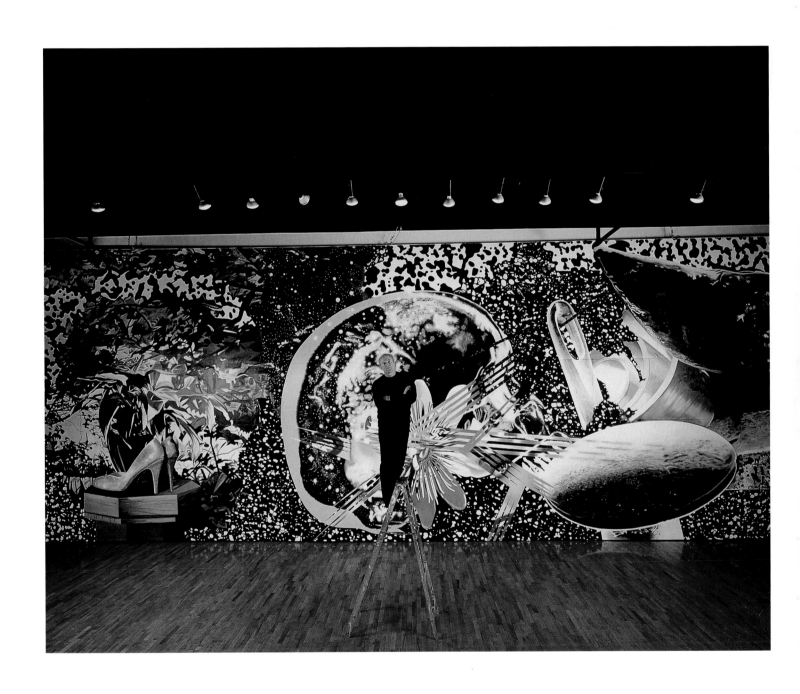

Plate 63.

James Rosenquist, 1988

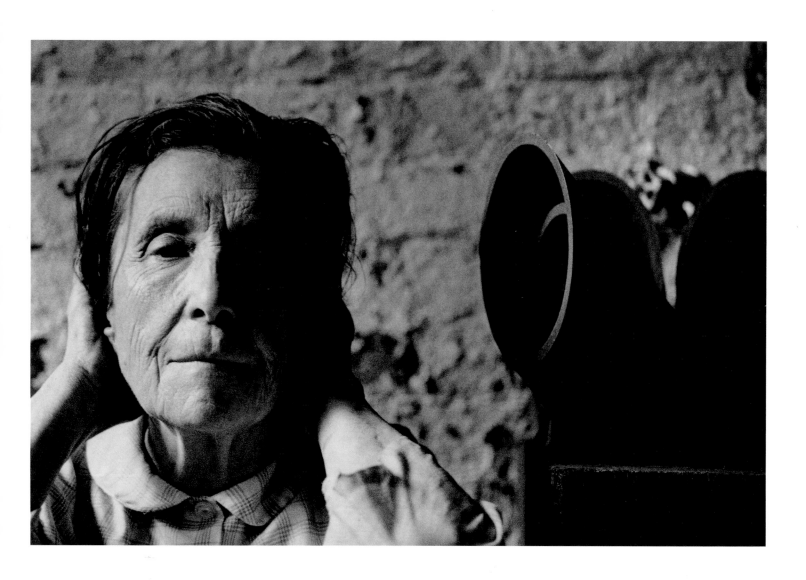

Plate 64.

Louise Bourgeois, 1978

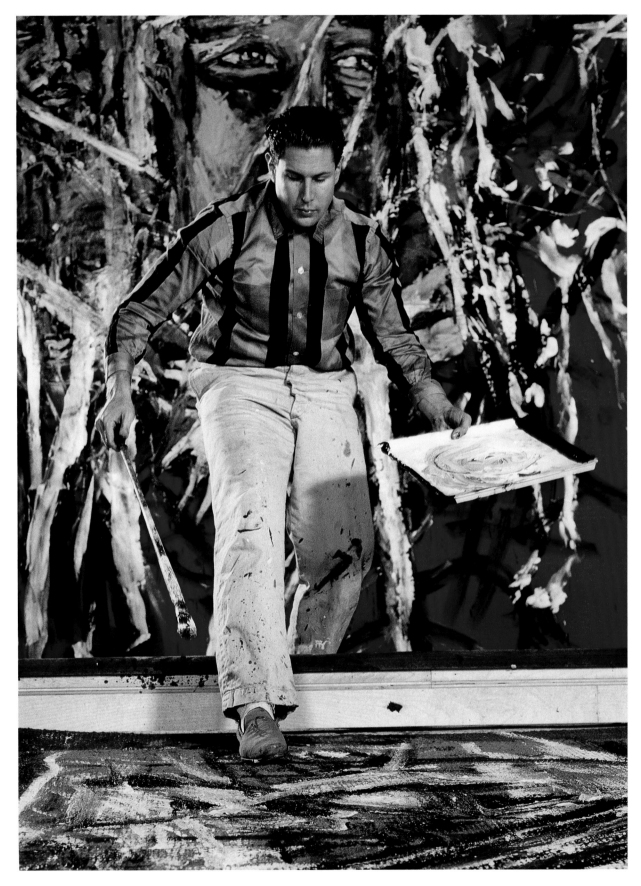

Plate 65.

Julian Schnabel, 1981

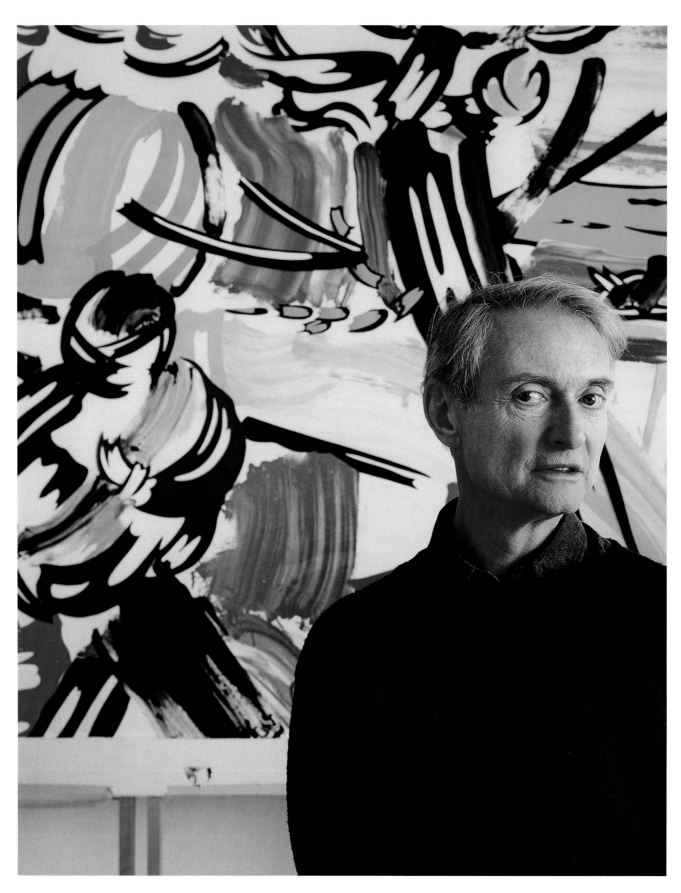

Plate 66.

Roy Lichtenstein, 1985

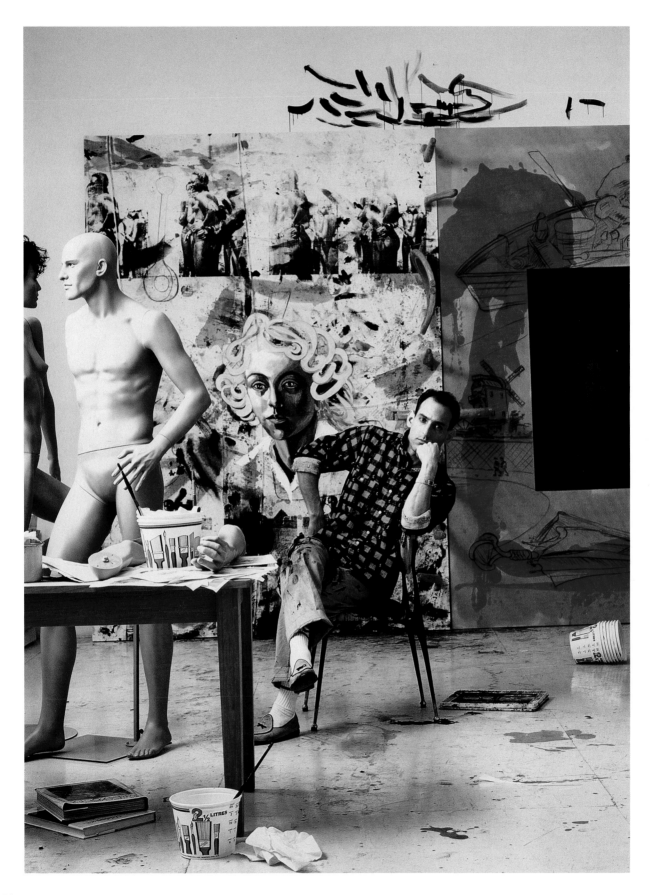

Plate 67.

David Salle, 1986

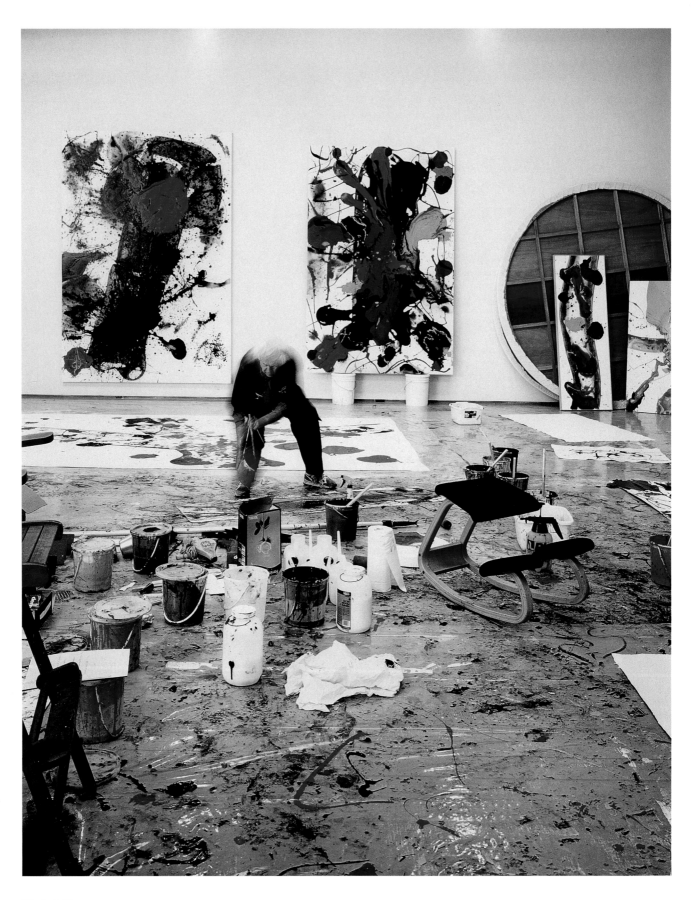

Plate 68.

Samuel Lewis Francis, 1989

Plate 69.

Jack Lenor Larsen, circa 1977–1978

Plate 70.

Richard Diebenkorn, 1982

152

Plate 71.

Lucas Samaras and Arnold B. Glimcher, 1981

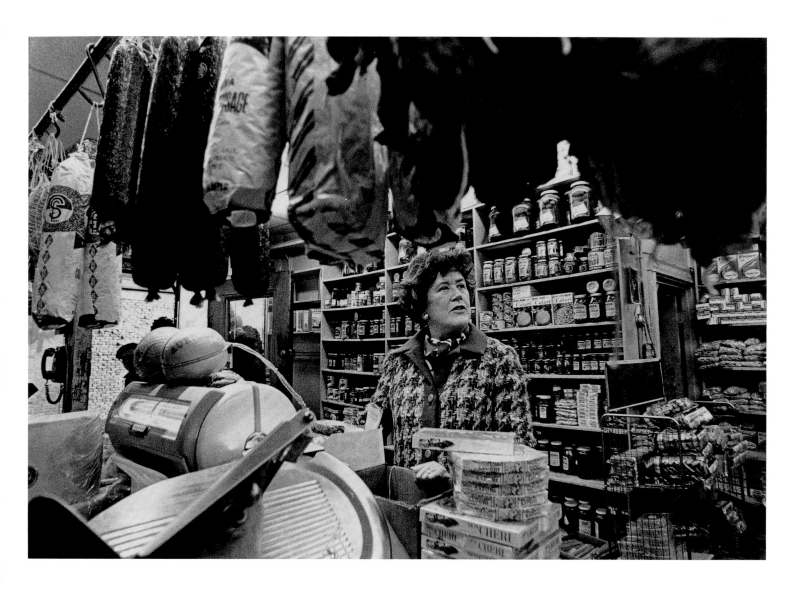

Plate 72.

Julia Child, 1977

154

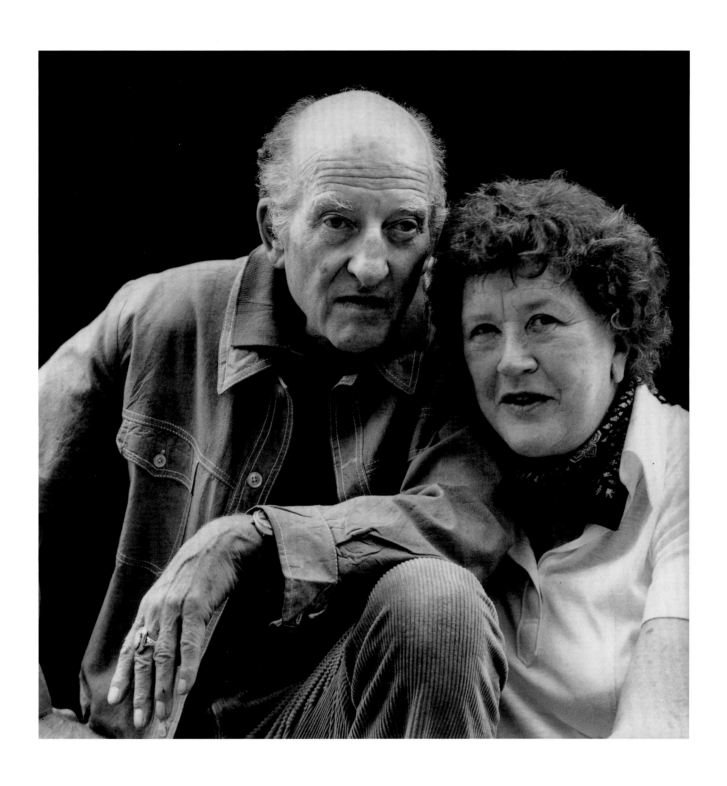

Plate 73.

Paul Child and Julia Child, 1977

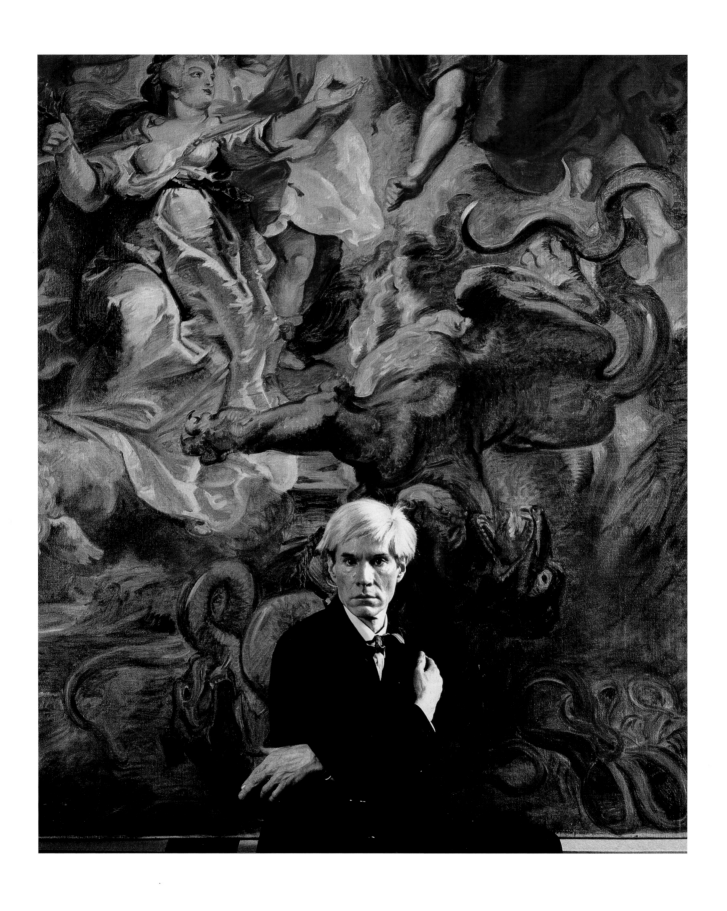

Plate 74.

Andy Warhol, 1981

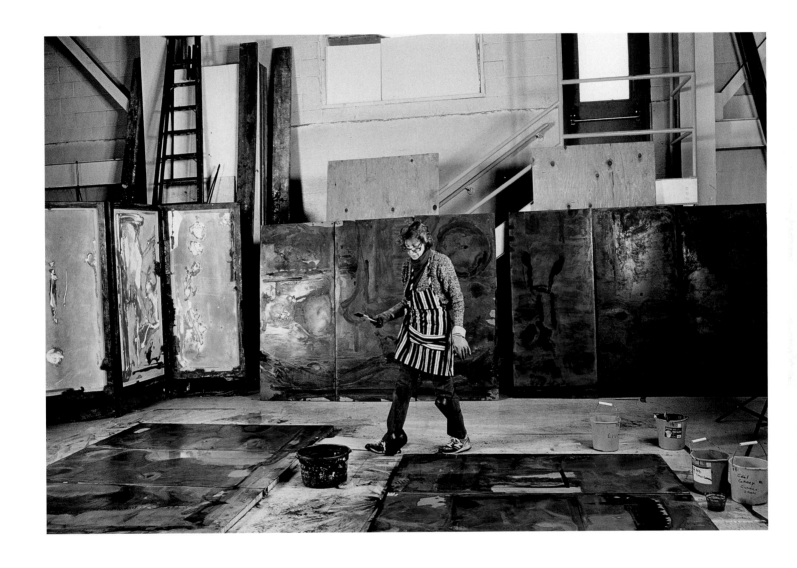

Plate 75.

Helen Frankenthaler, 1987

PLATE CREDITS

All images belong to the National Portrait Gallery, Smithsonian Institution, Washington, D.C. All measurements refer to the image size.

1 · **Hans Namuth** (1915–1990)
Self-portrait
Gelatin silver print, 1966
24.6 x 25.4 cm (9^{11}⁄$_{16}$ x 10 in.)
Gift of the estate of Hans Namuth

2 · **Jackson Pollock** (1912–1956)
Gelatin silver print, 1950
37.8 x 30.4 cm (14^{7}⁄$_{8}$ x 12 in.)
Gift of the estate of Hans Namuth

3 · **Jackson Pollock** (1912–1956)
Gelatin silver print, 1950
26.4 x 25.5 cm (10^{3}⁄$_{8}$ x 10^{1}⁄$_{16}$ in.)
Gift of the estate of Hans Namuth

4 · **Jackson Pollock** (1912–1956)
Gelatin silver print, 1950
40.8 x 35.9 cm (16^{1}⁄$_{16}$ x 14^{1}⁄$_{8}$ in.)
Gift of the estate of Hans Namuth

5 · **Jackson Pollock** (1912–1956)
Gelatin silver print, 1950
37.6 x 35.1 cm (14^{13}⁄$_{16}$ x 13^{7}⁄$_{8}$ in.)
Gift of the estate of Hans Namuth

6 · **Jackson Pollock** (1912–1956)
Gelatin silver print, 1950
30.3 x 30.5 cm (11^{15}⁄$_{16}$ x 12 in.)
Gift of the estate of Hans Namuth

7 · **Jackson Pollock** (1912–1956)
Gelatin silver print, 1950
40.8 x 31.5 cm (16^{1}⁄$_{16}$ x 12^{3}⁄$_{8}$ in.)
Gift of the estate of Hans Namuth

8 · **Barnett Newman** (1905–1970),
Jackson Pollock (1912–1956), and
Tony Smith (1912–1980)
Gelatin silver print, 1951
54.7 x 45.7 cm (21^{1}⁄$_{2}$ x 18 in.)
Gift of the estate of Hans Namuth

9 · **Clyfford Still** (1904–1980)
Gelatin silver print, 1951
28.1 x 26 cm (11 x 10^{1}⁄$_{4}$ in.)
Gift of the estate of Hans Namuth

10 · **Elaine de Kooning** (1918–1989) and
Willem de Kooning (1904–1997)
Gelatin silver print, 1953
31.3 x 27.3 cm (12^{1}⁄$_{4}$ x 10^{3}⁄$_{4}$ in.)
Gift of the estate of Hans Namuth

11 · **Willem de Kooning** (1904–1997)
Cibachrome print, 1968
33.3 x 49.5 cm (13^{1}⁄$_{8}$ x 19^{1}⁄$_{2}$ in.)
Gift of the James Smithson Society

12 · **Robert Motherwell** (1915–1991)
Gelatin silver print, 1953
24.6 x 19.5 cm (9^{11}⁄$_{16}$ x 7^{11}⁄$_{16}$ in.)
Gift of the estate of Hans Namuth

13 · **Robert Motherwell** (1915–1991)
Cibachrome print, 1982
49.2 x 39.3 cm (19^{3}⁄$_{8}$ x 15^{1}⁄$_{2}$ in.)
Gift of the James Smithson Society

14 · **Saul Steinberg** (born 1914)
Gelatin silver print, 1952
25.8 x 25.5 cm (10^{1}⁄$_{8}$ x 10^{1}⁄$_{16}$ in.)
Gift of the estate of Hans Namuth

15 · **Frank O'Hara** (1926–1966) and
Larry Rivers (born 1923)
Gelatin silver print, 1958
24.4 x 18.9 cm (9⅝ x 7½ in.)
Gift of the estate of Hans Namuth

16 · **Larry Rivers** (born 1923)
Cibachrome print, 1965
49.8 x 35.5 cm (19⅝ x 14 in.)
Gift of the James Smithson Society

17 · **Lenore Krasner** (1908–1984)
Cibachrome print, 1962
48.2 x 39.2 cm (19 x 15⁷⁄₁₆ in.)
Gift of the James Smithson Society

18 · **Walter Gropius** (1883–1969)
Gelatin silver print, 1952
19.6 x 24.4 cm (7¾ x 9⅝ in.)
Gift of the estate of Hans Namuth

19 · **Marcel Breuer** (1902–1981)
Gelatin silver print, 1952
34.8 x 26.8 cm (13¹¹⁄₁₆ x 10⁹⁄₁₆ in.)
Gift of the estate of Hans Namuth

20 · **Eero Saarinen** (1910–1961)
Gelatin silver print, 1954
34.4 x 50.5 cm (13⁹⁄₁₆ x 19⅞ in.)
Gift of the estate of Hans Namuth

21 · **Buckminster Fuller** (1895–1983)
Gelatin silver print, 1959
42.6 x 36.8 cm (16¾ x 14½ in.)
Gift of the estate of Hans Namuth

22 · **Frank Lloyd Wright** (1869–1959)
Gelatin silver print, 1958
25 x 20 cm (9⅞ x 7⅞ in.)
Gift of the estate of Hans Namuth

23 · **Ludwig Mies van der Rohe**
(1886–1969)
Gelatin silver print, 1965
33.8 x 27.1 cm (13⁵⁄₁₆ x 10⅝ in.)
Gift of the estate of Hans Namuth

24 · **Louis Isadore Kahn** (1901–1974)
Gelatin silver print, 1971
35.6 x 27.6 cm (14 x 10⅞ in.)
Gift of the estate of Hans Namuth

25 · **Philip Cortelyou Johnson** (born 1906)
Dye transfer print, 1987
55.6 x 42.9 cm (21⅞ x 16⅞ in.)
Gift of the James Smithson Society

26 · **Philip Cortelyou Johnson** (born 1906)
Gelatin silver print, 1987
48.4 x 38 cm (19¹⁄₁₆ x 15 in.)
Gift of the estate of Hans Namuth

27 · **Gian Carlo Menotti** (born 1911)
Gelatin silver print, 1954
23 x 30 cm (9⅛ x 11⅞ in.)
Gift of the estate of Hans Namuth

28 · **Richard Rodgers** (1902–1979) and
Oscar Hammerstein II (1895–1960)
Gelatin silver print, 1958
35.3 x 28 cm (13⅞ x 11 in.)
Gift of the estate of Hans Namuth

29 · **Stephen Sondheim** (born 1930)
Gelatin silver print, 1960
26 x 25.2 cm (10¼ x 9⅞ in.)
Gift of the estate of Hans Namuth

30 · **John Cage** (1912–1992)
Gelatin silver print, 1963
30.6 x 23 cm (12¹⁄₁₆ x 9⅛ in.)
Gift of the estate of Hans Namuth

31 · **Jerome Robbins** (1918–1998)
Gelatin silver print, 1978
23.2 x 22.7 cm (9⅛ x 9¹⁵⁄₁₆ in.)
Gift of the estate of Hans Namuth

32 · **Allen Tate** (1899–1979)
Gelatin silver print, 1952
24 x 18.9 cm (9⁷⁄₁₆ x 7½ in.)
Gift of the estate of Hans Namuth

33 · **Malcolm Cowley** (1898–1989)
Gelatin silver print, 1959
25 x 24.1 cm (9⅞ x 9½ in.)
Gift of the estate of Hans Namuth

34 · **John Steinbeck** (1902–1968)
Gelatin silver print, 1961
31.8 x 25.2 cm (12½ x 9⅞ in.)
Gift of the estate of Hans Namuth

35 · **A. J. Liebling** (1904–1963) and
Jean Stafford (1915–1979)
Gelatin silver print, 1962
19.6 x 19.5 cm (7¾ x 7¹¹⁄₁₆ in.)
Gift of the estate of Hans Namuth

36 · **John Henry O'Hara** (1905–1970)
Gelatin silver print, 1963
36.1 x 27.8 cm (14³⁄₁₆ x 10¹⁵⁄₁₆ in.)
Gift of the estate of Hans Namuth

37 · **Bobby Fischer** (born 1943)
Gelatin silver print, 1963
35 x 27.2 cm (13⅞ x 10¾ in.)
Gift of the estate of Hans Namuth

38 · **Edward Albee** (born 1928)
Gelatin silver print, 1980
27.1 x 26 cm (10⅝ x 10¼ in.)
Gift of the estate of Hans Namuth

39 · **Hans Hofmann** (1880–1966)
Gelatin silver print, 1963
26.6 x 21 cm (10½ x 8¼ in.)
Gift of the estate of Hans Namuth

40 · **Ben Shahn** (1898–1969)
Gelatin silver print, 1964
20.5 x 29.3 cm (8¹/₁₆ x 11½ in.)
Gift of the estate of Hans Namuth

41 · **Leonard Baskin** (born 1922)
Gelatin silver print, 1964
23 x 30 cm (9⅛ x 11⅞ in.)
Gift of the estate of Hans Namuth

42 · **Josef Albers** (1888–1976)
Gelatin silver print, 1971
29.3 x 23 cm (11⁹/₁₆ x 9⅛ in.)
Gift of the estate of Hans Namuth

43 · **Josephine Verstille Hopper**
(circa 1883–1968) and
Edward Hopper (1882–1967)
Gelatin silver print, 1964
19.4 x 19.3 cm (7⅝ x 7⅝ in.)
Gift of the estate of Hans Namuth

44 · **Mark Rothko** (1903–1970)
Gelatin silver print, 1964
22.3 x 30 cm (8¾ x 11⅞ in.)
Gift of the estate of Hans Namuth

45 · **Mark Rothko** (1903–1970)
Cibachrome print, 1964
34.8 x 49.6 cm (13¹¹/₁₆ x 19½ in.)
Gift of the James Smithson Society

46 · **Robert Rauschenberg** (born 1925)
with Hummingbird Takahashi
Gelatin silver print, 1971
17.9 x 25.4 cm (7¹/₁₆ x 10 in.)
Gift of the estate of Hans Namuth

47 · **Joseph Cornell** (1903–1972)
Gelatin silver print, 1971
33.8 x 22.9 cm (13¹⁵/₁₆ x 9 in.)
Gift of the estate of Hans Namuth

48 · **Andrew Wyeth** (born 1917)
Cibachrome print, 1986
49.7 x 39.4 cm (19⁹/₁₆ x 15½ in.)
Gift of the James Smithson Society

49 · **Marisol Escobar** (born 1930)
Gelatin silver print, 1964
32.5 x 26.4 cm (12¹³/₁₆ x 10⅜ in.)
Gift of the estate of Hans Namuth

50 · **Tony Smith** (1912–1980)
Cibachrome print, 1970
34.2 x 49.5 cm (13½ x 19½ in.)
Gift of the James Smithson Society

51 · **Jasper Johns** (born 1930)
Gelatin silver print, 1962
33.1 x 23.4 cm (13¹/₁₆ x 9¼ in.)
Gift of the estate of Hans Namuth

52 · **Jasper Johns** (born 1930)
Cibachrome print, 1973
40.8 x 33.5 cm (16¹/₁₆ x 13³/₁₆ in.)
Gift of the James Smithson Society

53 · **Jim Dine** (born 1935)
Gelatin silver print, 1977
32.3 x 23.3 cm (12¾ x 9³/₁₆ in.)
Gift of the estate of Hans Namuth

54 · **Jim Dine** (born 1935)
Cibachrome print, 1977
39.4 x 49.5 cm (15½ x 19½ in.)
Gift of the James Smithson Society

55 · **Louise Nevelson** (1900–1988)
Cibachrome print, 1977
43.5 x 39.4 cm (17⅛ x 15½ in.)
Gift of the James Smithson Society

56 · **Romare Bearden** (1912–1988)
Cibachrome print, 1980
50.4 x 34.2 cm (19¹³/₁₆ x 13½ in.)
Gift of the James Smithson Society

57 · **Frank Stella** (born 1936)
Cibachrome print, 1981
50.6 x 35.6 cm (19¹⁵/₁₆ x 14 in.)
Gift of the James Smithson Society

58 · **Leo Castelli and His Artists**
Standing, left to right: Ellsworth Kelly
(born 1923), Dan Flavin (born 1933),
Joseph Kosuth (born 1945), Richard Serra
(born 1939), Lawrence Weiner (born 1942),
Nassos Daphnis (born 1914), Jasper

Johns (born 1930), Claes Oldenburg (born 1929), Salvatore Scarpitta (born 1919), Richard Artschwager (born 1923), Mia Westerlund Roosen (born 1942), Cletus Johnson (born 1941), Keith Sonnier (born 1941)
Sitting, left to right: Andy Warhol (1928–1987), Robert Rauschenberg (born 1925), Leo Castelli (born 1907), Edward Ruscha (born 1937), James Rosenquist (born 1933), Robert Barry (born 1936)
Gelatin silver print, 1982
24.5 x 22.7 cm (9⅝ x 9¹⁵⁄₁₆ in.)
Gift of the estate of Hans Namuth

59 · **Leo Castelli** (born 1907)
Gelatin silver print, 1982
30 x 26.5 cm (11⅞ x 10⁷⁄₁₆ in.)
Gift of the estate of Hans Namuth

60 · **Ellsworth Kelly** (born 1923)
Cibachrome print, 1983
50.8 x 40 cm (20 x 15¾ in.)
Gift of the James Smithson Society

61 · **George Segal** (born 1924)
Cibachrome print, 1980
49.7 x 37.7 cm (19⁹⁄₁₆ x 14⅞ in.)
Gift of the James Smithson Society

62 · **Isamu Noguchi** (1904–1988)
Gelatin silver print, 1987
29.1 x 23.4 cm (11⁷⁄₁₆ x 9¼ in.)
Gift of the estate of Hans Namuth

63 · **James Rosenquist** (born 1933)
Cibachrome print, 1988
39 x 48.5 cm (15⅜ x 19⅛ in.)
Gift of the James Smithson Society

64 · **Louise Bourgeois** (born 1911)
Gelatin silver print, 1978
17.2 x 25.5 cm (6¾ x 10¹⁄₁₆ in.)
Gift of the estate of Hans Namuth

65 · **Julian Schnabel** (born 1951)
Cibachrome print, 1981
49.6 x 37 cm (19½ x 14⁹⁄₁₆ in.)
Gift of the James Smithson Society

66 · **Roy Lichtenstein** (1923–1997)
Cibachrome print, 1985
48.5 x 38.2 cm (19⅛ x 15¹⁄₁₆ in.)
Gift of the James Smithson Society

67 · **David Salle** (born 1952)
Cibachrome print, 1986
48.3 x 36.2 cm (19 x 14¼ in.)
Gift of the James Smithson Society

68 · **Samuel Lewis Francis** (born 1923)
Cibachrome print, 1989
49.3 x 39.1 cm (19⁷⁄₁₆ x 15⅜ in.)
Gift of the James Smithson Society

69 · **Jack Lenor Larsen** (born 1927)
Gelatin silver print, circa 1977–1978
33 x 24 cm (13 x 9⁷⁄₁₆ in.)
Gift of the estate of Hans Namuth

70 · **Richard Diebenkorn** (1922–1993)
Cibachrome print, 1982
39.6 x 49.7 cm (15⅝ x 19⁹⁄₁₆ in.)
Gift of the James Smithson Society

71 · **Lucas Samaras** (born 1936) and **Arnold B. Glimcher** (born 1938)
Gelatin silver print, 1981
23.5 x 22.7 cm (9¼ x 9¹⁵⁄₁₆ in.)
Gift of the estate of Hans Namuth

72 · **Julia Child** (born 1912)
Gelatin silver print, 1977
23.9 x 34.8 cm (9⅜ x 13¹¹⁄₁₆ in.)
Gift of the estate of Hans Namuth

73 · **Paul Child** (1902–1994) and **Julia Child** (born 1912)
Gelatin silver print, 1977
21.2 x 21 cm (8⅝ x 8¼ in.)
Gift of the estate of Hans Namuth

74 · **Andy Warhol** (1928–1987)
Cibachrome print, 1981
46.2 x 39.6 cm (18³⁄₁₆ x 15⅝ in.)
Gift of the James Smithson Society

75 · **Helen Frankenthaler** (born 1928)
Cibachrome print, 1987
33.3 x 49.3 cm (13⅛ x 19⁷⁄₁₆ in.)
Gift of the James Smithson Society

SELECTED BIBLIOGRAPHY

Archives

Namuth, Hans. Collection. Center for Creative Photography, the University of Arizona, Tucson.

———. Papers. Archives of American Art, Smithsonian Institution, Washington, D.C.

———. Personal papers, 1934–1947. Collection of Peter Namuth and Tessa Namuth Papademetriou.

———. Records of the Office of Strategic Services. Record Group 226. National Archives, Washington, D.C.

Books

Evans, Martin Marix, ed. *Contemporary Photographers*. 3rd ed. New York and London: St. James Press, 1995.

Jones, Caroline A. *Machine in the Studio: Constructing the Postwar American Artist*. Chicago and London: University of Chicago Press, 1996.

Karmel, Pepe. "Pollock at Work: The Films and Photographs of Hans Namuth." In Kirk Varnedoe with Pepe Karmel, *Jackson Pollock* (New York: Museum of Modern Art, 1999).

Kelly, Jain, ed. *Darkroom2*. New York: Lustrum Press, 1979.

Naifeh, Steven, and Gregory White Smith. *Jackson Pollock: An American Saga*. New York: Clarkson N. Potter, 1989.

Namuth, Hans. *Fifty-two Artists: Photographs by Hans Namuth*. Scarsdale: Committee for the Visual Arts, 1973.

———. *Early American Tools*. Verona, Italy: Olivetti, 1975.

———. "Photographing Pollock." In Barbara Rose, ed. *Pollock Painting*. New York: Agrinde Publications, circa 1980.

———. *Artists 1950–81: A Personal View*. New York: Pace Gallery Publications, 1981.

Namuth, Hans, and Georg Reisner. *Spanisches Tagebuch, 1936: Fotografien und Texte aus den ersten Monaten des Bürgerkriegs*. Introduction by Diethart Kerbs. Berlin: Nishen, 1986.

O'Doherty, Brian. *American Masters: The Voice and the Myth*. Photographed by Hans Namuth. New York: Random House, A Ridge Press Book, 1973.

Rose, Barbara, ed. *Pollock Painting*. With essays by Hans Namuth, Barbara Rose, Francis V. O'Connor, Rosalind Krauss, William Wright, and Paul Falkenberg. New York: Agrinde Publications, circa 1980.

Articles

"Artists' Portraits." *Art International* 6 (spring 1989): 40–49.

"Castelli Downtown Exhibit." *Art News*, January 1976, p. 117.

"Castelli Graphics Gallery Exhibit." *Art News*, May 1977, p. 127.

"Castelli Graphics Gallery Exhibit." *Art News*, May 1979, p. 176.

"Castelli Graphics Gallery Exhibit." *Arts* 53 (June 1979): 34.

"Castelli Uptown Exhibit." *Artforum* 14 (January 1976): 66.

"Castelli Uptown Exhibit." *Arts* 51 (May 1977): 30.

Cavaliere, B. "Pace Gallery Exhibit." *Arts* 56 (February 1982): 5.

"Early American Tools, a Photographic Essay." *Craft Horizons* 35 (December 1975): 28–35.

"Estremadura Front, Photographer Georg Reisner, 1936." *Arts Review* (April 25, 1986): 217.

Furman, L. "Namuth Exhibit at Downtown Leo Castelli." *Art News*, March 1974, p. 98.

Greenberg, C. "Reply to Rose Article with Rejoinder." *Arts* 53 (April 1979): 24.

Grundberg, Andy. "Hans Namuth, 75, Photographer Whose Art Captured Artists, Dies," *New York Times,* October 15, 1990, sec. B7, p. 50.

Hare, D. "Calder's Universe." *Craft Horizons* 38 (February 1978): 6ff.

Hopkinson, A. "Los Todos Santeros: A Family Album of Mam Indians." *British Journal of Photography* 136 (March 16, 1989): 18ff.

Jodidio, P. "De fil en aiguille: art contemporain (Hans Namuth est connu pour ses portraits d'artistes; voici ses dernières images réalisées à New York)." *Connaissance des Arts,* July/August 1988, p. 34.

Jodidio, P. "Obituary." *Connaissance des Arts,* December 1990, pp. 72–73.

Lifson, B. "Artists in Camera." *Art News,* March 1982, pp. 101–2.

McNaught, W. "Gift of Photographs to the Archives of American Art." *Archives of American Art Journal* 25, no. 1/2 (1985): 59.

Namuth, Hans. "Albert Renger-Patzsch: The World Is Beautiful." *Art News,* December 1981, p. 136.

"Namuth (Photographs from Todos Santos)." *Camera* 58 (January 1979): 16–21.

"Namuth's Artists." *Art in America* 62 (January 1974): 116–17.

"Obituary." *Art in America* 78 (December 1990): 190.

"Obituary." *British Journal of Photography* 137 (November 29, 1990): 9.

O'Connor, F. V. "Namuth's Photographs of Jackson Pollock as Art Historical Documentation." *Art Journal* 39 (fall 1979): 48–49.

Peppiatt, M. "Obituary." *Art International* 13 (winter 1990): 26.

"Phoenix II Gallery, Washington, D.C. Exhibit." *Arts* 57 (April 1983): 46.

Picard, D. "A la française (Portraits of Five French Artists by Hans Namuth)." *Connaissance des Arts,* April 1990, pp. 76–83.

Picard, D. "Portraits d'artistes (Galerie Yvon Lambert, Paris; exhibit)." *Connaissance des Arts,* January 1990, pp. 32–33.

Rose, Barbara. "Hans Namuth's Photographs and the Jackson Pollock Myth." *Arts* 53 (March 1979): 112–19.

Russell, J. "L'homme qui laisse parler le modèle." *Connaissance des Arts,* January 1983, pp. 44–51.

Russell, J. "Todos Santos (quelques portraits, d'un village Guatémaltèque)." *Connaissance des Arts,* July/August 1988, pp. 26–31.

Schneider, Sigrid. "Von der Verfügbarkeit der Bilder: Fotoreportagen aus dem Spanischen Bürgerkrieg," *Fotogeschichte* 8, no. 29 (1988): 29ff.

Strickland, C. "Camera and Action." *Art and Antiques,* September 1991, pp. 74–83.

INDEX